RAZORBILL®

An Imprint of Penguin Random House LLC

Penguin.com

RAZORBILL & colophon is a registered trademark
of Penguin Random House LLC.

First published in the United States of America by Razorbill,
an imprint of Penguin Random House LLC, 2017

LIBRARY OF CONGRESS CATALOGING-IN-PUBLICATION DATA IS AVAILABLE
ISBN: 9780448494333

Printed in the United States of America

1 3 5 7 9 10 8 6 4 2

Designed by Rodrigo Corral Design

SNEAKERS

RODRIGO
CORRAL

ALEX
FRENCH

HOWIE
KAHN

RAZORBILL

INTRODUCTION

The reporting for this book started as a purely objective exercise. We wanted to investigate sneakers, not as a product but as an idea. How do shoes capture the imagination? How do uppers and midsoles combine to generate feelings of lust, or even love? What makes sneakers timeless, obsession-worthy, and cool?

Sneakers, we noticed, define behavior. But how does a thing that covers your foot become habit-forming? How does it bring the most minuscule-seeming details into relief? You turn a corner and suddenly you agonize over aglets, lose your cool over colorways. You're lured into lines, digital and physical, in hopes of landing a new release. Maybe you buy a bot. Maybe you wrangle an invitation to a coveted event where you'll score an instant classic, but only if you complete an actual obstacle course created by the shoe's designer. Maybe you fall off a rope and break a bone in the process. Maybe you limp on and still score the shoes.

A few months in, it was clear: our objectivity had become compromised.

We were still looking into the same questions, but something else was happening, too. The shoes themselves were starting to get the best of us. Before we had real answers for any of the above, we found ourselves texting one another at three a.m., strategizing ways to get the Packer Consortium NMDs (and failing), DMing about super-rare Atmos Air Maxes (and drooling), having long debates about our own evolving personal styles (we had "personal styles" now, apparently). Here's what had happened: the sneakers were winning.

Get close and the sneakers will always win.

After a few more months of being led on by so many laced-up sirens, and watching the boxes (and the bills) rise in stacks, we remembered to look up—to see that a whole world of stories exists above the ankle.

Collectively, sneakers do not become the basis for their own culture without an incendiary and driven cast of characters perpetually pushing them forward, keeping them fresh.

This book is about those people. Over the course of more than one hundred interviews, they've met the demands of our original investigation by revealing why sneakers matter so deeply to them. With their words, and despite our title, this book isn't really just about the shoes. *Sneakers* chronicles creativity and hustle, art and design, big business and bigger dreams, adventure and risk, refining taste and deciding the future, the mindful labor of working together and working alone.

From a vast and ever-expanding world, we chose each of our subjects for both their prominence and their promise: every person in these pages has created a thing that matters and plans to do even more. The months-long arguments about who belongs in this book and who doesn't were as intense as the ones about which sneaker each of us would bring to a desert island. The discussions about balancing major forces like Nike and adidas with independent actors were ongoing as well, and were eventually only settled by an estimate. How much of your daily sneaker conversation is occupied by those brands? About a third of it? Yeah, that's how we felt, too.

The chapters all link. There's an Instagram-like, wormhole flow to the pages that follow, with one cultural touchstone leading to the next, whether it's a formative encounter between creators, a mutually significant shoe, a geographical connection, or an ethos. We'll introduce the major players and spell out the logic—which also involves NASA, Pringles packages, lasers, and epic parties—as we go.

Through honesty, intimacy, intelligence, and swagger, *Sneakers* amounts to a singular rubber-soled taxonomy, a global group portrait of a culture that's both personal and public, driven by commitment and curiosity and sustained by our definitive cast of storytellers, historians, and artists.

It's gotta be the shoes, right? It's boxes and boxes full, of course. But it's also the people, these people, your people.

Contents

SALEHE BEMBURY

BASED IN

LOS ANGELES, CALIFORNIA

VITALS

Bembury's lifelong obsession with design excellence, his unwavering curiosity, and a resume that features work for Yeezy and Greats, puts him squarely in the center of the sneaker zeitgeist. At 31, he's a footwear designer who defines this moment.

CHAPTER

01

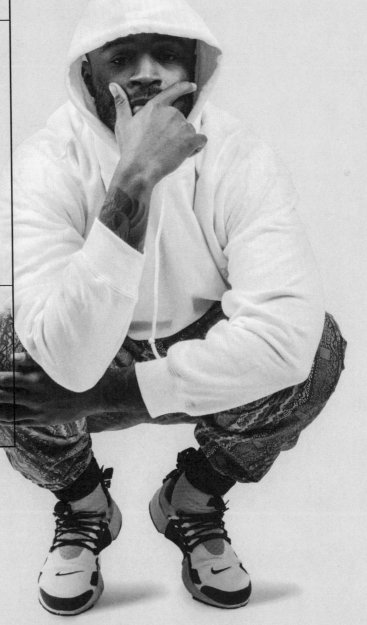

I.Hotlines and Remote Controls

During my middle school days, a lot of us suffered from delusions that we were going to the NBA. So if you were wearing some Jordans, it just assisted that delusion. I didn't know it at the time, but I was reacting to design. Design evokes emotions.

I noticed sneakers everywhere. I'd watch a sitcom and while my focus probably should have been on the storyline, I was paying attention to the sneakers the characters were wearing. Like the last episode of *The Fresh Prince of Bel-Air*: Everyone remembers what happened, and how they all moved out of the house and all that. But while everyone was watching Will hug Uncle Phil for the last time, I was paying attention to the fact that he was wearing all-white Jordan XIs. And obviously, the OG of all sitcom characters was Jerry Seinfeld. I wasn't so much into that show, but Jerry came correct.

And when *SLAM* magazine had their kicks issue, they would always have this little advertisement page with a phone number, and you could call in and it would be the basketball player on the phone, and he would be like, "Hello, this is Jason Kidd, thank you for buying the Air Zoom Flight '95. I just want to take a second to tell you about the shoe." Listening as a kid, that was crazy. I thought that was the player on the phone, and I would be like, "Jason! Jason!" And he would ignore me and keep going. It was obviously a recording but I thought he was just ignoring me and talking about the shoes. I would write down the number and tell my friends, like, "Yo, I got Jason Kidd's number. If you call it he'll tell you about his shoes."

Eventually I started drawing what I saw. At the time I definitely wasn't designing, I wasn't making up my own stuff, it was more like trying to perfect the shapes of what I saw. It's so crazy to me now that I get paid to design shoes, because that's essentially what I would run home from school and do instead of homework.

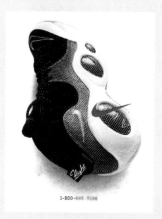

1-800-645-7256

THIS PAGE:

Jason Kidd ad from
SLAM Magazine

OPPOSITE PAGE:

Salehe Bembury

II. Dawn Patrol and After-School Specials

If you ever saw your boy walking to class with some new Jordans, there was definitely some jealousy. The Jordan XI was the shoe I had to talk to my parents about helping me out with the money, because I had been saving up. This was right around when *Space Jam* dropped; it just looked like a different shoe. Going back to the whole emotions thing, being a kid and putting on the Jordan XI, there was this adult feeling to it since it had the patent leather. At the time, I just felt so important when I put it on.

We didn't have the same amount of overall access to shoes back then that we do now. Sometimes a friend had a shoe that you would have had to travel to the ends of the earth to get. I had this one friend, we went to different schools. I lived in Tribeca and he was from Chelsea. We would meet up at six a.m. before school to trade Jordans. That's proof of the importance of fresh kicks at school.

I went to school on the Upper West Side at Calhoun and played basketball there. It's not a rough area at all. Most of the kids up there wear New Balance or ASICS, so when I was wearing my Jordans I definitely stood out. There was another school not too far away (shout out PS 811), and those kids would always try to jack your shoes.

Our team shoe was the Nike Flightposite 3. They had these big, giant bubbles on them and they were white and green, our school colors. And I was just wearing them at McDonald's and this kid started asking me all these questions about my shoes. When they ask your size, that's the red flag. That's when you figure out your exit strategy. Nobody ever successfully took my shoes. I'm not saying I'm a fighter. I just had the gift of gab.

III. City of Secrets

There were some mom and pop stores that I frequented. There was this place right below 96th Street called Sprint Sports. With the mom and pop stores, those were the secret spots because you could always get some kind of hookup, like getting things early, or maybe getting a couple more pairs than you needed. Obviously at the Foot Lockers and all those places there was no wiggle room for anything.

When I was younger there were no Flight Clubs or anything like that. There were underground spots. Back when I was a kid, the appeal to being a part of the whole sneaker culture was that it had this secret society feel to it. My buddy Wil Whitney had a spot called Nom de Guerre and that's where you went for the things that were more exclusive, like Japanese releases and things like that. There was a whole circuit of stores on the Lower East Side: from Nom de Guerre you'd shoot over to Classic Kicks, and then you'd hit Recon, and then you'd go over to Rivington and hit Alife. Alife had this employee named Kunle who would decide if he'd even let you into the store. It was scary. A lot of these places didn't promote because they didn't want to blow up too much. You really had to do your research to find them, which was what made them cool.

I tried camping out for shoes overnight probably two or three times just to see what it was like. It was the era of portable DVD players, so we'd be watching *Family Guy* in line and doing our bathroom business at the bodega around the corner. One of those mornings, we were waiting for some Dunk Highs to be released at Supreme and somebody tried to cut the line and this other kid actually came up and stabbed him. The cops showed up and arrested that kid while the rest of us just stayed still because nobody at Supreme wanted to lose their spot.

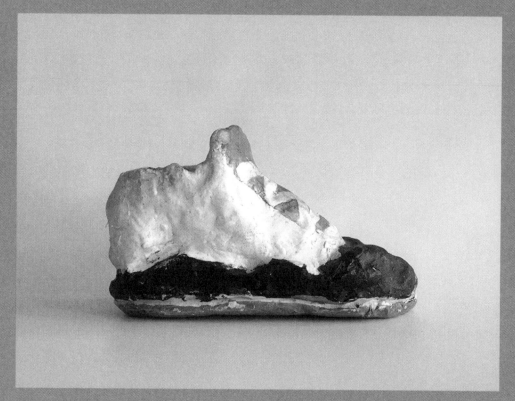

When his grade
school art
teacher asked
him, simply, to
make his favorite
thing, Salehe
molded a high-top
resembling the
Concord Jordan 11
out of clay.

THIS PAGE:

Air Jordan 11 Retro "Concord"

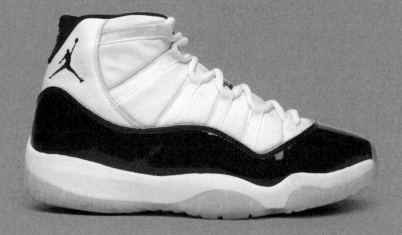

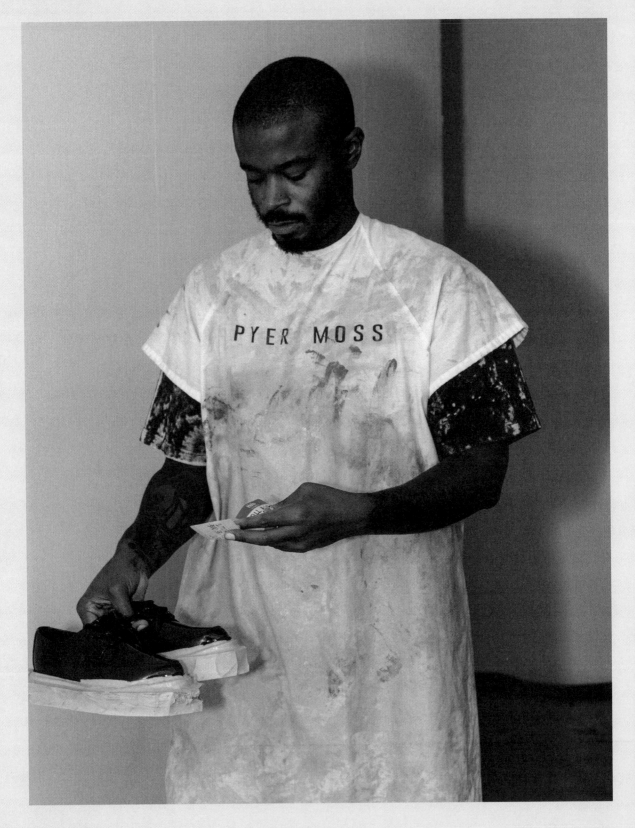

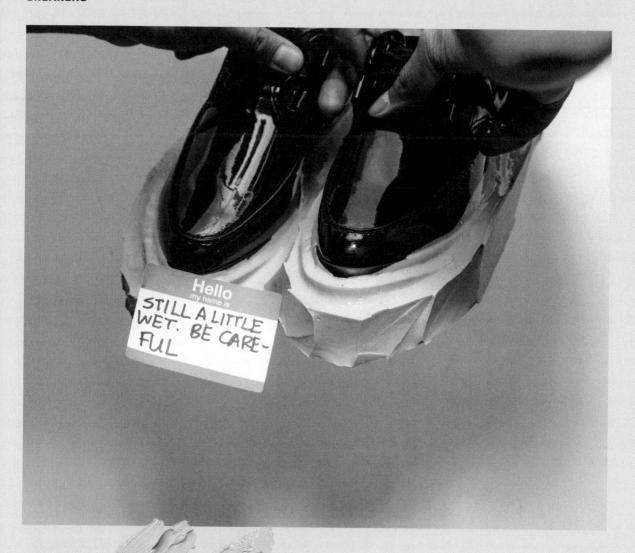

THIS PAGE:

Salehe Bembury for Pyer Moss
Spring 2017

IV. The Meaning of Yeezy

There's been some stale years. Times when the kids weren't camping out, times when reseller culture felt dead. I think one of the things that brought that energy back was adidas and Kanye.

Marketing can obviously push a product, but this is more about design. It's good design. You can't argue with good design. I've worn Yeezys and had people who know nothing about sneakers come up to me and just be like, *Whoa*. It helped start a moment with fewer rules. More creativity.

It makes me think of this episode of the cartoon *Doug*. There was this basketball shoe he really wanted. It was called, like, the Jimmy Jazz 5000 or something [The episode, which aired in September of 1991, is called "Doug's Cool Shoes." The shoes are the Sky Davis Air Jets]. It was this crazy-looking shoe. But in the '90s, obviously, it was never a shoe that anyone would ever wear since most silhouettes looked the same.

But now the design laws have kind of been broken. There's a new consumer base slowly growing into the mainstream, and with new consumers come new rules. Now, shoes are looking like organisms; they're looking like spaceships. As a footwear designer, that's a really exciting thing to be a part of.

THIS PAGE:

Yeezy Season 3 Military Boot
sketch by Salehe Bembury

Yeezy Season 3 Military Boot
"Rock"

Yeezy Season 3 Military Boot
"Burnt Sienna"

OPPOSITE PAGE:

Yeezy Season 3 Footwear

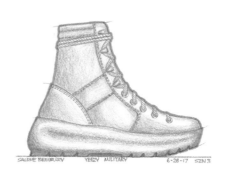

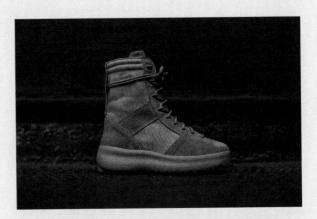

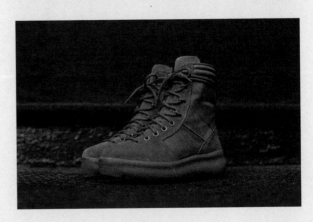

EDSON SABAJO

BASED IN

AMSTERDAM, THE NETHERLANDS

VITALS

Patta, the boutique Sabajo founded with his partner, Guillaume Schmidt, is globally known for iconic collaborations and sneakers found nowhere else. As with Bembury, the streets of New York played a role in getting started.

CHAPTER

02

I. Patta Bing, Patta Boom

Go back to the '80s when there was no internet. We had videos and records, man. You wanted the shoes those guys wore. Biz Markie, 2 Live Crew. There was a lot of Fila, crazy Nike high-tops. The first time I came to New York from Amsterdam was in '88 or '89 and I remember trying to cop the Jordan III. I couldn't get it, so I copped the IV. That was the first shoe I brought back home that nobody else could get. The Netherlands wasn't a basketball country. You couldn't find Air Force 1s; we grew up with runners and soccer shoes: Air Maxes, Kangaroos, and New Balance Epics.

My parents are from Suriname. Like typical Surinamese, they'd buy us three pairs at a time: one for playing outside, one pair for going to school, and one for socializing. But you only have those three pairs. That's it. When one's done, they'll buy you a new pair. So it's not like you're stacking and stacking. The minute that I started to earn some money with my paper routes, I'd try to get some shoes.

That Jordan IV: that's when I knew I liked having something different and knew I'd have to travel to get it. In '92, '93, I became a DJ and started going all over the globe. I started seeing one style of adidas in Yugoslavia and another in Germany. I started seeing colors we didn't have in Holland. It was all about the hunt. In 2002, after DJing and playing semi-professional soccer, I suddenly said, "Yo, man, let's start a sneaker store."

We opened Patta in 2004 with no accounts, nothing coming from any of the sneaker companies. We knew where to get shoes. There was one guy deep in the Bronx who had so many sneakers it was crazy. We had contacts in North Philly and West Philly. In Brooklyn, on Fulton. In Jamaica, Queens. We knew how to trade.

Like, we knew how to get one hundred pairs of chocolate brown Air Force 1s with a creamy swoosh that you could only get in Paris and trade them for a color in the States that didn't exist in Europe. So that's the kind of thing we did, back and forth, back and forth. Europe, New York, LA, Asia. We wanted to open a store with international stock. If we got a regular account, we'd just be getting the same stuff as everybody else.

I remember we had the Reebok Freestyle Hi before anybody else in Amsterdam. We were getting them from some crazy ghetto in Philadelphia. The neighborhood drug dealer took us to the shoes. They were old already, cracked on all sides, but still banging: crazy colors, purple, yellow, crazy green. I told the guys there that I wanted all the shoes, everything they had, for $10 each. It was the ghetto, they needed money. We took about four hundred pairs for that price and sold them for $110 a pair.

In Amsterdam, Foot Locker and the other chains started complaining to Reebok, saying, "Look, man, kids are coming in the store and they want to have this shoe but we cannot get it because it's not in your local catalog." And Reebok was like, "Yo, we don't even make this shoe anymore." So Reebok was like, *You know what? Let's make that shoe again*, and then they sold a lot of pairs. And they called us up, actually, saying, "Yo, thank you for doing that." From then on, we knew this wasn't a hobby anymore.

II. Partners and Points

After about two years, we started working on collaborations. We did something with Nike and *State Magazine*. But I consider the first one to be with ASICS. They came up to us and were like, "Look, man—you're making so much noise on the internet. Let's do this." We did the GEL-Lyte III. People from all over Europe showed up when it dropped. Huge line. The local news station, AT5, which is like NY1, covered it and did an interview with a German dude who drove for six hours and didn't get the shoe. So he was very pissed. But the reporter was like, "Yo, man, chill out, you can go to the Red Light, you can take ecstasy." We took the news item to the bank and got a loan right way. You can't go to a bank and say, "Yo, I did a collab with ASICS." They'd be like, *Whatever*. They can't translate that. But they do understand the news.

Then it was just on, you know? Nike came, they were like, "Yo, we're going to try this new project called Tier Zero, we want you guys to get involved." When we got involved, I think they had only twenty-four stores worldwide or twelve worldwide that had that account, and they were like, "Yo, we want you to have one of those." We said, "All right, we'll do that but we still want to do our parallel shopping, we still want to go to New York and buy stuff and put it in our store." They were like, "Cool, go." We've done a lot of collaborations with them since. We've also done Converse, Roos, Reebok, Diadora, and clothing with Bobbito Garcia.

You have to be careful with the collabos, though. If you're not, people will think your brand is wack and your brand will die.

There's one collaboration for me that stands out: the Kangaroos in 2011, that was the first time we ever made a contract where we got points, like the same way you would in publishing or music. You sell this shoe, you get 10 percent or whatever of all the profits you're going to make. Stuff like that for us is new and interesting. So is building a shoe from scratch, not coloring one that's already there. With the Kangaroos, we did the mold, insole, outsole, fabrics. We learned a lot from that. It was beautiful.

III. All Terrain

I still travel, I still hunt. My last hunt was in Dubai when I was there for Sole DXB. DJ Clark Kent was over there; Bobbito, too. We were all hanging out. And then my man from South Africa, he came and he's like, "Yo, what's up?" He said, "Yo, man, there's a store, an outlet spot like a half hour drive from Dubai." It's like an addiction for me. What are they going have? Crazy Jordans? Huaraches in some color I've never seen? The next day me and my boy took a car. We just drove off into the desert.

OPPOSITE PAGE:

Patta x ASICS GEL-Lyte III

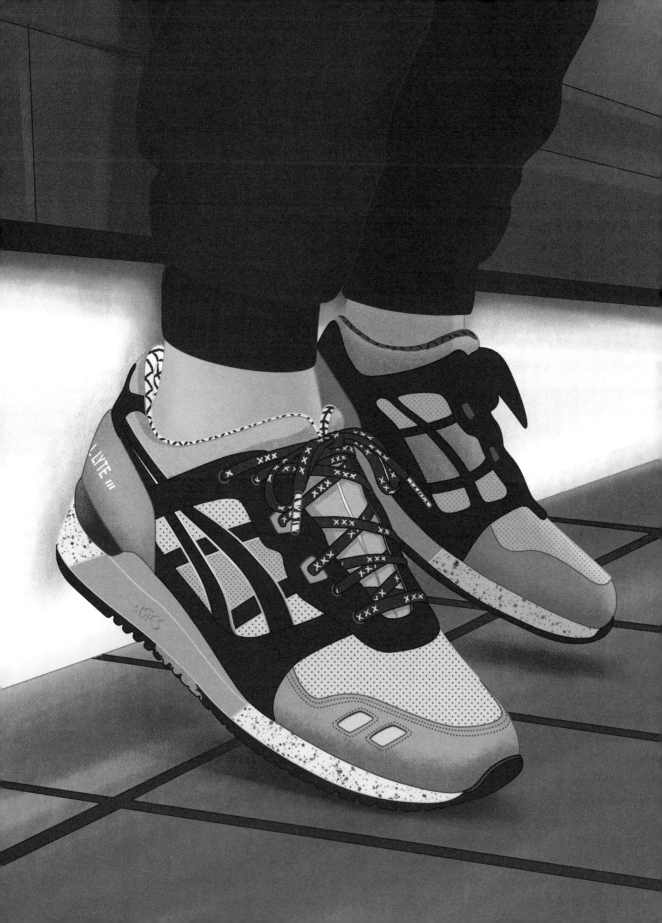

YU-MING WU

BASED IN

NEW YORK, NEW YORK

VITALS

He created Sneaker News and co-created Sneaker Con. Yu-Ming Wu discovered his path much like Bembury and Sabajo: by turning his passion into a business.

CHAPTER

03

I. Sweat Equity

OPPOSITE PAGE:

Yu-Ming Wu and his father

I was born in a small farming village in Guangdong, in the south of China. I don't even recall having shoes. Probably nobody had even seen a pair of sneakers. We immigrated to the United States as a family in 1985. I was six. We were living in Sunset Park, Brooklyn. My parents spoke no English. My dad got a job in a Chinese restaurant. My mom worked in a sweatshop.

I first started to understand what it meant to look fresh in New York City around the seventh grade. And I started to see my classmates with cool shoes. The Reebok Pump was probably the biggest shoe at that time. But obviously it was way too expensive for my parents to buy. They were like $135. So I begged for a pair of ASICS GEL-Lyte IIIs, which were probably in the $40–$50 range. Even that was quite a bit high for my parents, but they bought them for me anyway. Those were the very, very first pair of cool sneakers I ever owned. They were white with blue accents; they had microsuede and some cool mesh. I didn't realize until many years later how important that moment was in my life.

After that one time that I asked my parents to buy me a pair of sneakers, I never asked again. I realized pretty quickly how hard it was for them to do that, working such low-paying jobs. In high school, I worked in a sweatshop as well, a few different factories, actually, between Sunset Park and Borough Park in Brooklyn. I was the person pressing the piece of material onto button-down shirts where the collar starts to get stiff, at the base of the neck. I did it to make some extra money after school and on the weekends.

In high school, I wore Converse Chuck Taylors the entire time, just because they were cheap. You could get them for about $25, $30. My parents and I were still continuing to figure out how get by. By that time, my dad and his brothers owned a restaurant in Elizabeth, New Jersey. On the weekends, I'd go there and work. I'd work with my mom in the sweatshops and with my dad at the restaurant. The whole time, I'd be observing all the hardship. Just watching my family work and work.

There are obviously people who are born well off. Some of those guys definitely have quite a bit of a drive. But those who were raised without much? The drive is much stronger.

II. On the Origins of Obsession

In college I got my first real job and I was able to start playing around with my own money. That's when I discovered this cool world of sneakers. This was 2002, and there was one pair I really, really liked enough to try and figure out how to get them: the Atmos Air Max 1 Safari. They were $150, which was still quite a lot of money to me.

I was at Parsons studying graphic design and somebody introduced me to a recent graduate who was helping with the Parsons Gallery. They said, "Hey, this is the girl that can actually get you those shoes." I didn't ask

★ **<u>Do you like sneakers?</u>**

Do keywords "LeBron James" and "Kobe Bryant" ring a bell to you? Do you like websites?

questions. She just had them. They were a half size too big, actually. But that was cool. I eventually ended up with four pairs. That's how it all got started. That's when I started trying to figure this world out, to discover what it is and what makes it cool. That's when the research began and how Freshness Mag got started, too.

I looked up to this other website called Being Hunted out of Germany. I loved the site, but it wasn't fast enough. My hunger for news and information and the culture was insatiable, and as I just kind of constantly dug around the web, I didn't see anything moving at the right speed. I wanted something that was updated daily, you know? I was discovering all of these things happening downtown between Alife doing their art shows and their releases and whatever was going on at Supreme. No one was really covering it on that daily level except Nike Talk. Except on Nike Talk, it was just random guys posting the most random stuff. There wasn't any editorial authority.

One of the first posts on Freshness Mag: I was reading Nike Talk and someone had posted that Supreme had just restocked the Nike

Dunk Low SB collaboration. I saw that post and quickly ran down to Supreme. I think I waited in line for about fifteen minutes and I got my first pair of Supremes, and probably my second pair of Holy Grail-level sneakers. I wrote about that on Freshness.

But this was 2003. I was living on the Lower East Side before I actually moved back to the Sunset Park–Bensonhurst area. I met Dan Hwang. He was really in to this culture as well: the vinyl toys, the art scene, the downtown scene at that time, like Alife, Krink, Irak, Stash, Futura. I told him I had this idea I've been kind of playing around with, a website called Freshness, and I asked him if he would like to partner up and do it together. Right after college we started up the website as a business.

We quickly realized that there was no money in any of this stuff. The word "blog" was gaining popularity. So we realized that we just needed jobs. Dan moved to Taiwan to work for his dad and kind of find himself and all that. But I stuck around. I was browsing Craigslist one day and found a job listing that said, "Do you like sneakers? Do keywords 'LeBron James' and

'Kobe Bryant' ring a bell to you? Do you like websites?" And I thought, great, that sounds like me.

I applied. Turned out it was R/GA, the digital agency of record for Nike at that time—still is. They were looking to hire a UX designer. I didn't have a clue what that meant, but I knew through my years of playing around with the web, building websites and whatnot since high school, I could figure it out. Knowing what I knew about that, and having started Freshness, helped me get the job working on the Nike basketball account. R/GA actually encouraged me to keep working on my own site.

But the pay wasn't enough. I had to figure something else out.

III. Break Down/ Jump Start

My parents scraped together their life savings and purchased a house. Once I got my job they said, "You know what? Time for you to pay—help out with the family." There were student loans, too, but I said, "Absolutely, of course."

One day I was driving my 1989 Dodge Spirit home from work on the BQE and it just straight-up died. The R/GA office was in Hell's Kitchen. I'd moved back to Brooklyn. The tow truck towed me to a garage and they felt so bad for me, they offered me a car, a straight-up grease monkey car. Inside, it had these cotton seats that were once a tan color, but had turned black. They said, "You want

it?" I said, "Sure." What choice did I have? Maybe two months later, the same thing happened. That car died, too.

So I couldn't afford a car. My dad said he'd lend me the down payment, but I couldn't come up with the monthly. I started reading

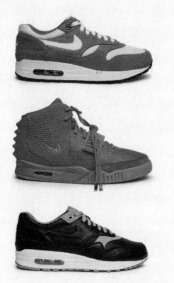

a lot of entrepreneurial magazines: *Business 2.0*, *Wired*. And I discovered something called affiliate marketing. One of the articles wrote about eBay and their affiliate marketing program, and I said, you know what? I spend a lot of time researching on eBay. If they offer this thing, let me just try this out.

I built a website called Kicks-Finder, and it was a visual directory to eBay. Basically, eBay paid me a commission every time I'd send traffic to them. It took me three

THIS PAGE:

Air Max 1 Curry

AirMax 1 Kid Robot

Air Yeezy 2 Red October

or four months to get it going and I think I made $10 my first month. Soon, it became a steady $300–$500 per month. That was enough to get a car.

At that point, in 2005, Hypebeast, Highsnobiety, Nice Kicks, Sneakerphiles, Kicks on Fire—those had all popped up and I started buying advertisements from all these different sites. I just tried my luck. I'd say, "Can I give you $100 if you put my ad for KicksFinder on your site?" Some of them agreed, but eventually they all said no.

By that time KicksFinder started to bring in some serious money. I was making double what I was making at R/GA from the site. And I said, "You know what? These guys just cut me off. I need to figure out what my next move is." And I realized, the world of sneakers is where I should have started. It's where I should have built my business in the first place.

IV. Prime Property

Another article I read in 2004–2005 was about how domain names would be the future of real estate. I was on to something with Freshness and with KicksFinder, but I needed a better name. That's when I purchased domains for Sneaker News and Sneaker Con. Around the same time, Nike offered me a job to be global digital director for Nike Sportswear, which they were launching in 2008. But I decided to take a chance and I told Nike and R/GA, "You know what,

guys? I think I'm going to go actually start this business I have in my mind. It's called Sneaker News." So in the summer of 2007 I left R/GA and I started building what Sneaker News is today, which is still the biggest part of my business.

When I saw the opportunity with sneakers on the web, I realized that even though these other sites had a lot of traffic—and I'm not trying to knock them at all—they were pretty lazy. Their websites were not that good, with the exception of Hypebeast and Highsnobiety; those are great. But, generally, the sneaker websites were horrible at that time. In 2005, 2006, 2007, sneaker websites were horrible. There was not a single good sneaker website out there. I knew that my passion for the sneaker world would define what the website would be. I would run it the way I wanted to run it.

At this point, I went solo. I was still running Freshness with Dan but I decided I needed full control of Sneaker News and I needed to run it the way that I wanted to run it. The business model basically was to use affiliate marketing, Google AdWords and whatnot, as the foundation of the business.

I also realized that because of the competition I needed to really break out and do what they were not doing. A lot of it was just they were just sitting back waiting for news to come to them. For me, I was lucky enough to be in New York City and I had become really, really close friends with a lot of the shop owners—Stash at Nort, the Alife guys. When I started my business

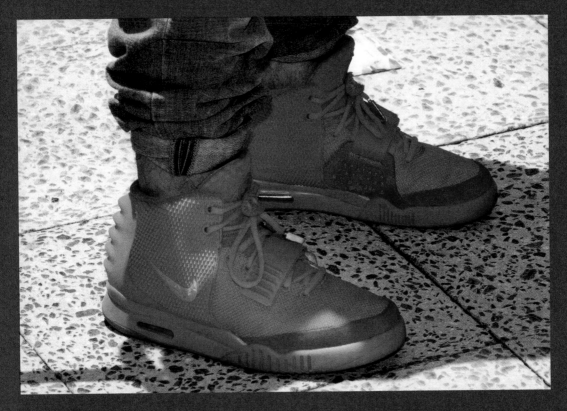

BOTH PAGES:

Sneaker Con Fall 2016

LEFT TO RIGHT:

Nike Air Yeezy "Red October"

Nike Air Trainer 1 "Superbowl 50"

adidas Yeezy BOOST 750

Odd Future x Vans Old Skool Pro "S"

Unidentified sneakers

Nike Air Jordan 6 "Golden Moments"

Nike LeBron 11 "2K14"

Nike Air Jordan 8 "Doernbecher"

adidas Yeezy BOOST 350
"Turtle Dove"

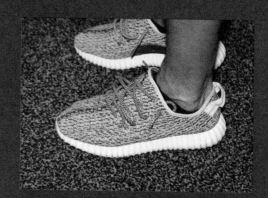

they figured letting me know what they were doing would help their stores. When they had news, they'd give me a call or text and I was able to break a lot of stories that way. This was my full-time now, my life, sixteen hours a day. People saw how much passion I was putting into it and the number of tips started to grow.

While I was building the business, I was still kind of broke. I mostly reinvested the money I earned into what we were doing. But I did start buying a lot more shoes. I had maybe three, four hundred pairs at the time.

Alife was always the most generous with me. Whenever they did a collaboration, they'd always give me a pair. They were my first friends and family. Their early ASICS collab, that's still one of my prized possessions. They have the early ASICS GEL-Lyte IIIs. One of them was modeled after the Pigeon Dunk. The other one was actually off of another early pair of shoes that I purchased, the Air Max 1 Curry.

In 2008, a year in, the traffic got pretty robust. But at the time, traffic wasn't my main concern. I was looking at revenue since I no longer had another paycheck from a corporate gig. I ended up signing on with Complex Media to sell our ads. I believe they started selling ads for other media with Nice Kicks and Highsnobiety, and there were, like, three more sites, I forget what they were. And then I worked myself up. Nice Kicks at that time obviously had more traffic than I did, but I worked my traffic up to the point where I was starting to beat them, and I showed Complex and they were willing to kind of take me on. Complex had maybe three salespeople at that time. They have a sales force of about forty now. That second source of revenue made me feel a little bit more comfortable.

But in 2008, the economy also tanked and a lot of businesses began to fall apart. We took a little bit of a hit. For about four months after the crash I couldn't pay myself. For about a month and a half I couldn't pay my employees either. It was a pretty scary time.

But with Complex helping with the revenue picture, and once the economy started to recover, I started to focus more and more on traffic. I didn't even have a million page views a month back then. Now, we have about 35 million.

V. Cash Money

When I was buying up domain names, it occurred to me that maybe one day there might be a sneaker convention similar to Comic Con. I said, "You know what? I'm going to buy Sneaker Con. It's available. One day maybe I'll sell." I wasn't really cyber-squatting because no one else had thought of it.

I had also met these two guys on eBay, Alan and Barris Vinogradov, when I wrote a story about the Carmelo Anthony PE on Sneaker News, and I forgot to credit them. They emailed me, I apologized, and they looked at my signature and said, "Hey, Yu-Ming, our office is like three blocks away on Chrystie we would love to chat with you, we have a pretty robust reselling business on eBay."

THIS PAGE:

Yu-Ming Wu

And so, we started chatting and they came to me with an idea of doing a sneaker show. They said, we've done it in the past in SoHo, but it wasn't that good because we didn't have any way of promoting it. I said, "No, guys, I'm in the middle of a pretty big crisis here. I'm trying to run my business and I really need to put some energy into this." But after maybe two or three months of kind of hanging out and talking, I was finally convinced by their passion for it. That's when I told them. I said, "Unless you guys have a better name, I already own 'Sneaker Con.'"

In March of 2009 we had our first Sneaker Con show in a small comedy club in Times Square on the corner of 42nd Street and 8th Avenue right next to the Duane Reade. Maybe six hundred people showed up.

We actually had Stash. At that point, he no longer owned the store and he had a large collection of sneakers, and I said, "Hey, Stash, would you want to come and sell some of the shoes that you own?" We had guys drive down from Boston to sell their goods. In 2016 we did thirteen cities. We're about to do our first international shows in London and Melbourne. We just had 4,200 people in Phoenix. We finally have a business license for Sneaker Con in China and we're doing one in Shanghai, but I've never been back to where I'm from.

Crazy things can happen at Sneaker Con. After one of the recent Texas shows, I learned someone flew in from Sweden to finalize a sneaker deal for a signed pair of the Red October Yeezys for $10,000. I've seen moms with thirteen-year-olds putting down $3,000 in hundred dollar bills for a LeBron pack multiple times. I've seen eleven-year-olds doing $300, $400 deals in cash, counting money like it's nothing. Those are probably some of my favorite moments, seeing these young kids, they hold their own—or a young kid selling to an adult, holding their own. Selling a pair of Jordans or something to an adult that's probably triple their age.

Security is one of the most important aspects of Sneaker Con. Early on, when we did Miami, we had a group of kids just hanging around after the show closed, and I said, "Guys, you have to leave. Show is closed, we have to clean up." They said, "Please, please, let us stay for a little bit longer, we don't want to go outside. It's dark and scary outside." And I said, "Why can't you guys leave?" They said, "Oh, we're waiting for our moms." And I said, "Where are your moms at? Why are they so late?" And they said, "Oh, they went to the beach—they dropped us off and went to the beach and they're stuck in traffic."

We realized at that time that we needed to ensure that these kids stay safe. We've had one robbery. We've had someone get their shoes stolen. We've never had any violence. A few times, we've had fake money. And we've had one kid purchase a pair of fake Yeezys and we ended up just buying them back from him because we couldn't find the seller.

VI. Family First

Why would I ever do a retail store? Anytime anybody had asked me to, I would always say no, never. My world is digital. But when John McPheters and Jed Stiller came to me with the idea for Stadium Goods, I jumped at it because I believe consignment is the future. Without resale there's not much value to the world of sneakers. Resale isn't exactly a new concept, but pair it with digital reach and there's a whole new generation of people from all over the world trying to hunt down the Kid Robot Air Max. Connecting the dots has been incredible.

When Stadium Goods opened in 2015 I had about 1,300 pairs of sneakers. I'm the CMO. I put 400 pairs

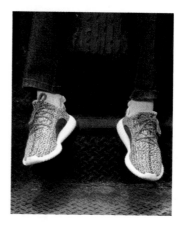

THIS PAGE:

Yu-Ming Wu's father

into consignment there: my doubles, triples, stuff that I was willing to live without. But since the store opened I'm back up to about 1,500 pairs of shoes.

I eventually paid off my parents' house and I still live there from time to time. I used some of the space on my level as a storage closet, and once I saw some room there, I couldn't help myself and I started filling it with sneakers.

If you ever see my parents walking with me, you will see that they are pretty legit sneakerheads. I got my mom and dad the UltraBOOSTs. They've had all sorts of Air Maxes over the years. My dad has a pair of NMDs as well, but not the supergood ones. I even let him wear my Yeezys.

TONY ARCABASCIO & JON BUSCEMI

BASED IN

NEW YORK,
NEW YORK, &
LOS ANGELES,
CALIFORNIA

VITALS

Alife co-founder Arcabascio
and luxury guru Buscemi
emerged from the same New
York City scene that gave rise
to contemporary street style.
While they were working on some
projects for the widening Buscemi
brand, we caught them for this
sole joint interview.

CHAPTER

04

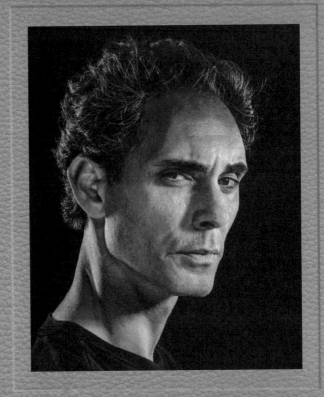

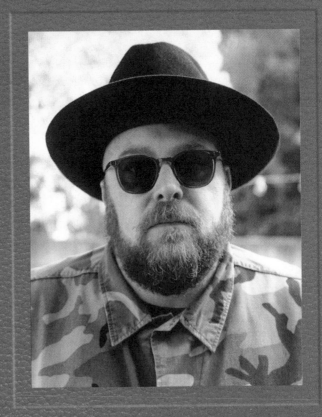

I. Shoveling Snow and Reinforced Toes

Tony Arcabascio

Jon Buscemi

JON BUSCEMI: Everyone was doing their thing in my neighborhood. This is, like, 1985–86. You were either break dancing or robbing houses. Those were the things you did. We were in the suburbs of New York City, Uniondale, Long Island. Style, we were always a month late to everything. But that's OK. The first shoe that really got attention? That's hard, man. But early on, it was the Puma Clyde with the fat laces. That was really the break-dancer's sneaker of choice.

TONY ARCABASCIO: You either broke in or broke danced in your hood.

JON: The kids with flavor all had that shoe. The first shoe I bought with money from raking leaves and shoveling snow wasn't even leather. I couldn't afford that. I had to buy a $25 pair of canvas Nike Bruins with a Carolina blue check. I put fat laces in them from Shopper's Village in West Hempstead for an extra $3.

TONY: I was always an adidas kid. I was born in Queens, and then grew up in Long Island. My parents were Italian immigrants, so right away it was soccer and Sambas. Then, I started playing basketball and it was all about the Jabbars. But as a break dancer, locking and popping, the shoe I really lived in was the Superstar—floating along the floor with that reinforced toe. Getting my first pair of white Superstars with white suede stripes turned me into the white-on-white guy I still am today. At one point in my life, I was rocking all three of those styles at the same time. I was playing sports, I was dancing, and I was running shit. And it was all in adidas. Nikes weren't really a part of my life back then.

JON: The real shoe that got me was the Nike Air Revolution. In my crew, that's when your head exploded from a price perspective, from a style perspective, from the tech perspective. I had the royal blue with the black. I think that was the first colorway. Then they did the red.

II. The Early Downtown Scene

JON: Tony's a mentor of all of ours in the industry, you know? I looked up to what Tony did. We all look up to what Tony has done. He's a pioneer. He's the founder of Alife!

TONY: We've known of each other for a long time. But we didn't really know each other until now.

JON: I've been involved in this streetwear world since the very beginning, right? As a consumer first. We would come in from Long Island and go to Triple Five Soul, Unique Boutique, all of these stores on Broadway. Streetwear really was what it was: clothes that somebody made and sold in the streets. Whether it was Camella, who started Triple Five Soul, in a broken-down apartment building's storefront on Ludlow Street, or if it was in a flea market next to Tower Records on Broadway, buying a Cowichan sweater and a mix tape. We were in the street. Alife was the beginning of organized streetwear, like where it became a . . .

TONY: We were a streetwear lifestyle store. If you needed quality ink for your marker, you came to us. If you wanted to listen to the right music, you bought it from us. If you needed a pair of customized sneakers, we were in touch with the forefathers of the graffiti scene. Everything about us was authentic. We only fucked with what we knew.

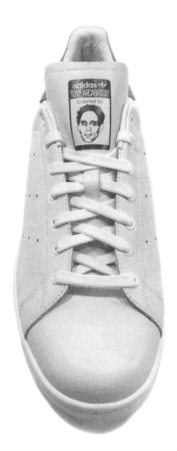

III. Alife as Life

TONY: In the beginning we were a consignment shop. We didn't even know what we were doing. We all came from the magazine game, me and my two partners. One of my partners' wives also got involved. There were four of us in total. Two of us kept our day jobs, while two went off to find a space. The cheapest one was on the Lower East Side, which was basically just a nighttime area, clubs and bars—and the bootleggers and the pickle guy and Russ & Daughters. It was the only place that we could afford.

There was a loft where we pretended we were starting a creative agency. We had a big wall that we used as a gallery, and everything was on wheels so the space could be transformed for events. We had a store filled with stuff that local artists would make, or we would curate.

At the time, in the late '90s it was still very much do-it-yourself. A lot of people were hand-making clothing or hand-drawing on shit. So the first sneakers in the shop were canvas Converse that we had a bunch of uptown cats take tags on, like Stayhigh 149 . . . guys like that.

Then the game started to turn for us pretty quickly once we started to make a worldwide name for ourselves. We went from taking most of our product on consignment and doubling the price of shit we bought at retail on our travels to places like Japan, to getting brands sending us stuff on a daily to check out and buy at wholesale. The store felt like it went from a market with our friends' stuff to a real shop, just like that.

As for the rest of the space, we always repped our graffiti roots hard. Being from the game, we knew everyone we needed to know. All the best writers. All the best painters. The first installation we had in the store was 360 canvas panels with tags from everybody. Old school bombers like TATS CRU, Seen, Futura, Haze . . . and newer cats like Earsnot, Sace, and the rest of the Irak crew.

That was our draw into this whole collaboration world. Because we had all of these connects, we were basically the liaison for

any big brand to get in touch with these street artists or whatever you want to call them. They're graffiti writers in my book, but no one really talks like that anymore.

So, if Rockstar wanted the true graffiti off the streets in their game to make it look authentic, they would come to us and we would get them the art. If Nike or adidas needed someone to do a custom shoe or installation or whatever—they would come to us. Everyone from Levi's to Hotel Chains were coming to us to help curate the right artists for the right jobs. Everyone was jumping onto that street art look. Everyone wanted to tap into that, because it gave them street cred. It made them cool.

Other than kids taking tags on shoes, the first collabo we did with a brand—I think—was with adidas in 2002 or 2003. We did a three pack: Top Ten, Grand Slam, and the Metro Attitude. I don't think any broke the $200 mark. We were never trying to be superexpensive.

It was a big deal for us because they wanted us to do one shoe and we said, "No, no, no." We tried to strong-arm them and say, "No, if we're going to do it—we want to do more." And they said, "How about three?"

We did one super lux, the Top Ten, with white kangaroo skin and silver leather lining. We did the Grand Slam with the little pegs in the midsole, and that was white as well, but with gold stripes, red lining, and the pegs to match. Then one of my partners got crazy with the high-tops, the Attitude. It was blue and black and leather with an all-over lightning bolt jacquard print and extra puffy tongue. It came with a gold chain and nameplate that spelled out "NYC" in lightning bolts and hung around the collar of the top of the right shoe. To be honest, it was some unbearable shit for me and I fought it. I was like, "Please, we cannot do this. It's something I would never wear." We did a limited run, and, of course, guess which one sells out?

JON: Sorry about that.

TONY: It's OK. It was also the only shoe press wanted to show or talk about. That was a real turning point for me . . . I realized that having a store wasn't only about me, it was about my customer. If it was up to me and stocking only the sneakers I would wear, we'd have been out of business pretty quickly.

IV. Rise of the Brands

JON: I left New York City in December 2002. But before that, I'll just keep it real, I was more Nort than Alife because I was more of a sneakerhead. Actually, before Nort opened, I was always trying to get sneakers from London and Japan. I was really a Nike head. 2000–2001, that's when it really cracked off.

You know, with the Wu-Tang Dunks, and all the Japanese things that no one saw, all those JD Sport Air Force 1s, all that London energy. All that was getting into the country through Nort. Nike caught wind of it through a few heads. I don't need to mention any names, I'm not going to give anyone props, because they caught on pretty quickly.

Then you started seeing the Atlanta Hawks Air Force 2, and all those Puerto Rican Air Force 1s. All that started coming out of Nike through this New York City energy.

But it was really because of what was happening in London and Japan, two at the same time, and then, you know, Jeff Staple, and that whole Dunk thing, that next wave when they did the City Pack. That's when the whole thing just exploded. It wasn't this special little thing anymore. It went mainstream. It's almost like this band that you knew about, that no one else knew, and suddenly, it's on Z100, and you're like, all right, I'm over this.

TONY: Nike was one of the reasons we decided to build the Alife Rivington Club in 2001. ARC was the first of the boutiques to hit the scene, and it all started with some kid coming into the original Alife store on Orchard Street one day. We were in our loft, looking down, and this guy was really studying every piece we had in the store. We were just about to smoke a joint and we were like, "Yo, come up."

And he did. We got stoned together.

OPPOSITE PAGE:

adidas Stan Smith special edition for Tony Arcabascio

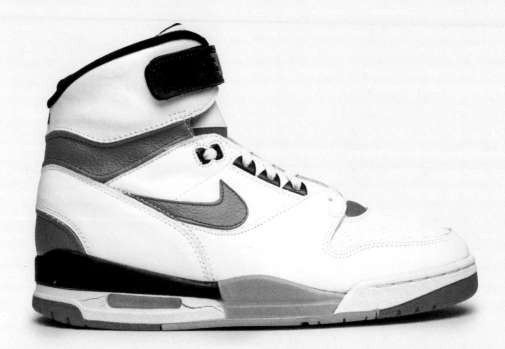

THIS PAGE:

Nike Air Revolution

OPPOSITE PAGE:

**Nike Air Force 1 Low
"Puerto Rico"**

JON: And it was Mark Parker from Nike.

TONY: No, it wasn't Mark Parker. But it was some dude who was like, "Yo, I work at Nike and we're looking for a place to launch this new shoe and we've heard about you guys and I think we want to do it here. Do you mind if I come up and show you the shoe?"

So this guy comes and he shows us this woven sneaker, and we were like, what is this? It wasn't like any of our styles. And we were like, yeah, let's try it. If we're going to be the only ones in the world with this, and you want to launch this here and try it out, we're down.

There was no Instagram then. Just word of mouth. Maybe some press. Something selling out in a day was pretty much unheard of because it had to spread by word of mouth.

I remember us putting out this $200 shoe, or whatever it cost back then, and all of a sudden it was just like, boom. It was instant. Word started to spread and by the end of the day we sold out. We only had, like, twenty-four pairs of the first colorway—and it was like, damn, we just made five grand off one sneaker style in a day. We couldn't believe it.

Then, Nike was like, "All right, let's try out some other colorways." And that's when it dawned on us. We already had some success and press on the customized sneakers we were selling, and now these Nikes were blowing out, why not open a sneaker shop? We were like, "Yo, let's just make the fanciest, most lux environment ever created for the sneaker game." And that's when the Alife Rivington Club was born, with all of the cherry wood, in all of its glory. But

you're right, Jon. Nort was definitely more Nike.

We never played the Nike game 100 percent. In the beginning, Nike let us take the reins. They wanted to be in our world. But once the sneaker game became hot again, if you were selling their product, Nike wanted to own you a bit. They knew they had the power they had. It's what sold most back then. They wanted control and they wanted front row. You know what I'm saying?

JON: That's all good, but that doesn't stop the fact that Nike had the whitest-hottest-coolest brand on the planet for that five-year stretch.

TONY: And—and I think they still are.

JON: No, not even close. Not even close anymore.

TONY: adidas is killing it now, once they started to innovate and stopped depending solely on their archive. But I remember reading some crazy statistic last year. It said something like Nike has 60 percent of the market and all these other brands have, like, 6 percent or less, or some shit like that.

JON: I'm talking about the cool factor, not the money.

TONY: Oh, okay. Yeah, yeah—

JON: They definitely changed the landscape of the entire sneaker industry in those years.

TONY: That's where we made most of our money. I just think they wanted a lot more from us that we just weren't willing to give up, and they were never really okay with that. We sold all different brands, not just the shit that blew out. At the Rivington Club we had—I think it was forty-two spots to fit forty-two SKUs. That was it. That was prime real estate, you know? We weren't going to give a majority of that to any one brand. We were very democratic.

JON: Yeah, the thing about Nike, if we're going to talk about this, is you were watching a brand single-handedly change the landscape of footwear. You've got some designer, I think it was Tinker Hatfield's brother—I've been up to Nike and I've been in The Kitchen and all that and I think it's his brother—or Mark Smith or one of the big designers up there, you

know, they went to a basket weaving class with their wife, and that turned into a shoe, which turned into the idea of woven, which now turned into Flyknit, which is now the whole world. Tony, you had a shoe when it started that means almost their entire business now, and you dumped that shoe off.

TONY: It's crazy, right?

JON: It's crazy, because the woven turned into knit, and now the knit runs the world, right? Nike, adidas, everyone is doing knit.

V. The Laws of Quality

JON: After I left New York, I was recruited to be a trend forecaster for a company called DC Shoes in California, which was at the time a very, very cool skateboard shoe company. I have no idea where the brand is now. But back then I was recruited to bridge the gap between the world they were in and the sneakerhead world. DC did the first Supreme shoe collaboration out of anybody.

TONY: Holy.

JON: They followed up with KAWS, and then Thomas Campbell.

TONY: And then Shepard Fairey, right?

JON: Shepard was fourth. That's pretty impressive for back then.

TONY: Yeah. Hells yeah.

JON: A year and a half into my employment, Quiksilver buys DC and the whole thing went crazy. It went from $100 million to $1 billion or something. And I just wasn't down for the mass market. So I lost interest about two and a half years into my employment. Actually, in my office at DC I started another brand called Gourmet, which was more men's streetwear, but super elevated. We made everything in Italy—cashmere track jackets, very nice sweat suits, like, guido-chic.

TONY: I must say, I was a little jealous when you guys started that. You guys took the whole Italian-American angle I wanted to fuck with for years.

JON: Damn. I didn't know that. So, Gourmet was really my first entrée into running my own business. I learned that not abiding by the laws of quality are detrimental to your health.

VI. How Lux Can You Go?

JON: After I left Gourmet, I worked at Oliver Peoples, an eyewear brand, and after I left there, I met one of my Italian partners very randomly, and had the idea for Buscemi. We could have made Buscemi anywhere. We could have done it in Portugal, in a very high-quality factory in Japan, in the US. But we picked Italy because they're known for the finest-made leather goods in the world, and the finest-made footwear. But also it really told the original story I wanted to tell at Gourmet, which was this kind of American-Italian, Italian-American one, really juxtaposing my childhood.

We had this idea to make the finest sneaker on the planet, but how? The idea for the first shoe was, what if we took a famous handbag and we disassembled it, reworked it, and reengineered it to be a sneaker? That was the idea. We took the elements of the handle and the leather and the hardware, and we paired them with an Italian-made rubber sole, and we put them back together, hand painted all the edges, and finished the shoe. It's called the 100 Millimeter. Usually on the manufacturing side, partners are looking to cut corners. How can I save a penny? Every other luxury brand on the planet is like, let's de-termine the price of the item before we go out and make it. What we did was, let's go make the item. Then we'll price it. That's true luxury, when all costs are out the window until the product is right.

I'm not going to quote how much it cost to make, but our first shoe came out to about $800 at retail. We were all taken aback, like, *oh no*. I'm not afraid to say it. We thought it would be a little bit less, and we were planning to work our way up to a certain status.

The first shoe was black, white, and red. We actually called it "guts," because it was blood-red. It got into Union and Colette, Arrows in Japan, Browns in London, and Kith in New York City—all these retailers that help form public opinion. I think having those retailers cosign was even more important than whether Puff Daddy or Justin Bieber or Cara Delevingne or whoever were wearing the shoes.

VII. The Knowledge

TONY: Last summer, this kid walked into my new office and he was wearing the 100 Millimeters and I was like, "What kicks are those?" I had known about Buscemi, but I actually never saw one in person. He was like, "Yeah, they're going to open up a store here in New York." And then—it was just like this revelation of, you know what? I haven't talked to Jon in a long time, I'm just going to give him a call, see where his head's at.

My friend then took the shoe off and handed it to me for a closer look, and I was like, "Wow, this is probably the finest-feeling sneaker I've ever held."

JON: It was—it was. It wasn't probably, it was.

TONY: You know, me and Jon didn't hang much back then and never really talked in depth on any of this before. It's pretty funny we're having this first conversation with a stranger, for a book.

JON: It's interesting to be able to be a part of history. We were in the middle of it. It's crazy to walk down the street and know where everything comes from. It's like that scene in *The Devil Wears Prada* where she's like, "You know why you're wearing that blue sweater?"

OPPOSITE PAGE:

Buscemi 100mm Leather High-Tops

SANDY
BODECKER

VITALS

Nike's current VP of Special
Projects, Sandy Bodecker,
has overseen research,
development, Action
Sports and soccer divisions.
Recently, he's been helping
athletes try and run a sub-
two-hour marathon. But it's
his foundational work on
Nike Skateboarding (Nike SB)
that's brought us some of the
most resonant collaborations
of all time.

CHAPTER

05

I. Road Test

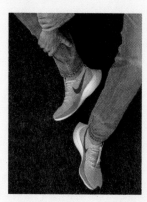

I started working for Nike in 1979. I was at the University of New Hampshire and coaching ski racing, and in the fall I would always run a lot to get ready for the season. In general, I was running about sixty to seventy miles a week. I started running with some of the UNH cross-country team. They were faster than me, so it was a good training challenge. I soon noticed they were all wearing these crazy-colored Nikes, so I asked what was up with the shoes and they said they were a part of the Nike wear-test program.

I said, "I want in!" They gave me a name and a number to call. The name was Mark Parker, our current CEO. I called and we chatted. He told me they only had a pair of size 6½s available. I said I could make that work. I was a size 8. I ran 600 miles in those shoes and kept a really good diary of each run, and this ultimately led to my being offered a full-time job in the wear-testing department in April of 1982.

II. Sandy and the Magic Lamp

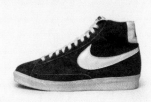

If you go back to the early '80s, skaters like Lance Mountain were painting or drawing on AJIs or Blazers, so there is a bit of history that leads to the idea of using the Dunk as a canvas to tell stories and to connect with skaters on a deeper, more personal and intimate level. There's always been a strong and vibrant connection to all things creative in the core skate community, but the most prominent connection was always the board itself. The graphic element of a deck is equally as important as the actual performance, and this led to brainstorming around how we could use the shoe as a canvas to tell a story in a similar way. T-shirts, of course, had been used, but never shoes directly.

The second thread was wanting to get the individual skaters more involved in the product ideation, design, and development. Working with the four OG skaters, Reese [Forbes], Richie [Mulder], Gino [Iannucci], and Danny [Supa], rewarded us with the opportunity to really get to know them as individuals on and off the board. It's from these conversations that the first SB Dunk collabs came, and when you look back and compare then and now, you can clearly see these first efforts were just dipping our toes in the water.

It's a bit like we rubbed the magic collab lamp and the genie popped out and said, "No way, dude, am I ever getting back in the lamp!" We had no idea how much of an influence it would turn out to be.

THIS PAGE:

Sandy wears Nike Zoom Vaporfly Elite

Nike Blazer Mid

OPPOSITE PAGE:

Sandy Bodecker

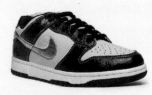

III. Futura-istic

What's my favorite collaboration shoe? This is one of those questions like, if you had only one type of food to eat or one song to listen to, what would it be? If you ask this question ten days in a row you'll get ten different answers. There were so many memorable collabs, some culturally relevant, others very personal.

There's no doubt, collabs like the Diamond, Pigeon, and Tokyo Dunks had a major impact, but I think my favorite was the FLOMs, the collab with Futura. The idea was generated in the famous, or infamous, Garlic restaurant in Tokyo around conversations we had about Futura opening a shop in Fukuoka.

He asked if we'd be able to do a special shoe for the opening. I asked when it was opening, and he said three weeks. Then he laid out the idea around a print of world currency on a Dunk Hi. I said, "Send me the graphic ASAP and I'll see what I can do." We delivered a very limited edition For Love or Money SB Dunk Hi in three weeks. It came with a companion board. I still rock those shoes from time to time.

SBs are made to skate in. If folks choose to collect them I'm okay with that, but for me skate the shit out of them; that's what they're for. The most challenging collaborator, I think, was Pushead. Not in a bad way, but he's very private and has some very strong points of view that don't necessarily align with Nike or big companies in general; however, he has strong ties to the art and music of the skate community.

I got to know him a little better while doing the collabs. I like and respect him and his work. The collabs, I think, speak for themselves.

IV. Sneaker Humor

Looking back to the beginning, the small crew involved shared similar views around what qualified as a legit collab. It had to have some connection loosely or directly with the core skate community.

The storyline behind the collab was equally as important as the shoe itself, and we tried to make sure the story was fresh, relevant to the particular shoe. Some shoes had a more local focus (shop collabs). Some had global reach. Many were able to do both.

Some collabs gave a nod to the culture of SB collecting. A good example would be the 3 Bears Bearbrick collab. There was a high, a mid, and a low, and accompanying Bearbricks. We also had a lot of fun with collections like the SB Golf Collection footwear and apparel with legit Dunk golf shoes, The SB Business Man collection that came with suit, dress shirts, tie, cufflinks, and umbrella sold at skate shops. We always included the core shops and had tons of fun with it.

THIS PAGE:

Nike Dunk High Pro SB
"Supreme Blue"

Nike Dunk Low Pro SB
"Diamond"

Nike Dunk Low Pro SB "Tokyo"

Nike Dunk SB "Pushead"

OPPOSITE PAGE:

Sneaker miniatures found on
Sandy's desk

I also like the Boston shop Concepts' lobster collab that evolved from the original "Boston lobster bake" to include more iterations based on rare lobsters, blue and gold. We always felt we wanted to make folks smile at the story, be stoked on the product, and see it skated every day.

There were certainly failures or ideas and shoes that were not as successful as you had hoped for. When you work in product creation, if you don't have some misses then you're just not trying hard enough.

The biggest misses for us were around the early attempts at bringing a higher level of innovation to skate shoes. We learned the valuable lesson that for skaters, how a shoe looks on the foot—especially looking down on the toe when on your board—was often the difference between adoption or not. We also learned that all new wasn't always a good thing. We learned to introduce things in such a way as to make it easier for them to try something newer. I always fall back on what footwear design legend Tinker Hatfield said to me many years ago: "Make sure you know who you're designing for, and then give them just the right balance of new and old."

JESSE LEYVA

BASED IN

PORTLAND, OREGON

VITALS

Skate has an aesthetic all its own, from street art to photos to music to film. It became Jesse Leyva's mission at Nike SB to get all that creativity onto your shoes.

CHAPTER

06

I. Bargain-Bin Shopping with Mountain and Hawk

Sixteen or seventeen years ago, Sandy Bodecker was like, "Hey, do you want to come do this SB thing?" I wasn't sure. Sandy has this group of misfits that he always takes care of. I would love to think that I'm in that little group of people who don't quite do the right thing all the time; Sandy really supports them. It's cool to see a dude who has been at Nike forever and has never conformed.

But I was working on Dunks and Air Forces in sportswear. I wanted to keep messing around with those. We were working on the first Pro Bs, which was connecting with the skateboarding community before we officially started up SB. We added the puffy tongue. We were working with Alphanumeric and Alyasha Owerka-Moore on a Dunk Low in 2001, which was the first skate collaboration Nike ever did.

The connection between Nike and skateboarding really goes back to 1973.

We work with an artist named Craig Stecyk. If you're familiar with *Dogtown and Z-Boys*, he is one of the pioneer photographers and artists that captured so much of the content in the early days. Back then, Craig had a studio in Venice, really around the block from Nike's first store down there. He knew Jeff Johnson, Nike's first employee. And Sidney Wicks, one of Nike's first basketball player endorsers, was one of his best friends.

So, when Nike was sending Sidney Wicks Blazers in the '70s, Sidney was giving some to Craig, and Craig was giving them to the skaters. Craig was also buying up stock at sporting goods stores and vintage stores. He'd get in a van or a station wagon with Lance Mountain and Tony Hawk and they'd find Jordan Is on sale for $19.99 and Dunks for $10.99. He'd buy them and give them out to skaters who already loved the shoe. So, we really have skateboarding roots with three shoes: the Blazer, the Dunk, and the Jordan. Craig still has Jordans on ice from those runs.

THIS PAGE:

Jesse wears Nike SB Benassi
Solarsoft Slide

Nike Dunk Low Pro B "A#"

OPPOSITE PAGE:

Jesse Leyva

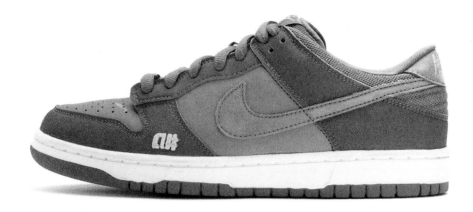

II. Public Enemies and Beautiful Losers

Fast forward to 2002 when SB started. It was really anchored by the Dunk. But where SB went down the route of skateboarding, I went down the route of art: everything that encompasses a skater's life—art, music, film, and everything else that kind of goes with the culture of skateboarding.

Sandy and the SB crew started really focusing on and connecting with the core, core, core skater customer. I was like, "All right, cool, I'm going to collaborate with Stussy and Geoff McFetridge." People on the periphery of skateboarding, but who are super in tune with the culture of it.

I think skateboarding, hip-hop, punk culture, all the subcultures that are now, I guess, mainstream, depend on collaboration. Skateboarding, it's all about collaborating. You don't want to do it by yourself; it's more fun to skate with your friends. And you like not just having the one sponsor, but a board sponsor, a wheel sponsor, a truck sponsor, a bearing sponsor. All of that is just because all those guys are your friends and that's who you like to work with. So, the idea of collaboration for us was really a natural one.

The crew that was originally working on a lot of these early collaborations, in the late '90s and early 2000s—people didn't even quite get us at Nike. They were like, "Why are you working with somebody else?" For a long time they didn't even know what we were doing. When we first started doing this, I remember one of the head sales directors saw the first line and was like, "We need to fire that guy." Like, "You're going to kill the Air Force 1! Why are you doing colors that aren't white and blue and team colors? Why are you doing this stuff? Why?"

Stussy and Undefeated were two of the partners that gave us some of the richest content back in the early days when we started working on collaborations, and a lot of it was because we were friends. I met these guys. Just knew them. And we would just work on stuff. When we first started on our first collaboration with Undefeated, Nike was like, "Who are these guys? Why are you working with this shop?" We just trusted that they were cool.

There's these early Stussy samples that we couldn't put out because we couldn't get the rights to the Public Enemy lyrics that were part of the design. Comme des Garçons was also like, "Yeah, you can't put 'Buddha blunts and old school stunts' on a shoe." We released them with different language instead. It just said "World Tour."

Geoff McFetridge, who is a skateboarder, graphic designer, artist, just rad dude—an early shoe we did with him was called the Vandal. Then he did a Paper Dunk for MOCA and SB. I worked with Aaron Rose on two of my favorite projects ever, the *Beautiful Losers* Blazer and Dunk. We did the *Beautiful Losers* Blazer to launch the book. When the film released, digital printing was brand-new, and so we took two hundred stills of the movie and created two hundred pairs with those stills. When people walked out of the

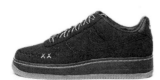

movie, the shoes were right there. Thomas Campbell was also in that film. He's now one of our artists in residence for Nike SB.

There's definitely some people out there who I would really like to collaborate with. In the early days, I was just working with whoever I liked. I didn't care if it sold—I didn't have that filter. It was just like, I like Geoff McFetridge; I'm going to work with him. I like Stussy; I like Supreme. I like the guys from *Beautiful Losers*; I'm just going to work with them. I'm going to do a shoe, and we'll see what happens.

III. Color Theory and Horse Hair

I took a couple of graphic design courses in college, but I hated the process part of it. I was really into cutting and pasting, and living with a Xerox machine and making zines and stuff. They weren't teaching any of that. So I was like, I can do this on my own.

When I got to Nike, the guy who pushed me into product design started noticing when he was designing shoes that I would color them different weird colors. Some nights he would give me a stack of line art (this was prior to us working in Illustrator for color), and he would be like, "Hey, can you color these up?" And then I would start coloring the Air Sunder and the Zoom Haven and putting patterns on them, and he was like, "This is really cool; you need to do more of this." Eighteen years ago, doing a trainer with brown suede and an orange swoosh, people were like, "What are you doing?" And we did it and it actually sold, which was kind of crazy. In general the craziest things I ever worked on were probably the Maharams, because they were all horsehair. The real croc stuff we did with the Air Force 1 was also pretty cool.

My own sneaker collection is really weird because I work in sneakers. For a while, I only collected the mistakes. And then it got really crazy, because the year of Air Force 1s twenty-fifth anniversary was a really heavy year for me from a design standpoint, and that was the year I stopped wearing color in sneakers. From that moment on I've only worn black. I still buy sneakers that are in color, but I won't wear them.

Wearing color just felt like overload for me. There was so much good stuff that we were working on. And then I remember reading a quote from Steve Jobs. I think every creative kind of obsesses over Steve Jobs. And Michael Maharam, who I also met at the time and who is kind of a mentor to me, felt the same: to be at your most creative, just simplify things. Simplify your thinking as much as you can simplify it, and it will open up other areas. And I'm like, "Okay, cool: sneakers. I'm going to simplify."

But my sneaker collection is mistakes, and then it's sneakers that either take me back, make me remember something, or are just so cool I have to have them. And maybe I'll wear them but I probably won't. I will never wear the Vapor Max but I can't wait to own a few pairs of those. The

THIS PAGE:

Beautiful Losers x Nike Make
Something Dunk High

Beautiful Losers x Nike Make
Something Dunk High

Maharam x Nike Blazer High

OPPOSITE PAGE:

Geoff McFetridge x Nike SB
Paper Dunk High

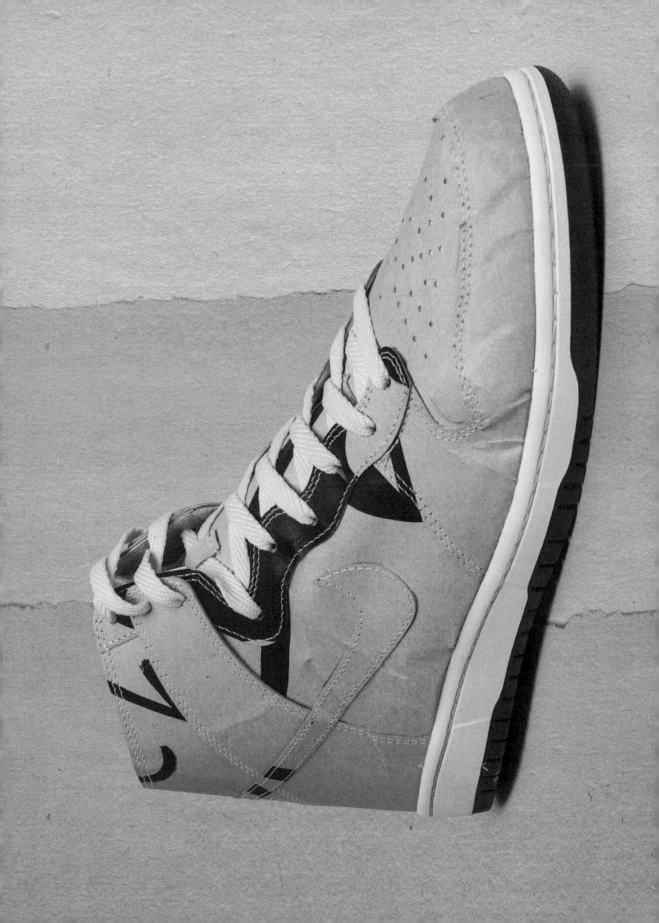

Flyknit Racer, I only wore the triple black, but I'm such a sucker—I'll be like, "Okay, I'll buy that color."

The things I really keep and hold on to are projects that I worked on with friends of mine; so collaboration projects I'll still hold on to. But rarely the production sample. So a lot of times when you see the samples that I have, they will still have the development tag on them. Like my Questlove AF1 Low doesn't even have the sock liner in it because it probably went to some photo shoot and never came back. Nobody else has that version of the Questlove. These KAWS Air Max, nobody else has. I don't want anything I have to be the one that everyone else can get. I'm kind of a nerd like that.

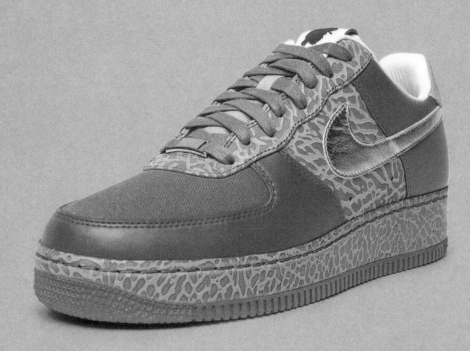

THIS PAGE:

Maharam x Nike 1World Air
Force 1

Questlove x Nike 1World Air
Force 1

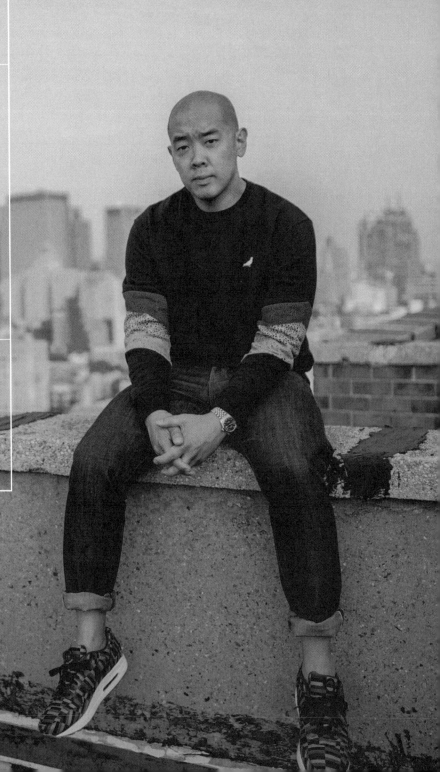

JEFF STAPLE

BASED IN

NEW YORK,
NEW YORK

VITALS

Jeff Ng (a.k.a. revered
designer Jeff Staple) is
responsible for one of
the most famous uses of
Bodecker and Leyva's Dunk
SB canvas. His own Staple
Pigeon brand has released
shoes with New Balance,
Puma, Converse, and even
Payless.

CHAPTER

07

I. Fight or Flight

For the 20th anniversary of the Dunk, Nike asked me to create an edition inspired by the city of New York. I probably owned like thirty pairs of Dunks at that point. It was the hottest shoe out at the time. To design it, in dedication to New York City, my city, the greatest city in the world, was like a dream. I would have paid them to do the project, you know?

We toyed around with the Statue of Liberty Dunk, or the 6 Train Dunk. But you can live in Idaho and be like, "Oh, I get it! The subway on a shoe!" I picked the Pigeon because nine out of ten people think a pigeon is a rat with wings. There's a small subculture of people—probably who grew up in New York City—who have a spiritual connection with the pigeon, a love-hate relationship. I wanted to do a design where, if you were from New York, you immediately recognized it as like, "That's my mascot, that's my thing." And if you don't live in New York, if you live in Connecticut or Pennsylvania or New Jersey, you're like, "I don't get it. Why a pigeon?" I'm glad Nike understood that vision.

I wanted to make a really wearable shoe. The Pigeon is gray toned with pink on the sole. We spent a year designing and sampling the shoe and then a whole bunch of things happened that were out of my control. Five days before the release some kids started sleeping outside Reed Space in tents and sleeping bags. It was February and there was a blizzard. The cops came down to break up the line. But when a cop starts telling the kid who has been sleeping outside in a blizzard to get off the line, the kid is faced with a tough decision, right? Like, disobey the law? Or stay the course because you spent blood, sweat, and tears to get these? The kids didn't want to get off the line, and they were literally saying, "Fine, issue me a summons, arrest me, but just let me get the shoe first." After that, things really got crazy.

II. The Classic Toothpick Move

I was into sneakers probably more so than the average kid was. The Jordan I came out in 1985. I was ten years old. They were fine. They were banned by the NBA and there was a must-have fervor around them. And the commercials were great. I wanted those shoes but I wasn't like obsessing over them. When I got them I used the Air Jordan I (and the Jordan II) as regular sort of sneakers, commodities. When the Air Jordan III came out, that's when the tables turned.

I was late for social studies class the first time I wore my Jordan IIIs. I was in sixth grade in New Jersey. I walked in and everybody looks at me because I'm late, and their necks just went boom, like down at my feet. Even the teacher. I was like, "Holy shit, I just snapped thirty necks." I was hooked for life.

The Jordan III was really a departure from the language of any other designs back then, you know? You started at the Converse Chuck Taylor—

THIS PAGE:

Staple Design x Nike Dunk Low Pro SB "Pigeon"

OPPOSITE PAGE:

Jeff Staple

NEW YO

LATE CI

WEDNESDAY, FEBRUARY 23, 2005 / Sunny, 44 / Weather: Page 62 ★ ★ R

Sneake

Hot s

SNEAKE

K POST

25 CENTS

FINAL

www.nypost.com

25¢

frenzy

e sparks ruckus

STORY, PHOTOS: SEE PAGE 7

R RIOT

the Adam of sneaker culture and design—and then every shoe, even up to Jordan I was like an iteration of the Chuck Taylor. The Air Jordan III was really like a left turn in footwear design.

I loved those shoes. I cleaned the outsole when I was done wearing them each day. There was a back plate on the Air Jordan III where "Nike Air" was painted, and just from going to school the black paint would wear off, so I'd take a toothpick and black model paint and slowly caress the toothpick back and forth, and retouch the paint. Even the way I laced those shoes, like the religiousness of how the laces had to be flat, and if they twisted I'd redo the whole thing.

III. The Great Sneaker Riot of 2005

So the Pigeon and the aligning of the planets: The cops tried to break up the line outside but it got physical, and the NYPD actually had to call in the heavier duty, SWAT-like police force, because kids were holding on to the gates of the store like it was a soccer match, like they weren't letting go. It honestly was a shit show.

We tried to create order. Before we opened the store we wanted to offer a ticketing system. Everyone gets a ticket with a number on it. I hired this 6'5", three-hundred-pound security guy. You can imagine the scene of this guy, this huge guy, holding up his arm, and saying, "All right, we're going to start a ticketing system," and the line looked like *The Walking Dead* where like zombies just consumed this man. His arm is the only thing you see, with tickets in it, and surrounding it is hundreds of kids just pulling him down.

Adding to that was a group of older dudes, they didn't really look like sneakerheads to me, hanging on the corner outside the store. It was obvious they were waiting for kids to get the shoes and then they were going to get the shoe from the kid one way or another. These guys had baseball bats tucked under their snorkel jackets. We found a machete on the sidewalk. I have a photo of it, it was like a *Crocodile Dundee*-sized machete. We had to get the kids into the store through the front door and funnel them into cabs that we had waiting out back.

The story was covered by the CBS Evening News, NBC News, Fox, and it was on the front page of the *New York Post* the next day. The shoes started reselling immediately for like $500–$600. Now you can find them on eBay for $6,000.

THIS PAGE:

Nike Air Jordan 3

Nike Air Revolution

OPPOSITE PAGE:

Staple's legendary Pigeon Dunk

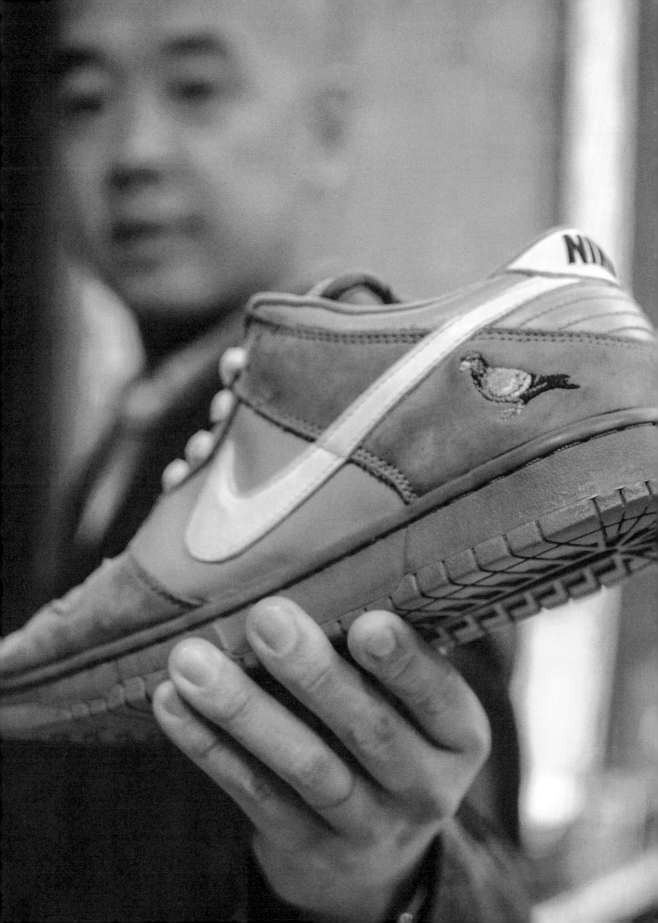

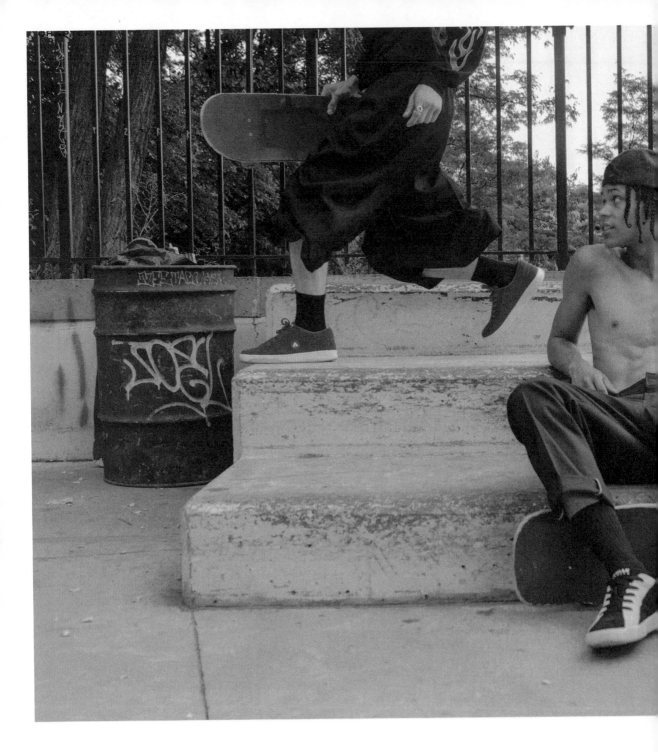

BOTH PAGES:

Jeff Staple for Airwalk

IV. National Staple

Since the Pigeon Dunk, I've done shoes for New Balance, Converse, Timberland, and ASICS. After doing superpremium shoes that are $5K or $10K and kids are practically getting robbed, I really wanted to do a shoe that could be released at Kmart or Walmart. Airwalk came to me about a collaborative project. Airwalk had its heyday in the '80s with Tony Hawk and Jason Lee. I owned Airwalks as well. But when they contacted me, it was pretty much a dormant, dust brand. If I was going to do this collaboration, I really wanted to do things that I wasn't able to do with the other sneaker brands. When I asked, they didn't hesitate.

This deal tested the waters on what sneaker culture and street culture could digest. I knew I was risking a lot—I had the clothing line; I had Reed Space; I was the guy who had designed one of the most coveted shoes of all time already. When the press release first came out that this was happening, before any of the shoes were seen, all across the internet, it was like RIP Jeff Staple. I was called a sellout. A couple of weeks later when images of the product surfaced, you could see it turning, and you could see people like, "Well, these are pretty fucking nice!" Or like, "What? $50 for this? I mean, not for nothing but I might cop three pairs of these." I got an email from a kid in Idaho who was like, "I don't live near Reed Space or Undefeated, and finally I get to go to my local strip mall and get a Staple shoe," you know? That's awesome.

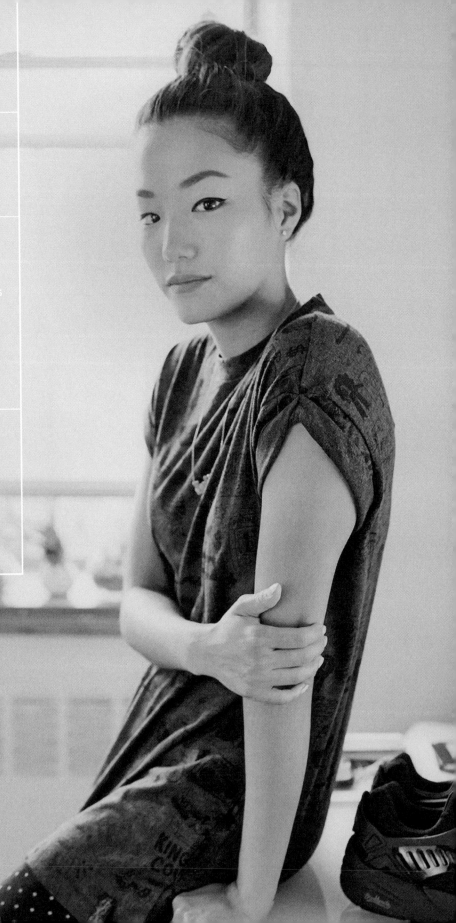

SOPHIA CHANG

BASED IN

LOS ANGELES,
CALIFORNIA

VITALS

Queens-born Sophia
Chang was once Jeff Staple's
student at Parsons
School of Design. Now,
Chang's work is impacting
the next generation.

CHAPTER

08

I. Living in America

In the late '90s, if you came to my block in Flushing, Queens, you'd find Asian kids wearing do-rags. The Indian and Guyanese kids would be all decked out, too. It was the look to have matching Jordans with your partner; the guy would wear a jersey and she would wear a jersey dress. I had a fascination with couture fashion but I couldn't shake the neighborhood. I aspired to be fashion director at Christian Dior. I made sketchbook after sketchbook of fashion drawings, but they're all tops with a long slit skirt and both pieces have the Tommy logo all over them.

In high school, I worked at a sneaker store for the discount. My first really cool pair was white adidas Superstars with light blue stripes. Everyone was so influenced by hip-hop culture; your whole outfit was based on your sneakers. If I was wearing all-black Air Force 1s with pink laces, I'd put on a pink belt. I'd wear a J. Lo jean jacket with a Marc Ecko T-shirt and Baby Phat jeans. And then I might have my hair done a certain way, which a lot of times was influenced by the Dominican and Puerto Rican girls, parted with the bangs plastered to the side of my head. Sometimes we'd get braids, too. I'd go visit family in LA and they'd be like, "Why do you look black?"

THIS PAGE:

Sophia holds Sophia Chang x Puma Basket Classic

OPPOSITE PAGE:

Sophia Chang

II. Finding Jeff Staple

When I got to Parsons School of Design in 2006, it was a shock to be pulled out of my very specific bubble and exposed to a lot of upper class and international students who were wearing Alexander Wang. I began to refine my own style, mixing high fashion pieces with street style.

While I was taking the usual studio classes and illustration programs I had a few internships: at Complex; with Ryan McGinness, the artist; with a designer named Peter Chung, who showed me how streetwear was designed from ideation to production to designing colorways. I took extra classes while I was in school like web design, coding, typography, and packaging design. I wanted to gain as many skills as I could, soak up everything like a sponge.

Late one night my sophomore year in college, after a brutal stretch in the computer lab, I was on the subway home and spotted Jeff Staple out of the corner of my eye. Of course I knew who he was—Hypebeast had been my internet homepage in high school; I used to check it all the time. We happened to get off at the same stop, so I walked up to him and tapped him on the shoulder and was like, "Are you Jeff Staple? I'm a huge fan of your work." He was like "Oh, cool."

But then it got awkward as we were walking up the street together. I asked if he was going to Reed Space, his store, and he explained he just finished teaching a class up at Columbia. A little later I found out the class was about luxury design and business strategy between Parsons and Columbia Business School. When it became available again I made sure to enroll.

All semester long, I was still too nervous and intimidated to speak to Jeff. After the semester passed, I summoned the courage and sent him a really awkward email about meeting him on the subway and then taking his class. I told him I was an illustration major and I really interested in contributing to his brand. Months passed without a word.

Then one day I got an email about contributing artwork for the next season of Staple Design T-shirts. It was obviously a form email that he'd sent to a bunch of designers, but I still freaked out. The theme was

"film school," and Jeff wound up choosing two of my pieces, including the *Coming to America* illustration, which remains one of my most recognizable illustrations to this day. It ran as a print ad for Jeff's line. That started our relationship.

He also recommended me for a junior designer job at Umbro right when I got out of school. I went to Jeff's office with my portfolio and then he walked me to the interview and made introductions. I didn't take the job, but it was the start of a really unique friendship with Jeff. He became a mentor—providing business advice, teaching me about professional etiquette. As my career has grown I've also helped him keep a fresh perspective, introducing him to new rappers, artists, and other things going on in the world.

The funny thing is that if you ask Jeff for his version of the story, he remembers me as the super creepy girl who followed him home from the train.

III. Don't Call Me an Influencer

By the time I graduated in 2010 I could choose the direction I wanted to go. But making money in New York as an illustrator is so difficult as a recent college graduate because you're competing against people who have been in the industry for years. I had to carve my own niche, because it was like, OK, I have all of these great skills but what do I actually like? What do I care about? I kept coming back to street culture.

I worked hard at putting myself out there. I sent hundreds of emails every month trying to get work. The first big break was illustrating a series of posters for Anthony Bourdain's show on the Travel Channel. By the way, I got that job through a friend whose rapper name is Reckless because he gets drunk and becomes a liability.

The year after I graduated college, Puma approached me about designing a full line: shoes, clothing, and accessories, all inspired by New York. They called it Brooklynite. It was a global launch. I wanted to make shoes that represented New York culture here in New York but were also recognizable as New York to

people from Portland, Japan, or Germany. I wanted to make something that was great for the forty-year-old auntie who still wears fresh Air Force 1s on the subway, the Hypebeast kid, the mom who shops for her kid and doesn't really know what cool is.

The pink Brooklynite with the gradient sole sold at Urban Outfitters so I had to think about hipsters. They wanted a high-heel platform sneaker—nothing that I would have worn—but I was happy to design them because I knew there were people out there who would love them. The Puma project took place after high-end sneakers like Buscemi and Yeezy started coming out with these crazy $800 sneakers. Some of the silhouettes looked really cool. If you look at the black high-top with the gold hit I designed for Brooklynite, the inspiration came from Yves Saint Laurent.

That clothing collection, though, wasn't actually my collection. It was more of a collection of clothes with my name all over it. They drew over my artwork and sent it into full production without my consent. I think Puma wanted "Sophia Chang," but they really didn't want my input as a designer.

It was more like "Hey, she's a girl, she's young, she's cool, let's just have her stand there and wave." Nowadays that's what we call being an influencer. I don't really take any jobs that are just, like, bullshit, like "Can you put something on your Instagram, we'll give you like $5,000 for it?" That has nothing to do with me. I've maintained a solid following because people can tell when it's an authentic message versus constant selfies and nudity. I know what my skills are and how hard I've worked for them.

The internet and all of the crazy release schedules may have destroyed the whole search aspect of sneaker collecting, but not for me. I'm a women's size five and those are pretty impossible to find. I don't know how many pairs of sneakers I have now. Maybe fifty or sixty. It's a well-considered collection. Sometimes it's an insider thing, other times it's a pair of shoes that makes you stop and look. I like to wear an all-black or all-gray outfit and have the sneaker be the hero piece.

THIS PAGE:

Jeff Staple
Sophia Chang x Puma Basket Classic
Sophia Chang

DJ CLARK KENT

BASED IN

BROOKLYN,
NEW YORK

VITALS

Since working his first
turntable at the age of nine
in Brooklyn, Rodolfo Franklin
has produced tracks for
Jay-Z, the Notorious B.I.G,
Rakim, and 50 Cent. He's also
developed an encyclopedic
knowledge of sneakers.

CHAPTER

09

GOD'S
FAVORITE
D.J.!

★ IN PURSUIT OF FRESH ★

On my block were the guys who created the gang the Jolly Stompers. They were superheroes to us as kids in Crown Heights. They taught us how to play stickball, football, basketball. They protected everybody.

You had Greg, who had the best car. And you've got Orlando, who's the OG, super tough, but also super smart. And you've got Ishmael, leader of the Jolly Stompers. You got Jonathan. You got Choo Choo.

All of these older guys, they had this one thing about them that we all used to think was mythological: they were always super fresh, you know what I mean? So you would look at them and go, oh man, they got the AJ Lesters, they got the Lees, they got the suede fronts, and they got the best, cleanest sneakers. So if I'm a kid in Brooklyn, and I'm looking up to them, I know that I can't wear suede fronts. I know I'm not getting any Lees. I know I'm not going to get AJ Lesters. But I have to have a pair of sneakers to survive, so my mom's going to buy me a pair of sneakers.

So every kid's going to get sneakers, but the idea was how fresh and how clean were you going to keep them? Up until I was like eight or nine, I never had a name-brand pair. By eight I knew what PRO-Keds were, and my uncle bought me a pair of PRO-Keds. I cleaned those PRO-Keds every single day, just so they would look as clean as Orlando's, as clean as Ishmael's.

We had these two older guys on the block, Mr. Medford and Mr. Palmer—I lived right next door to Mr. Palmer. Every week one of those two guys gave

STAY FRESH!

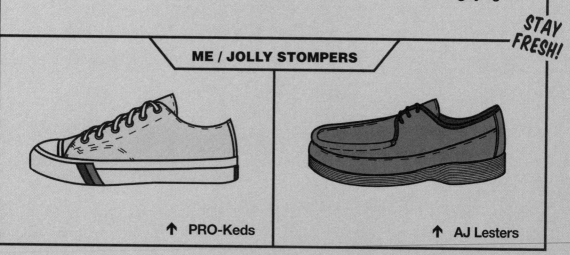

ME / JOLLY STOMPERS

↑ PRO-Keds ↑ AJ Lesters

↑ Puma Clyde

us something to do. We would make $10 from one of these two guys, and our mission when we made that $10 was to go to Glenwood Flea Market and buy a pair of sneakers. There was no other mission. Go buy a pair of sneakers. We risked getting robbed, we risked getting hurt just to go buy a pair of sneakers, so that when we came back and wore them the older guys would see that we were trying to be fresh.

It wasn't about having a bunch of pairs, it was about, are you fresh or not? I just wanted to be fresh all the time. I'm still on it like that. I don't do it so I can have a shoe someone else doesn't have. I don't do it to have the most sneakers. Ninety percent of people don't believe me, but I only do it to be fresh.

★★ THEN CAME CLYDE ★★

We saw him in fur coats. We saw him with a Rolls-Royce. In the hood, a good car is the Thunderbird. He's in a Rolls-Royce. That shit was a spaceship. Greg was the coolest motherfucker in the world, but he was trying to be Clyde Frazier, and he could never be Clyde. This is '75. Clyde brought us championships. Let's put it this way: the shoes that Clyde wore? The Pumas, you wanted what he had.

UTICA AVE.

★ CROWN HEIGHTS

LINCOLN TERRACE PARK

NEW YORK AVE

ROCKAWAY PKWY

↑ My Block

★★★ MAGICAL THINKING ★★★

When the AF1s first came out, 1982, Nike would send reps to the basketball leagues that we played in. They were letting us try the shoe. I put them on for the first time; those shits were magical.

I kept playing in what I was playing in, put those Air Force 1s in my bag, and stole them. Dead serious. I was like, "I'm not playing in these! They're too beautiful!" White and silver. I was going home them. I actually never wore them because I thought they were so special. That's the oldest pair I've kept. I have about 3,000 pairs now.

★★★★ ON SNEAKER CULTURE ★★★★

I never say the words "sneaker culture." There's no sneaker culture. It's just people who are enthusiastic. More enthusiastic than the average person. I'm one of those people. But culture? Culture has laws, belief systems, art instilled in it. Culture is a serious word. Sneaker culture? What are you talking about? Where's the laws? Where's the belief system? What do you believe in? White laces? Sneakers are clothes, and they were always clothes to me. Clothes make you fresh.

Spike Lee's the reason there's a thing called "sneaker culture." Spike Lee. Period, and I'm going to say that until I'm dead. Yeah, we like Air Force

BE FRESH!

1s. We didn't think they were more than sneakers. Spike made Air Jordans a character in his movie. When dudes stepped on his sneakers in *Do the Right Thing*, they didn't step on his sneakers—yo, they stepped on his Air Jordans! His Air Jordans are broke. Broke. They broke your Air Jordans. That's a character; it's not a sneaker anymore. It's a character. Even before that, in *She's Gotta Have It*, all the way through the movie, Spike never took off his Jordans. He's in bed with a woman, Jordans on! They're a character. Is it the shoes? Fuck no! It's Spike. He's the reason why there's a thing called sneaker culture. Spike Lee. Period. And I'm going to say that until I'm dead.

 # GOD'S FAVORITE COLLABORATION

The Air Force 1 twenty-fifth anniversary event was coming up and Nike knew that I had at least one pair of practically everything. They were talking to me about getting some of my shoes to put on display. In the meeting I was like, "Man, y'all should just do an Air Force 1 store." They were like, "What?" I was like, "Why don't you do an Air Force 1 store?" And then they were like, "Well, we were thinking about doing something like that, and we were going to have an ID lab inside." So I said, "Why don't you do a VIP ID where you can come and do anything you want?" And the guy was like, "Okay, hold on, do you have a lawyer?"

And I was like, "Yeah." So they were like, "We can talk to your lawyer real quick." And then they talked to him and handed me, like, "We want to sign you to consult us on this Air Force 1 store." That became 21 Mercer, with an ID lab in the back where you could do things like bring the same leather that's inside your car and get your sneakers made.

This was 2006, and in the first meeting out in Portland, I said, "Can I do a shoe?" And they were like, "What do you mean?" I was like, "Can I do one shoe, like how you let Bobbito do that shoe with his name on the side?" In like three to four minutes I had two shoes done. And then I did more. I just

wanted one pair. I just wanted it for myself. They were like, "No, this is a pack, and it's great."

They were like, "What do you want to call it?" I was like, "Brooklyn!" And they were like, "Clark, don't be so literal." And I was like, "What the fuck, I'm from Brooklyn? We'll call it the DJ Clark Kent Pack." They were like, "Don't be so literal." I was like, "We'll call it 718 Pack." And then I was like, "No, don't call it 718." And they were like, "Why?" I said, "Because 718 is not only the Brooklyn area code, but it's also Staten Island and Queens and the Bronx, and fuck them."

So I sat down trying to figure out what to call the pack. And then I just started looking at my address, and then I remembered my old address, and then I remembered another address, my mother's address, and my cousin's address, and I remembered all of their zip codes. All of the zip codes start with 112. In Brooklyn, all of the zip codes start with 112. No one is going to know what that is, perfect, 112. People aren't going to know what it means until they ask me. They were like, "That's how you think, Clark." And I was like, "Yes!" So the 112 Pack was born.

MAKE FRESH!

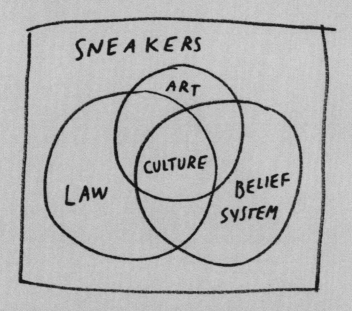

THE FINEST ONES

I've got four pair of sneakers, and the boxes are all made from basketball court floors of championship teams. That's cool, but once you've seen it that's a'ight. The best packaging I've seen might have been in the shoes that Nike gave to LaDanian Tomlinson. They made him a pair of Air Force 1s, and the box was out of this world. It was a box but it had this roll top. So instead of the top coming off, the top rolled into itself and displayed the shoes. I was like, "How did you make that?" Yo, it was so dope, I was like, "Can you just make me a box? Just make me a box." And they were like, "This is made for LaDanian Tomlinson." I was like, "Make me one. Please, just make one. Just do it." And they were just like, "We can't do it; we don't want to copy it again."

I did a PE for LeBron, and it was called All Black Everything because him and Jay-Z were friends, and Jay-Z was just everything at that moment. I wanted to make a shoe that commemorated their friendship and give it to them on All-Star weekend. The shoe, simple, all black, luxury

ALWAYS FRESH!

↑ Lee Cooper

materials. But on the tongue of the left shoe is LeBron going like this. And on the tongue of the right shoe is Jay-Z going like this. [Kent makes Jay-Z's "rock" sign with his hands.] The left shoe represented LeBron's part of the friendship. So, on the foot bed, there's lasered in facts about LeBron. On the right, all the facts on the inside are about Jay-Z. The box is exactly the same thing. So the inside of the box I gave to Jay-Z has facts about Jay-Z, but on the outside is all the facts that were on the foot bed, lasered into this wood box that's made out of the wood from whatever school LeBron went to. I made twenty-four pairs, but there's only three of these boxes. One for each of them. One for me.

 ## BROOKLYN'S FINEST

I get the mail at my house because my wife would give everything away. My wife tries—has tried on numerous occasions—to give the sneakers back to the deliverer. And I'm just like, "You can't do that, because then the company is going to feel like I don't appreciate it." She says, "Well, I don't appreciate it." Well, it's not for you, so don't worry about that. But on average, I get about eight pairs a week.

They were sending me sneakers before I did the 112. They were sending me sneakers when Puff Daddy put out his album. They were sending me sneakers before the Notorious B.I.G.'s album. When Nas made his first album I was getting sneakers from Nike, because I was DJ Clark Kent. '93, '94, something like that. But I was a popular DJ.

I don't get sneakers to be in competition with anybody. Sneaker king? I'm like, I don't care about that. I get them to be fresh. I have 3,000 pairs of sneakers, but I have 140,000 records. I've got two whole separate lives. I don't even know how that happened. I was just trying to be fresh. There's kids watching the sneaker game who see me and they go, "Hey, DJ." They don't even know it's because I'm a DJ. They think it's just a title, like Mr. They don't know what DJ means. They're going, "Hey, DJ," and I'm going, no no no no. You're missing it! It's not what you think!

MATT HALFHILL

BASED IN

FRESNO, CALIFORNIA

VITALS

Nice Kicks founder Matt Halfhill is a web pioneer and a former retailer. A pair of Nikes he designed with Clark Kent were displayed in his Austin, Texas, store. Recently, he's launched a podcast and has started writing his first book.

CHAPTER

10

I. Shox to the System

I never had a gateway shoe as a kid; my gateway was my first job. I was sixteen years old and my family had just moved to Canada. It was my third high school. I started in Fresno, California; then we moved to Grenada in the Caribbean. I finished in Vancouver. And I started working at this mall store called Athlete's World on March 30, 2001. Victoria, B.C., was hardly stylish. Retro Jordans had just started and people didn't know what to think of them. adidas Originals had just started. It was the infancy of the retro boom. People were more into Phat Farm denim suits with Timbs or Lugz. Shox were huge because Vince Carter wore the BB4s.

The job was pretty much strictly commission. I got addicted to that on day one, that push and pressure of commission sales. You can make whatever you want to make—but it's all on you.

I obsessed over knowing every detail about every product in that store. The best way to sell was the PK—the product knowledge—and I constantly read whatever early sneaker websites existed in 2001: Nike Park, Nike Talk, Kixology.net. I set all kinds of sales records. I also started buying shoes on clearance from my store because the economy was suffering and my manager was having a hard time selling things. My manager knew I bought and sold things on eBay—I'd been doing that with musical instruments since the eighth grade—and he was like, "Hey, do you think you could possibly sell shoes online, too? I have all these shoes that are exclusive to just Canada and Hong Kong."

They were yellow Nike Shox XTs. And the Shox XT was sold in the US market—but not in this bright yellow color. So I buy up eight or ten pairs on the spot and list them on eBay. They all sold within a couple of days and I made more than I made in a whole month working in the store. After that, I just kept buying up the clearance product from the company and selling it online. That was how I got my start in footwear.

Kevin Ma, who founded Hypebeast, and I used to live about two miles from each other in Vancouver. We didn't know each other at the time. I read his site but I didn't know exactly that he was living right where I was. Back before I started the blog—this is December of '05—I built a sandbox blog. I still have the domain name; it's called Sneakerhype.com, which kind of pays homage to Hypebeast in a way.

But Kevin had a counter at the bottom of his website. The stats weren't protected. So, if you clicked on the counter you could see the stats. And I saw that Hypebeast was getting like 36,000 visits a day and I'm like, holy shit! I had no idea there was this many people out here talking—looking for dish on sneakers and streetwear and toys and all of this other stuff. And I'm like, you know, look I'm not going to cover all that other stuff but I know if there are that many people interested in that whole gamut there's probably a pretty decent amount of people out there like me who just really love sneakers. So that was almost this little bit of validation and motivation.

Nice Kicks launched in 2006. I'd moved from Vancouver to Austin, Texas, where there was no sneaker culture whatsoever. I picked it because of

an article I'd read in *Business 2.0*. I probably scared the crap out of my parents. I dropped out of college, gave away my scholarship, got married, moved to another country, all in the span of two months.

On the first day of the blog, I think I had close to 5,000 visits. There were almost 20,000 visits a day by the end of that summer. It was mainly built off knowing what people were already looking for, making sure we had that information readily available.

Invisible Air Force 1s was one of our first breakthrough posts. That post had over 1,100 comments

on it in a couple of weeks. For us, that was ginormous. But I had no business plan, just an idea that a lot of people really wanted to talk and talk about shoes. Things started growing way faster than I ever thought they would.

III. URL to IRL

I'd been wanting to do a store since back at Athlete's World, and even more since starting the blog. We opened the first Nice Kicks shop in Austin in February of 2010 with a line of seven hundred people at the door. DJ Clark Kent was there; we did a T-shirt collaboration with Bun B.

I wore my Texas Air Force 1s to the opening, the ones that were

released for the 2006 NBA All-Star Game in Houston. They had the silhouette of Texas on them with the star in the middle. The star wasn't where Houston was; it was where Austin was.

DJ Clark Kent was bugging me to wear these bespokes we designed together in the Lab in New York. That was one of the greatest moments of my career, but I wanted to save that pair for display. They were cognac leather Air Force 1s, with the leather turned back to suede, too. I made these in 2009 and I guess it was right when that Americana look started to take hold. I got inspired by U.S. 281, the highway I'd driven up from San Antonio through the Texas Hill Country. There was salvaged denim on the back on the shoe and an alternated swoosh in red and white patent leather to pay homage to the Taiwan glossy AF1. The tongue was original mesh because on the Texas flag, often the star has a different texture than the stripe. I was going for that—an homage to Texas.

But it's sad, a couple of years ago I had a puppy that destroyed that pair I made with Clark.

Anyway, I knew how my store was going to run. I wasn't going to do what a lot of other stores were doing: overcharging on release days, back-dooring the product. I also wanted to market the shoes the way they deserved to be marketed. That's the son of a marketing professor talking, but it's also about knowing a shoe's place in history.

So many stores would get in product and just put it up on the

shelf. But I was thinking, you get in the Zoom Turf or the Speed Turf and you're holding a piece of history. Make the experience in the store match the product. Make a great experience. That's what I set out to do. The goal of the first store was not to make money. It was to be an offline, tangible, physical extension of the digital brand. It was to put Austin on the level of New York or LA.

We had releases nobody in the South had. We were the only store in Texas to have the Yeezy 2s and the South Beach 8s. We did some Game Day Campus 80s with adidas with long-haired suede in burnt orange, and I got a branding iron and hand-branded all three hundred pairs in the run, which made me nervous at first—you don't want to mess it up—but ended up feeling awesome.

IV. CP3 and Me

There's this great story about Chris Paul in 2009.

He had done an interview about his favorite Jordan, which was the Flint Jordan XIII. He'd had them for only one day, worn them to school, took them off at sixth grade intramural basketball, left them on the bench, and when he came back after the game they were gone. They'd been stolen the first day he'd ever had them.

When those shoes rereleased in '05, I bought like sixty pairs and vaulted them up. They were some of my favorites, too. After hearing Chris talk, I started asking people

THIS PAGE:

Nice Kicks x adidas Campus
80s "Game Day"

OPPOSITE PAGE:

Nike Air Force 1 Premium
"Fantastic 4 Invisible Woman"

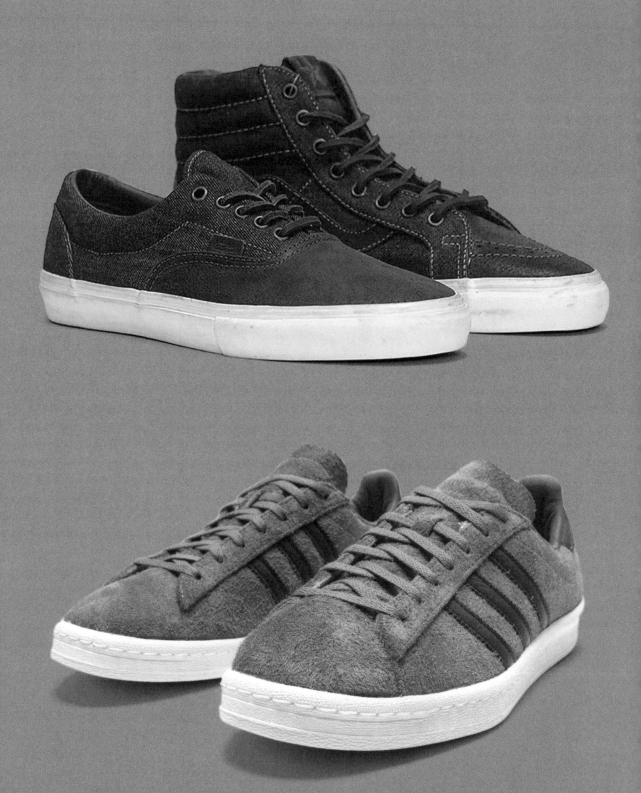

at Jordan Brand, had he ever gotten the shoes? They were like, no, he still doesn't have them. And apparently he was talking about them all the time; every time he went to Oregon he talked about the pair that got away.

I heard Chris was having an event promoting the CP3.II at the Foot Locker on Canal Street in New Orleans. I drove like nine hours from Austin to get there. I remembered his size because somebody had posted his PEs on eBay and I made a mental note: he was a twelve and a half. So I pulled it from the vault. I was like, I'm gonna surprise that dude. I told the other Jordan people what I was doing and Chris's parents were there, too, which was great. They couldn't believe what I had.

Chris had been signing autographs for like two hours and I made sure I was the last person in line. When I got to him, I was like, "I want you to sign your intramural basketball trophy." I was making a joke about where his shoes were stolen. And he's like, "My what?" And I held out the box, and the look on Chris Paul's face—I will never forget that look. To thank me, he made a pair of Nice Kicks special edition CP3.IIs that have never even hit the web. He gave them to me and to everybody on my team and even made pairs for my kids.

V. The Future Is ... Print?

Once upon a time I had thought about going into print, not digital, and now I'm working that, too: a magazine and a book that's like an overarching history of sneakers. I'll take it to a publisher once I'm ready but I might go solo and just print on demand.

It really starts with Bob Cousy and the PF Flyer All American, the first signature sneaker. That's my way of setting the record straight: Michael Jordan was not the first signature athlete, and it's not Walt Clyde Frazier either, as Puma keeps repeatedly saying in every marketing campaign. It was Bob Cousy with the PF Flyer All Americans. And not only did Bob Cousy have a shoe that had his likeness attached to it, it had his name on it and he had a series of shoes. He had almost a decade of new models and it's like this forgotten history that nobody wants to acknowledge.

THIS PAGE:

Nike Air Jordan CP3.II

OPPOSITE PAGE:

Nice Kicks x Vans Vault "The Duel" Pack

Nice Kicks x adidas Campus 80s "Game Day"

KEVIN MA

BASED IN

HONG KONG

VITALS

Kevin Ma started a blog while in college to explore his passion for sneakers. He kept at it, perfecting the product, while working at a bank. Now Hypebeast is one of the most respected and widely read arbiters of taste around.

CHAPTER

11

"Hypebeast" was originally a term referring to people who bought things simply to follow the trend in lieu of being a true fan or knowing the story behind the product. I launched the site in 2005. At first, I just focused on sneakers. Eventually we expanded into exploring street culture, high fashion, arts, culture, and the transformation of this scene from a subculture into a globally shared lifestyle.

I object(s) My Computer

HYPEBEAST

LIFESTYLE

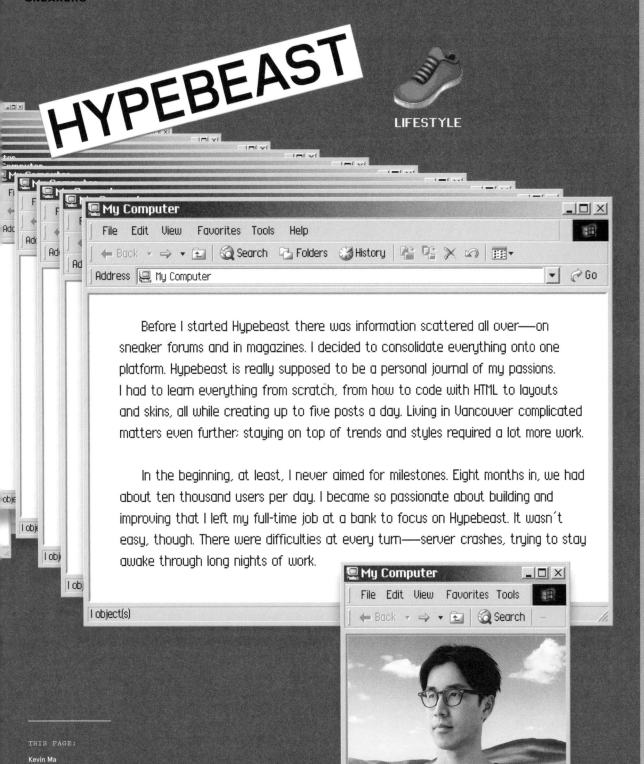

My Computer

File Edit View Favorites Tools Help

← Back ▾ → ▾ 🔁 | 🔍 Search 📁 Folders 🕘 History | 🔏 🖳 ✖ ↶ | 🔳 ▾

Address 🖳 My Computer ▾ 🡒 Go

Before I started Hypebeast there was information scattered all over—on sneaker forums and in magazines. I decided to consolidate everything onto one platform. Hypebeast is really supposed to be a personal journal of my passions. I had to learn everything from scratch, from how to code with HTML to layouts and skins, all while creating up to five posts a day. Living in Vancouver complicated matters even further; staying on top of trends and styles required a lot more work.

In the beginning, at least, I never aimed for milestones. Eight months in, we had about ten thousand users per day. I became so passionate about building and improving that I left my full-time job at a bank to focus on Hypebeast. It wasn't easy, though. There were difficulties at every turn—server crashes, trying to stay awake through long nights of work.

I object(s)

THIS PAGE:

Kevin Ma

FOLLOWING RIGHT:

adidas x Hypebeast
UltraBOOST Uncaged

10.000

Address 🖳 My Computer

I grew the site by keeping an open mind and a curious attitude, and gradually developed a personal taste that has become more elevated and refined. But I knew the site was having an influence because I could hear the noise on the street. I'd line up for a sneaker release and hear kids talking about the site. That's how I knew it was real. Right now we have almost eight million users.

I never get bored with my job. This culture doesn't sleep. This industry moves so fast. It feels like there's something new, vital, and important every day. And the diversity of the people working in this culture is fascinating. Five years ago we took that energy and launched **Hypebeast magazine**. By then the website had positioned itself as the best website for pushing forward ideas and products that we really believe represent what's cool. We started the magazine because we wanted to transform that belief into something permanent and tangible.

HTML

For the tenth anniversary of Hypebeast we collaborated with adidas on a new interpretation of the UltraBOOSTs There was an increasing trend of people blending fashion and performance into the streetwear scene to be stylish and comfortable. My requirement was that the sneaker had to be comfortable, lightweight, and breathable. We'd seen a trend of people cutting the cages off of their UltraBOOSTs, so we designed our shoes without them. They looked "hacked," raw, and primal. I guess after a decade of commenting on the culture you get a chance to steer it.

1 object(s)

PERSONAL TASTE

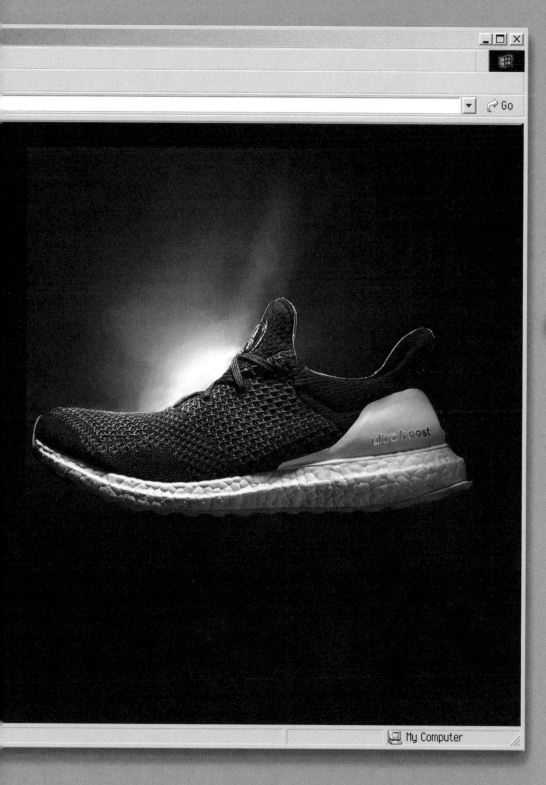

ARTS

INFLUENCE

SIMON WOOD

BASED IN

MELBOURNE,
AUSTRALIA

VITALS

While Halfhill and Ma made inroads into the digital world, Simon Wood's coveted and collectable journal, *Sneaker Freaker,* appealed to one of the core tenets of sneaker obsessives: he created something extraordinarily cool, dialed in, and deep—and it's something you can hold.

CHAPTER

12

I. From Impetus to Influence

When I started *Sneaker Freaker*, the only thing I thought I might get out of it was some free shoes. I had the idea on a Monday; three weeks later I had made a magazine. It was pretty raw, pretty basic, but I put it out and all these people turned up. There were others before us certainly, most of them were guys with very similar backgrounds to mine. I had worked in London for more than four years in advertising. I ran T-shirt labels that were successful locally in Melbourne. I had worked in the fashion industry designing advertising and building brands. I must have done a thousand T-shirt prints. I was a gun for hire.

I'd do something for three or six months and get bored, so I would go off and find something else. I worked in the film industry for a long time, on some really shocking films with big budgets. I worked as a graphic designer. I wrote newspaper articles. I also had interest in things like muscle cars and Japanese toys.

For *Sneaker Freaker*, I got to pull all of those skills and obsessions together. But I thought it would just be another thing; it would last for a period of time and then I would move on. But the magazine took on a life of its own. This was 2002 and there was no sneaker media, there was no social media, WordPress didn't exist yet. A lot of people were laying the groundwork locally for what was to come globally: guys like Stash in New York and Hikmet, who started Solebox in Berlin. But none of us knew each other yet; it was very hard to buy shoes online, too. That presented some challenges, but also provided some opportunities. Right from the start I had immense media coverage, and by our second issue I was selling *Sneaker Freaker* all over the world. Not long afterward I had brands flying me places to talk about shoes and get my perspective.

OPPOSITE PAGE:

Simon Wood

II. Survival of the Freshest

When I was a kid I had a strange fascination with tennis. I didn't play tennis but I loved McEnroe, Connors, I loved all the bad boys. And I was very big on what they were wearing, so their apparel as well. I liked Stefan Edberg and Boris Becker, who won Wimbledon at seventeen. He wore Puma shoes.

So I would go down to the sport store and if I was lucky I'd see his shoe on the wall. I engaged the possibility that if you wore that shoe you could be as good as Becker: run faster, jump higher. But I also remember looking at my shoes in the mirror and thinking, no, these don't work with these pants. I'm not a fashion horse, but I was really concerned about my sneakers and this is really something I kept to myself until I started the magazine. I didn't go around telling people, hey, I've got a hundred and fifty pair of shoes.

If I walked past a store in Melbourne or London and saw an amazing pair of Air Force 1s I would buy three pairs. That's what we did in the '90s, when I was twenty-five, twenty-nine, because you didn't know when your next amazing pair of shoes would come. So you'd get three pairs and put two on ice. Nowadays there's so much coming out that nobody puts anything on ice because they either want to sell it or just wear it.

I made my first trip to New York in the early '90s and I was amazed. I reckon somewhere down around Canal Street, I walked into a spot and I swear there were about fifty colorways of Air Force 1s on the wall. I didn't know if the store was legit or not. I was living in London at the time, working in SoHo, and on most lunch breaks I'd walk to the stores that brought shoes in from New York and Tokyo. But this moment in New York changed me. I spent the next hour in there trying to pick a pair. I wanted to buy them all. I ended up buying the black canvas with the maize swoosh. And that was a prized possession of mine, my quintessential sneaker for a long, long time. Eventually the toe came out, the sole gave way, they were really gone. To my eternal regret I did get rid of them. I've never seen a similar pair since.

I don't really buy a whole lot of Jordans, but there are some that I still love. I have an original pair of 1s that is amazing. I love showing them to people because the leather is so thick; they weigh a ton. And I love buying pairs that are just weird, like adidas Falcon and Response or Nike Kukini because I put them in the magazine. Doing that serves as a reminder that everything has been done before and that it's interesting to see why a shoe works, why it survives. I think it's that weird aspect of time and timing: getting the shoe to look good for the right moment. I love seeing brands go for it and do something ambitious, but unfortunately the market doesn't always respond positively. At this point there's a whole graveyard of failed models that I think are amazing. The adidas 1, the computer shoe

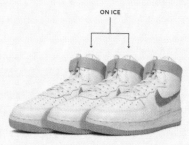

ON ICE

301. *"So you'd get three pairs and put two on ice."*

with the motor in the sole. The Nike Choad and Ovidian, which were failed skate shoes. The adidas Kobe, which were so bad he left the company. And the hilariously outrageous Reebok ATV. These just never found an audience.

III. Freaker Fetes

I've always liked weird Nike ACG hiking shoes or boots, and I've collected quite a few over the years. Some of my favorites are the Wildwood, Wildedge, Air Terra, and Vulgarian. Years ago my fascination with ACG let me to Moab, Utah, for a Nike press trip. It took me thirty hours to get there. It was probably 100 degrees. The other people were far more fit than I was. We walked for like eight hours that day; I was just totally out of it by the time we arrived at our campsite. And then we sat down and had a few beers. Some of Nike's designers were there. Tinker [Hatfield] starts telling these really funny stories. He's a PR person's nightmare. He seems to take huge satisfaction in saying the worst stuff he can about Nike. It's one of the most brilliant things about him, and there aren't many people that would have the balls to tell stories about the early days of Nike: Mark Parker and all of those guys, going canoeing and drinking crazy amounts of beer and going wild out in the bush. Later I got him to take a photo and he actually put the Mowabb OG on his head.

Another Nike trip brought me back to New York in 2006 for the twenty-fifth anniversary of the Air Force 1. That's when Nike had Kanye West, Nas, Rakim, and KRS-One make a song with Rick Rubin for one-time-only performance. It was an amazing party called 1 Night Only. And that's where Stash's Air Force 1 Highs from 2002 got named the greatest of all time.

The best part of the night, though, was when the party was over. I went back to my hotel at like three in the morning and Bruce Kilgore is standing in the foyer. Bruce was the original designer of the Air Force 1. It's the only time I've ever spoken to Bruce since Bruce is super happy to stay in the background. He doesn't know anything about sneaker culture. He kind of knows that people dig on the shoe, but he's really more focused on whatever he's working on, at least he was then. We went to a bar across the road for another couple of hours. He said, "I'm going to tell you everything, it's off the record."

We had this amazing conversation and, off the record or not, honestly I can't remember any of it. I wish I could. We'd had a lot to drink. The next morning I had the PR from Nike ringing me saying, "I heard you were with Bruce. Do you know where he is? He missed his plane."

IV. On Clearing Immigration

I come home to Australia, and my passport looks crazy. It's like, "Oh, you went to New York for two days, London for two days, and then Tokyo for twenty-four hours, and then you came back here?" The officer is like, what kind of idiot travels like that? So then they haul me off to immigration and I have to go sit in a room while they grill me on my crazy passport that makes no sense to anyone. Actually, the same bald officer kept pulling me into the room. It happened like twenty times in a row.

He says, "So what do you do?"

I say, "Well, I—I write about sneakers for a magazine."

They go, "Yeah, right."

And then I have to give them copies of the magazine.

And then they start looking at it and they go, "Oh, these are really cool."

It's that same reaction of anyone who doesn't really have sneakers on their radar. You can exist in this world without knowing about shoes, strange as it may be.

But you give someone the magazine and they go, "Oh, I like that one. Oh yeah, I reckon I could wear this one. Or, I don't know, that's crazy, I wouldn't wear that one." Some Jeremy Scott shoe made of teddy bears or something. But people just get drawn into it quickly. It's kind of amazing. Even in the airport, even in immigration.

THIS PAGE:

Nike Air Mowabb

Nike Air Vulgarian

BRUCE KILGORE

BASED IN

PORTLAND,
OREGON

VITALS

Wood met Kilgore at one of
the most legendary parties in
the history of sneakers. We
met him in an office at Nike.
He created the Air Force 1.

CHAPTER

13

I. Product Placement

I went to school in Pennsylvania to become a metal sculptor, believe it or not. I used to rip apart car parts and put them back together into some organic, kinetic structure with a welding torch. I'd go to the junkyard, get an old automatic transmission, bring it home, and carry it down into my bedroom to take it apart. I'm surprised I didn't kill myself in the process. At Kutztown University, one of my professors talked me into going into industrial design instead. He helped me transfer schools, and I ended up at the University of Bridgeport in Connecticut.

Before Nike, I worked for Sundberg-Ferar designing major appliances for Whirlpool and Sears. If you have a dishwasher, washer, or dryer that you bought in the early '80s, chances are, it has a control panel or control knob that I worked on. I also worked in the automobile industry in Detroit designing automation equipment. I worked on the underbody assembly line for the '79 Thunderbird and a skunk-works program that became the Pontiac Fiero.

It's funny what you learn from places like that. It taught me that I really liked working on products where you could interface with people. We would design products, control panels, doorknobs, and bring people in to test them: How does this knob work? Do you understand the graphics? Do you understand the messaging? Is the handle comfortable? That sort of thing.

I got a lot out of just seeing people interact with the product. So that's what was intriguing to me when the footwear opportunity came around. It was like, wow, I can actually try this on myself! It's one thing to have somebody else come and try out your product, but it's something very different if you can put it on and experience it firsthand.

II. Entering Exeter

The shoe that made me want to come to Nike was the Tailwind. I got a call from a headhunter in New York back in early '79. She said, "I've got this company in New Hampshire. They're looking for a designer." She didn't say what the company was. Later, she said, "Oh, it's Blue Ribbon Sports." I said, "I've never heard of Blue Ribbon Sports."

"Oh," she said, "it's a company you'll recognize." So, I flew out and when I got out to Exeter, I realized that it was Nike. They gave me a pair of Tailwinds, and I went for a quick run and it was the most unique running experience. The shoes were silver and gray, but the look wasn't as impressive as the feel. I was a wrestler. I hated running because my big running event was running stairs. My shoe of choice was the Tiger wrestling shoes. I wasn't used to any real cushioning.

In the early '80s, we'd developed Nike Air and wanted to figure out how to put it into a performance basketball shoe. Nike had a think tank called the DCEC committee. It included podiatrists, biomechanists,

THIS PAGE:

Nike Lava Dome

Nike Air Tailwind

OPPOSITE PAGE:

Bruce Kilgore

an aerospace engineer. They had some concepts, but they weren't that versed in how to get their concepts made into reality. I basically took their ideas, and what I knew about working with Nike Air soles, and merged them into something that I thought could be a performance product. The design was inspired by a lightweight hiking boot that Nike was making called the Approach, designed by Trip Allen.

We ended up calling the new shoe the Air Force 1.

III. Socks and Shox

By the time the Air Force 1 had really caught on and took on a second life, I was on to other stuff. I had no idea to be honest. I'm fairly naive in that way. In fact, I was back in Asia for a trip for something else in 1987, and somebody says, oh, you've got to come and see this, they're making the hottest shoe. And they took me over to this factory and I saw all of these Air Force 1s. I didn't even know we were still making them.

The next big highlight was probably the Sock Racer in 1985. I think it really changed the paradigm of what people expected. I always like pushing the needle a little bit too far, and seeing how far can we take it. Some of this came from my interactions with Bill Bowerman; everything with him was a competition. What's the lightest? What's the most minimal thing you can actually make

for somebody? It only has to go the distance. I was in that mode.

The people in the sports research lab said, oh, we have this idea, we want to make this minimalist shoe, we want it to be sock based. They had taken some medical support hose and stuck on three pieces of EVA. They thought, if we have a heel piece, a midfoot piece, and a toe piece, that's really all you need. They had some people run in it and the shoes were really squirrely.

We got tighter support hose, but it didn't help. Then I went to a neoprene-type bootie, and it was a little better, but it was hotter than hell. We punched holes in it to try to get it to cool, but it still wasn't good. And then I got the idea that, maybe it's not the upper we should be concerned about, but it's actually the bottom. If we could contour the bottom, it would provide the foundation to keep the foot stable on the bottom platform. The upper really wasn't that important. So I took one of our lasts, and some morphology data that we had, and carved the bottom of the last to make a foot shape. I made a midsole that mirrored this shape, and then I put the sock back on that. Lo and behold, you could run in that shoe, and it was all fine. So it was really the anatomical contouring of the bottom that was important; it had nothing to do with the upper. The two straps provide stability while making lateral movements. The Sock Racer has its fingerprints on a lot of different products, like Nike Free and many of our products that use stretch materials.

Shox was an interesting story that started with a gentleman by the name of Tom McMahon who was a professor of applied mechanics at Harvard. He had come to Exeter for his sabbatical, and he was the designer of the Harvard tuned track, which was the fastest indoor track at the time and might still be. His hypothesis was that if you could match the spring constant of the track to that of the runner, that you could optimize their performance, and it would result in faster speeds and lower injuries.

So, we made this aluminum shoe; it probably weighed five pounds. It had the ability to put different compression springs in the forefoot and the heel. And then we put these on people and we would have them run in them on the treadmill. We found that there was a certain spring constant that yielded the best efficiency of running. So then the idea was, how do we now capture that into a shoe?

We had some ideas about using carbon fiber in a leaf spring design.

At the time, around 1985, boron composite tennis rackets were really in vogue. And so we tried boron

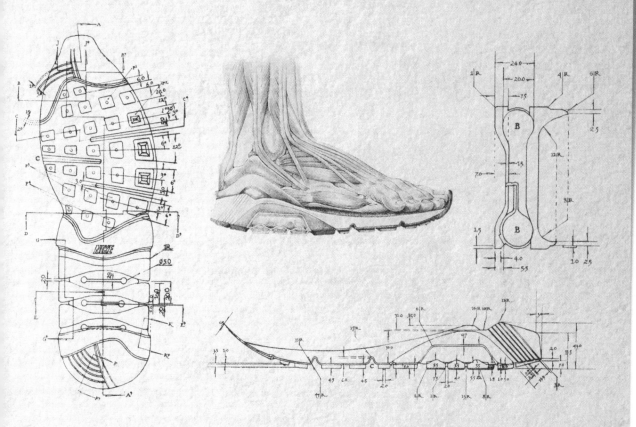

and carbon fiber. We were able to get them to where they achieved the target spring constant, but most of the shoes broke within a mile. A few made it to four or five miles. It was a problem.

When I was back in Detroit on other business, I was meeting with a company and I described this problem. I said, if I could find a material that could withstand 50 percent, 60 percent deflection, and have high resiliency, it would be awesome! And they said, well, you know we have this material that we sell for jounce bumpers in cars. Basically your car is riding on four of these foam columns, and they last for twenty years. They withstand all

sorts of weather and exposure to water, salt, oil, and gas. I told them the spring constant I wanted, and they made me some columns of this material. I got back to Exeter and got rid of the leaf spring design that was causing the failure in the previous design. I made up some new shoes, and it was amazing. I got it to the point where it had a dramatic feel, and it would stand the test of time, durability-wise. I think I had more than a thousand miles on one pair. And they still felt like new.

That product actually didn't go anywhere because we had a big investment in Nike Air so it sat on the shelf. And then I think when people pulled it off of the shelf,

they said the shoe was great. We launched the Nike Shox in 2000. We're coming up on the twentieth anniversary. To me, it's a Nike product franchise that we haven't fully tapped into. I still think there's just a lot of opportunity out there.

THIS PAGE:

Nike Air 180 Max by
Dugald Stermer

IV. The Force Is with Me. In Very Limited Amounts.

I've never been to Supreme. That's not me. I'm always looking to create the next thing. I do have three pairs of Air Force 1s and I have bike shoes I made with Dunk bottoms. I ride seven to eight thousand miles a year.

One pair of Air Force 1s, I wear. The other two were given to me around the time of the twenty-fifth anniversary and were the ones that were handcrafted in Italy with the alligator, anaconda snakeskin thing. I got this little form that says, you cannot leave the country with these shoes. Those are just up on the shelf. The alligator ones are dark brown, the snake-skins are white.

My original pair disappeared. Around ten years ago, I had shown them to some people, and they said, "Oh, we have this road show, and we would love to put these in this museum thing." And I said, "That's great but am I going to get them back?" And they said, "Oh yeah, you'll get them back." I wrote my name and everything on the inside of the shoe.

Never seen them since.

V. Home Office and Military Labs

I call my home BK Enterprises. I've got a laser there. I've got presses, sewing machines, several looms, computer controlled machining—much to my wife's chagrin. There's parts around the house. I can't park the car in the garage.

For me, the shop is always open. I'm working nights. I work weekends. If I've got an idea, I'm up and I'm working on it, even after thirty-eight years. I'm having more fun now than I've ever had.

Way before your time, probably, I was having a beer with Richard Donahue, who was the president of Nike in the '90s. And he says, "Don't you think that the design era is over? That it's just going to be a styling exercise from here on out?" I said, no, I don't believe that at all. I said, if that's what it was then I would be out of here because there's nothing more to do.

But when you look at sort of new materials, new processes, new ways of thinking about things, I said I don't see any end in sight, which is why I'm still here and still engaged. But I think he was of a mind-set that he could see not putting so much investment in sort-of design, and engineering new performance products, and that it's about spinning styles and colors and things like that. And I'm like, I can't accept that that's really where we're at. Today I think there's probably more opportunity than I've ever seen before. It's just a matter of, are we able to grab that opportunity and run with it while it's out there? I've been fortunate to get into our federal labs and see stuff that's going on that's not going to see the light of day, but it's an indication of what's possible. New materials, new material science, new processing techniques. It's really unbelievable what I think we could do. I can't tell you what they are, but I've got a few irons in the fire that I think can be really big game changers for Nike. I'm not going to tell you more.

THIS PAGE:

Nike Air Force 1 Lux 07 "Crocodile"

OPPOSITE PAGE:

Nike Air Force 1 High

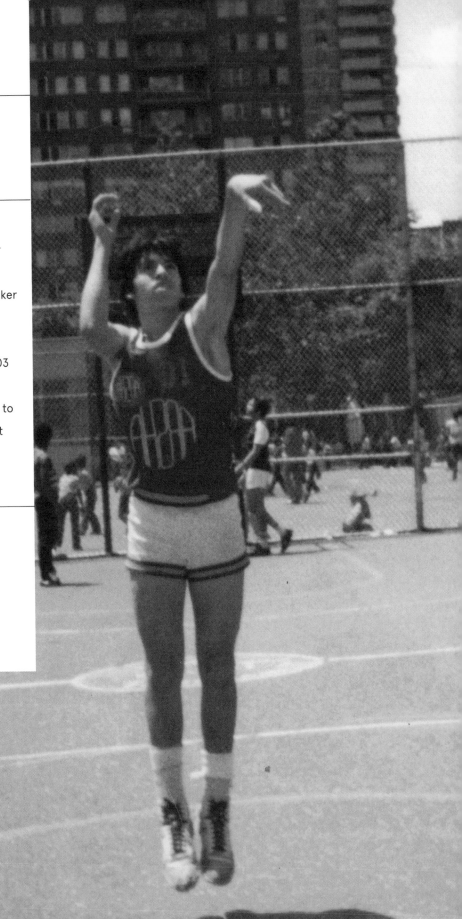

BOBBITO GARCIA

BASED IN

NEW YORK,
NEW YORK

VITALS

Garcia is the greatest ever
champion of Kilgore's Air
Force 1. He's also the sneaker
world's most prominent
scholar and intriguing
polymath. His seminal 2003
book, *Where'd You Get
Those?*, is the first volume to
truly capture the idea that
sneakers have both soles
and soul.

CHAPTER

14

I. The Education of Bobbito Garcia

I grew up in a basketball family on the Upper West Side. I didn't have to look no further than my brother Ray when it came to sneakers. He was incredible. My oldest sibling. Eight years older than me. I'm looking at his cues before I'm even going to the park, and I'm like, *oh shit*. He's the real legend of our family. I'm just the one that wound up becoming world famous, but he was so ahead of his time.

He didn't want to start trends. He just didn't want to see anybody with the same sneakers he had on. Before him. Or after him. He wanted to have a single experience, and not share it. He would cut the stripes off his sneakers so nobody could identify them. He's the one who got me into painting my sneakers, and he played ball. So that's how it all starts.

I'm nine years old in 1975 when I get my first brand pair of sneakers, the Super PRO-Keds. By '78-'79, that's when I'm starting to get my brother's hand-me-downs, wearing five, six pairs of socks to wear sneakers that are two sizes too big on me. But you got to remember, dudes in the '60s and '70s, we used to do that. It looked like casts around the ankles. That was the cushioning before brands started making cushioning.

The first shoes Ray did that I remember paying attention to were probably the pair of white-on-white Pony high-tops. And he had a pair of white-on-white Puma Super Baskets with a suede stripe. And he had the Nike Blazers, the '77. This is '77. Nobody's wearing Nikes in the city, period. They were wearing PRO-Keds, Converse, a sprinkling of adidas. Pumas in '77 were big. And Pony. Nike was not even splashing. They were just getting on the scene. My brother was way ahead of anybody. When he wore Nike Blazers to play ball at the Goat where we grew up—99th Street and Amsterdam Avenue, also known as Rock Steady Park to the hip-hop world—people were making fun of him, like, "Yo, what's up with them moon boots?"

THIS PAGE:

Bobbito Garcia at home, 1982

Nike Canvas Blazer

OPPOSITE PAGE:

Bobbito Garcia at Goat Park (NYC), 1981

We left New York, moved down to Pennsylvania. The first time I saw the Air Force 1 was in '83, at the Galleria Mall in Philly. I was like, "Yo, these things are ugly as shit. Like, are these hiking shoes?" They were clunky. In '83, sneakers were pretty sleek.

But my school team got a discount. I went to Lower Merion, same school Kobe Bryant graduated from twelve years later. So we all bought Air Force 1s. Once I wore them I was like, oh, these shoes are crazy.

I had played in the Nike Dynasties, which was a nylon-mesh-leather combo. My real favorite sneaker of that era was the Nike Franchise, which had a limited run, like '79–'81, and that was the shoe of shoes. Until the Air Force 1 came out.

Playing in them: there was a big difference. Me and my teammate, Ahmad Hooper, we'd play ball outdoors, winter, spring, fall, whatever, it didn't matter. We weren't on AAU teams, playing in air-conditioned gyms. Yo, Ahmad wore his Air Force 1s out so hard, and he got curious. He was like, "Yo, I'm going to cut open my outsole and see if they really got air." And lo and behold, there really was air. We looked at the midsole pockets, like, "Yo, there's air in here!"

Every iconic sneaker starts with performance. The Shell Toe for adidas, the Chuck Taylor for Converse. Once you look cool on a court, you can look cool off the court.

I was painting Air Force 1s as far back as 1983. The only ones available then were white uppers with a gray swoosh. And since I played for Lower Merion, I painted my swoosh burgundy to match my uniform with Esquire shoe dye and acrylic paint. At the end of the season, I took off the burgundy, and put light blue paint on the swoosh.

By the end of the '80s, I'm painting the entire upper of the Air Force 1, and repainting the swoosh to make my own three-color schemes, which Nike wasn't doing. I was very much ahead of the game when it came to that. And that's how I got my rep in hip-hop, when I was painting sneakers. People started asking me to paint their sneakers, too. But I didn't do it. Took three, four hours, man. I must really like you to even consider that— but no, that wasn't something I did for somebody else. I could have made a business out of it, who knew?

II. Swoosh Goes South

1987 was really a turning point in my life. I was at Wesleyan University, second semester of my junior year, and got cut from varsity three years in a row. But I never stopped playing ball. It was so important to me. I was so passionate about it. Spring semester, I come home to NYC and I'm playing at the Goat. Right there, I get scouted to play pro ball in Puerto Rico! I became the second pro in Wesleyan University's history. I hadn't even played varsity yet.

The sneakers I had on at the time? The Nike Air Force 1. Nike claims the first ones were released '82. In my records, it wasn't available until '83. I'll never contest Nike about that but—but basically the '82s came and went. They sold what they did. But the '83s created a tremor in the basketball community, particularly the basketball community that cared about sneakers.

Under pressure from a couple of retail stores, Nike decided to reissue the sneaker, and so the only place you could get them in New York was in the Bronx at a spot called Jew Man. The real name of the store was Rosie's Dry Goods, but everybody officially called it Jew Man. The dude who owned it, I don't even think he cared. He might have even played that up. But you could go in there, and the sneaker was $75, but if you only had $65, it would be like, "Yo, can you not charge me tax if I give you cash?" My boy got me a pair of Air Force 1s. White and royal. I was up at Wesleyan. He mailed them to me. I sent him the money. Then I went to Puerto Rico.

My eventual roommate picks me up at the airport in Puerto Rico. He had never seen video tape of me, never seen photos. And my roommate, Ishmael, who had played at Oregon State, comes up to me, he's like, "Are you . . ."

And I say, "Yeah, but how'd you know?"

He said, "You got Air Force 1s on. Only people in New York have those."

I was like, holy shit. So he knew. He was a sneaker cat, too.

That was where I was at in 1987.

THIS PAGE:

Bobbito x Nike Air Force 1 "Pilgrim"

OPPOSITE PAGE:

Bobbito x Nike Air Force 1 "Aubergine"

III. High-Tops. Hi, Fashion.

When Nike started reissuing Air Force 1s in '87, they started doing all green uppers with a white swoosh. And all brown cookies and cream, and all brown with the off-white swoosh. They started freaking it. It became more of a fashion statement, less a performance shoe. Towards the late '80s, early '90s, that's when the Air Force 1 really starts to take off as style.

The incubation for the fashion part is at the basketball court. The drug dealers and hip-hop artists who watched us thought it was cool and started wearing what we were wearing. A big-time drug dealer like Pee Wee Kirkland would just go to Italy for a weekend and buy gear, and then come back to Harlem to be fresh. I never smoked or drank, never sold drugs or nothing. But my friends and the recording artists I've surrounded myself with have always been heavily influenced by drug dealer apparel because the drug dealers always had the most money in the hood, and it was all disposable income, because they're not trying to save. They're thinking, they may not be around for too long—like, *I might only be in this game for three years, so, all right, fuck it, let's spend it all.*

But all the hip-hop heads didn't really start wearing Air Forces 1s until '86, '87.

They're late. Hip-hop—when it comes to basketball shoes, I think, it's always late.

That's second tier. But everybody was wearing Air Force 1s in the late '80s.

Clark Kent, the foremost DJ, was spinning on tour with Dana Dane, and then he was Jay-Z's tour DJ, and Biggie's. He's monumental in hip-hop, and he's the number one Air Force collector in the world. Of all time. No one can touch him. So he's a heavy hitter. But Rakim wore them on his cover for *Don't Sweat the Technique*. Rob Base and E-Z Rock wore them on their album cover for *It Takes Two*. Cats really made their own decisions back then. There wasn't really any marketing for Air Force 1s. It took off, really, because it was the people's choice.

IV. Bobbito Goes Mainstream

In May of '91 I published a landmark article called "Confessions of a Sneaker Addict" in *The Source*. But it wasn't on any brand's radar, because it came out and nobody hit me up. But within the hip-hop community it made waves, and Dave Perez, a music video director, got hired by Wieden + Kennedy to do some research, and he was like, "Yo, this kid Bobbito!" So he came to my crib in November of 1993, and I was breaking it down to them: talking about the Nike Blazer's sole, which pairs were made in Taiwan, and I had the Nike Franchises right there to show them.

They sent that research back to Portland and they were like, "This kid knows his shit. He knows more information than, like, a PLM stands for product line manager." They were like, "Yo, we got to get him in the fold." So they had just hired a dude named Gerry Erasme from the University of Michigan, in the New York office, which was tiny back then. And they decided to launch this NYC Swoosh campaign, which was the first time that Wieden + Kennedy and Nike as a brand decided to really focus on one city, to tie New York and basketball and Nike together as a trinity.

Yeah, so they were telling Gerry, like, "Yo, hit up Bobbito, hit up Bobbito." He said, "All right, cool. I'll find out where to contact him." We get on the phone, and he started talking, and I'm like, "Yo, this is Gerald?" He's like, "Yo, is this Bobbi?" Yo, we grew up together. I mean, he played at Syracuse and he went to the University of Michigan Law. So we hadn't seen each other in like ten years, but he grew up playing at the Goat on 99th and Amsterdam, and I loved his game, so I was like, "Yo, Gerald!" And I came by the office, and—the rest was history, man. I wound up doing like forty commercials for Nike. And announcing their first tournaments in New York. And doing location scouting. And writing scripts. And being the voice of their 800 number. We had this 800 number where you could vote for

the top five NYC players of all time, and get information about where the tournaments were. People were voting for a lot of the older players from the '70s like Tiny Archibald and Pee Wee Kirkland, and Earl Manigault, and Helicopter Herm, the ones that had been revered over decades.

I was on the radio at the same time, so Nike started underwriting a show, the first of its kind in media history, called *On the Fence*, which I conceived and I did it on WKCR 89.9 FM, where me and Stretch were. So they gave a grant to the station, so it was noncommercial, and for half an hour every week I talked about playground basketball. It was crazy, I had loyal listeners. I did a lot of stuff with Nike from like '94 to like '98.

My first national ad for Nike was a story about Helicopter Herm playing against Willis Reed at Rucker. And they ran that during the Indiana Pacers–New York Knicks playoff. So a lot of people saw that, but my face wasn't on it, so people who knew my voice from the radio show were like, "Oh, that's Bobbito!" But everybody else, like—I could go in a park and be obscure, like nobody knew that I had just done an ad that won awards.

V. Godfather of Sneaker Culture . . . and Father of a Toddler

As far as existing collabs that I've done, I'm most proud of the Air Force 1 in that they allowed me to collab on seven releases—in one year.

That's unprecedented, that many colors and fabrics in one year by who? A kid who plays ball. I'm not an NBA athlete. I'm not Jay-Z, I'm not a platinum record recording artist. A kid who plays ball, you know, and he's a nerd about sneakers, sneaker history, and here I'm doing seven shoes with the biggest brand in the world. That's crazy, yo.

Now I got like three pairs of sneakers that I rotate.

I donate a good amount of sneakers I'm sent on a quarterly basis to a number of nonprofits, most notably Hoops 4 Hope based in Zimbabwe and South Africa. I'm not wearing anything important now.

I got a kid. I go to the park every day.

He's two, man. He's gonna spit milk on my sneakers.

THIS PAGE:

Bobbito x Nike Air Force 1 "Kool Bob Love"

OPPOSITE PAGE:

Bobbito x Nike Air Force 1 "Aubergine"

JON WEXLER

BASED IN

PORTLAND, OREGON

VITALS

If Garcia represents the OG version of hype, Jon Wexler is a descendent of that tradition for the digital age. He's adidas's VP of Influencer Marketing, which means he's got Kanye on line 1, Pharrell on line 2, and a closet full of shoes you never get sick of looking at on Instagram.

CHAPTER

15

I. Family Edit

I'm always reluctant to talk about sneakers from other brands, but there was definitely a wide variety I wore growing up in Chicago. James Worthy wore a certain type, I had those. Magic Johnson wore a certain type, I had those. Moses Malone, I had those. One of my best friends played on that Villanova team that won the Final Four in '85. I had a pair of those. My older brother was on the Cornell basketball team and he sent me shoes. He'd made all these friends at Five Star Basketball Camp who played at other colleges and they'd come play in my driveway and I'd always get into those games and those guys started sending me their team's shoes, too. They were never mint condition, but I did OK when it came to the sneaker closet.

But I didn't consider myself a sneaker collector. I collected comic books. And beer labels. I used to peel them off of bottles and I had a book full of those. Sneakers were just something that I had, and thought were dope. I wore them trying to stun people. It wasn't like the way kids are collecting now, where they're archiving them and getting financial value out of them like a stock portfolio. I wore mine until my mom threw them away.

Uh DEED us vs. Ah DEE dahs

II. "My adidas" to Yeezus

Superstars were originally created for use on the basketball court. But when Run-D.M.C. told 22,000 kids at a Madison Square Garden concert to raise their adidas above their heads in 1986–87, the sneaker transcended from the court to the street. Run-D.M.C. established adidas in the US. That's even why we call it Uh-DEED-us. Outside the US, it's Ah-DEE-dahs.

Years ago, our competitors benefitted from the fact that they had the best player in the NBA. The Bulls played on NBC every Sunday. Then, on ESPN it would be another twelve hours of highlights of Michael playing. But now there's social media and so many different places to get information. You're not only locked into those networks. ESPN doesn't dominate the pop culture lexicon the way it once did.

What we're doing now is sort of an offshoot of what we established in the '80s with Run-D.M.C. That was a truly innovative way to approach business in the late '80s, so innovative then that even when we replicated it in 2013 by signing Kanye West and then announcing our partnership with Pharrell, people were like, "That's going to undermine adidas's sports positioning."

All of these "experts" from the industry were taking shots at us, and at me personally. And now here we are. We started talking with Kanye in November 2012 and signed the agreement a year later. We knew he was getting increasingly frustrated with the people he was working with. We were in contact. But at first, we just had the discussion internally. It's like, we can keep letting him work with the competition and beat us, or we can actually give him the creative output that he's always dreamed of. Eventually we said, "You're stuck in a box over there? Why don't you come over here?" In essence that was the deciding factor for him. Working with his team has been really inspiring because their creative process is almost like sports. They're trying to dunk on people.

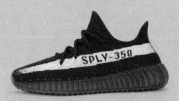

THIS PAGE:

adidas Yeezy BOOST 350 v2

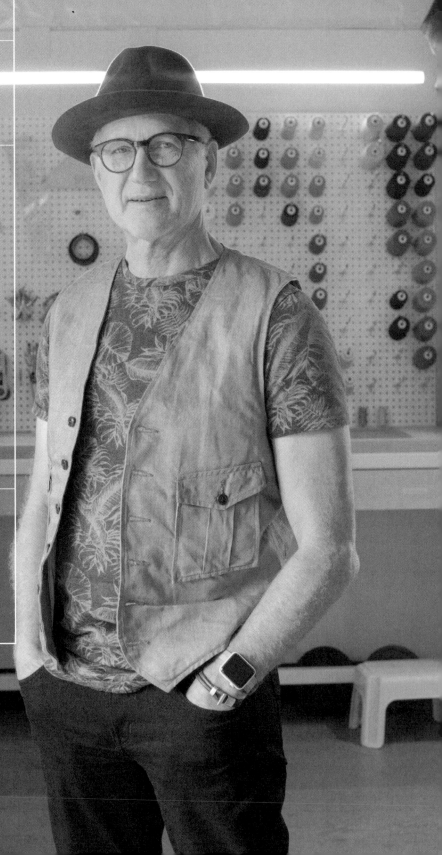

TINKER
HATFIELD

BASED IN

PORTLAND,
OREGON

VITALS

Decades before "influencer" became part of sneaker culture's vernacular, design legend Tinker Hatfield defined how much cultural influence a product designer can have. In Hatfield's case, the amount is historic. There's the Jordan III and onward. The Air Max. The Air Trainer. And that's merely a fraction of the story.

CHAPTER

16

I. Nike,
Meet Zeus

I was sitting in the water, getting ready to be towed out on a slalom ski, which is kind of a violent thing. You're hunched up. You get yanked. You have to hold on. And you're always in these neoprene booties. You're locked in. You yell, "Hit it!" The boat takes off and hopefully you get out of the water.

Skiing, snowboarding, and whatever, that's my source of inspiration. The neoprene booties made me think. The way they conformed. The stability. It seemed like a good idea for a shoe. So, I popped up. I skied around. I went back to my studio and drew up this bootie idea with an exoskeleton over it.

The very first person I showed it to at Nike was Sandy Bodecker. This is the early '90s. A bunch of guys my age all worked together on a lot of projects. Sandy took one look, said it looked like a Greek sandal, and wrote on the drawing, "Sneaker of the Gods." It was a nice affirmation that there was actually something to this idea.

The Huarache.

The development started on that project, and it took like two and a half years—a year longer than we should normally take. But it was different, a different kind of shoe. So, I kept refining the drawings, it was all on paper then, and I realized there was no place to even put a swoosh. Normally, you have to leave some real estate for that. But I wasn't going to do it. Everybody kept seeing the drawings and saying, "Where's the swoosh? There's no swoosh, so forget it."

There was no heel counter in this shoe either, which had never really been done before in a running shoe. It used neoprene, which had never been done in a running shoe. And had this exoskeletal presence, which, really, had never been done before in a running shoe. A lot of crazy stuff. So, a lot of people were like, this is nuts, this is no good. But my process is to kind of think outside of that proverbial box, and then slowly sort of socialize the idea with people one by one. Sort of win them over a little bit here and there. So, instead of trying to come in with some big presentation, I was kind of working it. And that got some people interested, so we started development.

When we started taking the prototypes out, they got no orders. Zero. So, Nike said, no, we're not doing it. But one of our product managers actually thought it was awesome, and without proper authorization, he signed an order to build five thousand pairs even though there were no orders. He stuck his neck way out there. He saw what I saw. And he took those five thousand pairs to the New York Marathon, not a place you typically went to sell shoes, and he sold them all in like three days at the exhibition hall right there near Times Square. Word got out. They

THIS PAGE:

Huarache concept sketch by
Tinker Hatfield (1990)

OPPOSITE PAGE:

Tinker Hatfield

ZEUS

went like hotcakes. In a month, we went from zero orders to orders for half a million pairs.

Before we knew it there was an ad made that showed the shoe going by like a centerfold. The last part of the shoe was shown as it whooshed by, and then on the first page there was a big, black bold type that said, "What was that?" Because it was so weird and different.

I like the phenomena of the Huarache because after, every category wanted to start doing shoes with neoprene, or with a kind of conforming, internal structure with an exoskeleton. And it became important in some more meaningful ways, too.

I got this amazing letter from this woman in New York, a runner. A taxi-cab ran over her feet, crushed her feet. So she had to have surgery and couldn't run anymore. It was too painful. She went through all of this rehab and still couldn't run. I'm getting choked up reading this letter because you could tell how much running meant to her, like a part of her life had gone missing. Anyway, she put on the shoe and it was the first time after the accident that her feet didn't hurt and she could run without pain. I think she just wanted to thank me personally. It tugged at me, the idea of helping somebody resume something that's very important to them.

Anyway. Guess what our number one shoe is today at Nike, worldwide?

It's the Huarache. This past fiscal year, we will have sold over four million pairs. We're planning to sell a similar number this coming year. It's our number one shoe and at one point it had zero orders.

II. Backcountry of the Mind

Maybe six or seven years later, I got this idea: well, why don't we design a shoe that doesn't even touch your foot? Except, well, you have to stand on something, but the rest of the shoe doesn't touch your foot. A shoe like a backpacking tent. We've all been in a backpacking tent, and you put your sleeping bag in there, and you get inside, and there's air, and a little bit of light comes in and it's like an environment. I'm like, well why don't we do shoes like that? Typically, all shoes, except for sandals, are dark and kind of moist. And we do that to our feet every day. So if you stuck your head in your shoe—if you could get your head in your shoe—you would die in about half an hour. You just would perish, right?

So I got this idea that we should design a shoe, and I called it Foot Tent. You can imagine how this one went. It had a platform like a running shoe, but it actually had little fiberglass poles and stays, and it kind of floated above your foot just a few millimeters.

I remember making the presentation to like five hundred designers. And I called up a friend of mine, Mark Smith, and his wife, Val, who was also working at Nike. They both came up. There was already a backpacking tent on stage, and some pillows inside there, and Mark came up, and I was

THIS PAGE:

fragment design x Nike Sock Dart SP "Oreo"

OPPOSITE PAGE:

Nike Air Presto Foot Tent

telling this story about what we do to our feet, you know? It's not always such a great thing.

I had somebody come up behind Mark and throw a big heavy blanket over him, and they tied him up with rope, dumped a bucket of water over his head, and then put a heat lamp on it. You can tell he can barely breathe. When his wife came up, I asked if she'd go sit in the tent. She's sitting on a couple pillows. We put a fan there. The idea was to present this idea of what we do to our feet and how Foot Tent will make it better.

So the shoe got designed. We actually made it. Because it required a little space around your foot it was fat; it was chubby. It was kind of like this dumpy-looking tent thing on your foot. We sold them, but it went nowhere. It was one of my worst projects of all time. I have heard some clamoring about people wanting us to remake the Foot Tent now. I'm like, please don't.

III. iPARKER

My most inspiring collaborator? I need to give you two names. One would be Michael Jordan. It's just hard to not be inspired by somebody of that caliber. We've done so many projects together. And there's still nobody on the athlete side that's just that good of a collaborator. Then, this is going to sound like I'm sucking up, but the other person that I think has been really important to me has been Mark Parker.

He has a different set of skills. As a creative person and designer, he was always a little bit more about the utilitarian side, but that's actually sort of flipped. I think we inspire each other. We send each other drawings in the middle of the night, two in the morning, using our iPads or our phones. Text, email.

We draw kind of simple, more cartoon-type sketches, then just shoot them right across. I'll send him a drawing and I'll think, oh, maybe I'll hear back from him in a few days. Fifteen minutes later he'll send me back seven drawings. Seven back because he's like, oh, that's cool, but what about this? And this? We've been doing this for years and years and years. He's a friend, but we click as collaborators.

It's not really my business thinking about this kind of stuff, but the drawings could fill a book. I did mention that to him, I said, "Mark, we've got so many cool sketches and they're all on the phones, you know?" So they exist digitally and you could fill a book with this stuff. They're variations on a theme. Usually somebody will start the theme and it just goes. It gets kind of crazy. Invariably, we start drawing pictures of each other, too.

He'll send me a sketch back. Then, I'll draw one that has a psychedelic color to it or something. And then he'll take a photo of me and put glasses on me, like psychedelic glasses, like it's obviously a comment like, now you've gone too far. And I'll send a drawing back to him showing him as a

complete hippie, with long hair and a headband and John Lennon glasses and paisley. We have a lot of fun just making fun of each other. But there's always a subtext to the whole thing, which is kind of like testing each other about where we think we can go with these projects.

IV. Tinker, Tailor, Future Maker

I'm part futurist. It's not unusual for me to be thinking twenty-five years down the road. It's part of my job. I think shoes are going to go in two very distinct branches, if not three.

One branch: people are always going to want handcrafted footwear. Sometimes, there will be this nostalgia attached to it through the retro thing. That's still going to be here in the year 2035. And then there's going to be this über crazy adaptable stuff, like the HyperAdapt. That was also a long haul to develop. It was difficult politically. Internally, people thought it was going to be a gimmick. Nobody wanted to spend all that money. But it's a huge part of our vision for the future.

Most shoes, I think, will have some kind of ability to adapt, react, maybe even think a little bit. They will do more for us.

I think it's a pretty easy prediction. When you go back and think about that original attempt to do a Foot Tent, well that's an okay idea, but the better idea is a shoe that keeps changing as your foot changes, as your activities change during the course of the day, or during the course of an athletic event. And that's what we're going to see. That's what you're going to see in 2035, shoes that automatically relax when you don't need them to be tight, and they will tighten back up, and maybe even become a little bit more rigid when you are making that cut on a trail or in a basketball game. That's the future. But if you're trying to pass yourself off as a futurist, you better have some big dreams.

OPPOSITE PAGE:

Tinker wears Nike SFB Boots

GARY
LOCKWOOD
A.K.A.
FREEHAND
PROFIT

BASED IN

VAN NUYS,
CALIFORNIA

VITALS

Hatfield helped imbue
sneakers with the kind
of holiness that makes
Lockwood's work so
audacious. In lesser hands, it
would just be sacrilege, but
in Lockwood's it's fine art.

CHAPTER

17

Freehand Profit Speaks:

I didn't have a lot of money for sneakers as a kid. My parents raised me on Walmart and Payless. I got clowned for that. I was twenty before I had my first pair of Jordans.

I've always had an artistic inclination. And I was a nerdy kid. I loved comic books and action figures. Anime. Anything Marvel. I drew a lot of Teenage Mutant Ninja Turtles and created my own superheroes that were inspired by the ones that I liked reading about. Being from the DC area, I loved the Smithsonian. What I saw in those museums in a roundabout way has impacted my work. Masks have played a role in human cultures for a long time. In the National Air and Space Museum I loved seeing the flight helmets. They were so futuristic.

As I got older, I got really into hip-hop. After high school I went to the Corcoran School of the Arts & Design in Washington, DC, and did a lot of portraits of hip-hop icons who inspired me. I ran into a lot of walls in art school, though. I was working with the visual language of hip-hop and my professors just couldn't relate. I grew really frustrated with the fine art they were trying to push on me because I just couldn't really relate to the turned-up-nose elitism of the art world. I spent a lot of time in school feeling alienated, and after college I steered clear of making art for a while. I moved out to Los Angeles. I managed an independent hip-hop group. And for a year I worked as a dog trainer. But art has always been the biggest part of who I am. I still kept sketchbooks. And the art that I was creating in my own time had a real graffiti vibe to it; gas masks were a recurrent theme. Eventually, I started a little project that I called the Guerrilla Art Squadron, which was a collection of gas masks that were made to look like animals.

Along the way I got inspired by a multimedia artist named Noah Scalin. He had a project called Skull-A-Day, and every day for a year he created a work of art based around the figure of a skull.

The project's real focus, though, had nothing to do with skulls. It was about the daily creative process and showing the rewards of putting the effort into creating every single day. My friend who turned me onto the Skull-A-Day project was inspired, too. He wanted to start his own creative project. He called it Burger-365 and it was exactly what it sounds like: He wanted to come up with fun designs and creations inspired by cheeseburgers. I saw the potential for a real creative push. I wanted to undertake a project with him. It would be like having a gym partner. We'd be accountable to each other. Doing a series of masks really made sense.

My Mask 365 project started with me designing a mask of some sort every day and putting it up on my blog. The first physical mask I made was from a purse. I didn't know anything about purses. I'd never carried one. They weren't important to me in any way. It was just because somebody was going to throw one out and I grabbed it and decided to cut it up and make this mask out of it. The project was a success, but after I finished I realized that I wanted to use materials that weren't just durable, but

also had a personal meaning to me. I wanted something with really cool branding and interesting colors. I looked down and realized the answer was on my feet.

I start the masks by laying the parts of the sneaker over a base, some sort of gas mask or helmet. The first mask I made out of sneakers was a pair of Nike SB Blazer Green Sparks that I picked up for $20 at a Nike outlet in Sunrise, Florida. They were bright green and bright red, like a pimento. I bought two pairs because I didn't know how much material I would need. When I finished, I posted photos and everybody was like, "Oh, it's a Ninja Turtle mask!" There's no hiding my influences. My ninth mask was an adidas Super Skate Storm Trooper. I've done Darth Vader and Master Chief from Halo and an Iron Man mask and arm combo. The Gold Metal Six mask is based on Briareos, a character from the anime *Appleseed*. I made a tribute to MF Doom by using a pair of Nike MF Doom SBs. I turned a pair of Air Max 90 Atmos into a saber-toothed tiger skull. I sculpted a pair of bright red Jordan IV Toros and sculpted horns to look like the Chicago Bulls logo. I made a golden stag from the Air Max 90 liquid golds and a triceratops head out of hemp Nike SBs. My hundredth mask was an elephant made with Jordan 5Lab3s. It took me seventy-two weeks from start to finish. That's my favorite. I have it tattooed on my wrist.

The core of my work is hip-hop art. The best hip-hop to me is a balance of the conscious and the mainstream, the fly and the flashy versus the knowledge. You can't listen to nothing but Talib Kweli and you can't listen to nothing but Jay-Z, but if you listen to both you'll have a better understanding of the world. And so the sneaker represents just that, the fly, the classic staple of hip-hop culture, but also materialism. But then the gas mask represents the knowledge that we're a world at war, there's civil unrest and environmental issues.

I've cut up just about every shoe you can imagine.

The first time I spent a lot of money on a pair of shoes that I knew I was going to cut up was the Cheech & Chong SBs. I paid $325. I got home and it was like, "Am I really going to do this?" But I knew it was going to be a really cool gas mask. And yes, you can smoke weed out of it.

But some of the shoes I've cut apart have been absurd; sneakers that I just cannot afford to own. There's definitely a moment of hesitation. I've cut up the Yeezy 2 three times. I've cut up Supreme 5s. When a collector asked me about chopping up a pair of Doernbecher Jordan Vs, I looked at pictures of the shoes in natural and UV light and they reminded me of an anglerfish, right down to the sharp teeth on the midsole. Namely I was thinking of the black sea devil, which has this glowing, fleshy growth coming from its head that lures prey. So I made resin molded teeth and eyes. I also cut out the original LED light and soldered in a new black light to pick up all of the accents on the sneaker. The whole thing glows.

Right before the release of my hundredth mask on I went Adam III's TV show, *Getting High With*, and showed off a few of my masks. After seeing

THIS PAGE:

"Liquid Gold" Air Max 1 Gas Mask

OPPOSITE PAGE:

Gary Lockwood a.k.a. Freehand Profit

PREVIOUS RIGHT:

Princess Mononoke ASICS GEL-Lyte III Gas Mask

Mask crafted from
adidas Oddity Luxe EQTs

Nike Día de los

Muertos Cortez

EQT Quetzalcoatl

Mask

Tattoo artist Isaiah
Negrete with a Day
of the Dead-inspired
mask crafted from Nike
Cortez

Reebok
Basquiat Pump

Mask made from Basquiat
x Reebok Pump Omni Lite

Mask crafted from Air
Jordan V "Premio" Bin
23 Collection

3Lab5 Elephant Gas
Mask, made from Jordan
3Lab5s

Jordan BIN V

SIDEBAR Q&A

1. What's on your feet?

My collection now is basically
focused on Jordan IIIs and Air
Max 90s. It's very rare that
I'll step outside of those.

2. Do you wear your masks to
Sneaker Con?

I love wearing them for photo
shoots, but no. There's so
much of the community that
doesn't understand the work,
and thinks that it's about
getting attention, so I try
not to make a spectacle. I try
develop an understanding that
this is artwork.

3. Are you the first artist you know
of to make sneaker masks?

As far as I know is the only
person before me that created
a mask out of sneakers is a
Canadian artist named Brian
Jungen. He made Inuit masks
out of them. And when you
look him up you'll see the
difference between our work.
His are more tied to his
culture of the past, and to
current culture. I'm looking
more towards the current and
future.

the show a collector commissioned two masks, sending me Tiffany Dunk Lows and a pair of 2011 deadstock Air Mags. There was a mania surrounding the Mags. In the fall of 2016 Nike made eighty-nine pairs and raffled them. When that happened Russ Bengston, the editor at *Complex*, called the Mags sneaker culture's great equalizer—the thing everybody wanted but nobody could have because it didn't really exist. I posted videos of myself dissecting the shoe. A website picked up the video and received over 300,000 views. People went insane. Total shock and awe.

I spent a lot time coming up with the concept for the Nike Mag mask. I separated the pieces and let them speak to me. I did some sketching. Normally, I don't do that. Most pieces are freestyle. But you don't just go willy-nilly with a pair of Mags. I wanted to make sure the concept was tight. I brought in an animal theme, a reference to the Jaws in *Back to the Future Part II*—right after Marty puts on Mags the 3-D shark swoops down from the movie marquee and chomps at him.

I'm not sure how much longer I'll make masks before I want to peel off and do something else. Each piece costs anywhere from $4,000–$10,000. They take up to two hundred hours to complete. When you break it down hourly and track materials, it's a pretty respectable day job.

DOERNBECHER FREESTYLE DESIGNERS

BASED IN

PORTLAND, OREGON

VITALS

The issue of what sneakers can mean to different populations is central to our story. With the kids, families, and doctors of Doernbecher Children's Hospital, they generate hope and spur the ability to dream at a time when that's needed most.

CHAPTER

18

MICHAEL DOHERTY (Nike Creative Director, Brand Presentation): I've had a lot of jobs at Nike. I came to the company way back to develop a film division. I was in sports marketing; I started Nike.com, which was a sports portal at the time, not a commerce site. I organize and produce and write stuff for people who step on the stage of Nike when they have to present a product or initiative. I help them realize their vision with staging because we're not event people, we're content people.

Years ago a friend who used to work at Nike reached out to me. She was on the board of Doernbecher Children's Hospital in Portland and she asked me to join. She told me, "We need some fresh ideas around our family fundraising events." They had done tickets for the Triple A baseball team with a portion of proceeds for that night going to the hospital. Or when the circus came to town they had a promotion. Having my Nike sensibility, most of my ideas required a lot of money, and that's the bane of the existence of a foundation staff. I was clamoring about what I was going to do, and that led to a conversation over dinner with my son, who was fourteen at the time and a serious sneaker collector. He said, "You should do a shoe design program with the designers of Nike. Put the shoes online and I guarantee you collectors would be crazy for this. The shoes would be unique. They would be custom designed for kids who are patients at the hospital."

ISAIAH NEUMAYER-GRUBB (Doernbecher Designer, 2015; Age at time of release: 8): When I was seven I started getting migraines. Three or four a week.

MICHAEL DOHERTY: Then the idea evolved into: instead of heavyweight designers like Tinker [Hatfield] creating the sneakers for the kids, we could put the kids in control. We could have them create the design. We gave them blank outlines of one of our skate models and had them fill out the design. We started in 2004.

MELISSA NEUMAYER (Isaiah's mother): I took him to his pediatrician and she referred us to a neurologist, and he was like, "I'm not worried, I really think it's just childhood migraines. I think he's going to grow out of it. But just in case I want to do an MRI." He even joked about it, like, "Yeah, insurance companies always get mad because I'm always doing MRIs and they always come out clean but I like to just be safe, you know?" So that's how it all started. Two weeks later Isaiah had an MRI. His doctor told us he'd be in and out in forty-five minutes.

ISAIAH: I was there for, like, two hours.

TOM MILLER (Father of Missy and Laurie Miller, Doernbecher Designers, 2004 and 2014): We were very familiar with the program. We had a daughter, Laurie, who was one of the first designers in 2004. Laurie passed away from a brainstem tumor in 2005. Laurie was very artistic and loved to color and draw. The Doernbecher Freestyle Project was right up her alley. Laurie was nine when she was diagnosed, she probably would have been ten when she did the shoe, and then she was eleven when she passed

OPPOSITE PAGE:

Corwin Carr (patient-designer) and David Nickless, Nike SB footwear designer

away. The shoe is an aquatic theme. It's got fish on the upper with seaweed and a seahorse on the back. It's teal and pink.

MICHAEL DOHERTY: The first year, Dan Wieden of Wieden+Kennedy graciously allowed us to use his atrium for the event. Maybe 125 people showed up and we auctioned shoes by six kids. We introduced each of the kids and had them come up and chat about their vision and inspiration. The goal that was set for me in terms of what we'd been making was about $100,000 to $120,000 for those family events. Much to my surprise, the shoes went for, you know, eight, ten, twelve thousand dollars. We made about $120,000, so I was thinking, "We're on a roll here. We can do this every year."

MISSY MILLER (Doernbecher Designer; Age at time of release: 14): I got an MRI on my heart and they found out about the hole. I needed open heart surgery. That's when we went up to Doernbecher.

MICHAEL DOHERTY: After the success of the auction I went to Elliott Hill, VP and head of Nike Retail, and I said, "Hey, Elliot, can I get these shoes into Niketown, Portland?" He's from Texas. He calls me Doh, for Doherty. "Doh, why do think so damn small?" He said, you know, "Let's put them in all the Niketowns!" I said, "OK," and that was Miami and New York and Chicago and LA, and we got more visibility, and then through Nike.com. That year we made like $500K and spread out, and we got more shoes in more categories. We got a running shoe and a basketball shoe and then eventually the Jordan people got involved. We named the program the Doernbecher Freestyle Program the first year. And it became a real program within Nike, and suddenly I'm in an auditorium with the seventy-five or one hundred key stakeholders in the program and we're talking about rolling out the next season and bringing the kids here to campus.

LEE BANKS (Nike, Product Director): Every year we put out a call across the company for volunteers for the program. It's not anybody's full-time job. Once

we know who our designers are, we start with a little questionnaire to get to know their families better: What do you want to be when you grow up? If you could travel anywhere in the world, where would it be? If you had a superpower, what would it be? Who is your favorite athlete? Based on that questionnaire, we'll match kids up with footwear style and apparel so that they can design something that is going to be meaningful to them. We try to have as few rules and regulations and checkpoints around it as we possibly can. This should be the most fun thing they do all year.

MELISSA NEUMAYER: On the day of the MRI it was just my husband and I in the waiting room and I just kept saying, "Something's up." When they brought him out, you could just feel the energy was different. A few days later the neurologist called and asked us to come in. He told us they found a lesion in Isaiah's brain. I had no clue. A lesion, what does that even mean? So my husband, Justin, and I, we didn't tell Isaiah. We went into the office, and as we're waiting for him we're Googling what a lesion is, and it was the worst decision because it was anything from "It's okay" to "He's going to die." The doctor referred us over to Dr. Selden at Doernbecher Children's Hospital. And he said, "You know what, we're not going to do any surgery right now, but I would like to keep an eye on him and run more tests. Do another MRI, a sleep-deprived EEG to see if he's having seizures." And he also was going to take his records up to the Tumor Board and get their advice. That's when we told Isaiah he had a brain freckle. That was the only way we thought we could explain this to a seven-year-old. He started to panic and I told him that we'd heard Batman had a brain freckle, too.

Isaiah asked questions like, "Am I going to have to have surgery?" And, "Am I going to die?" Three months later the doctor told us that Isaiah needed brain surgery. It was pretty much a guarantee that he was going to come out and not be able to talk. He was going to have to learn how to walk again. I was scared. I mean, that word—"scared"—seems so small for actually what

A standout example of the
Doernbecher Freestyle
Project design in 2016:
ten-year-old Braylin Soon's
Kermit the Frog Hurache
Ultra. An aspiring actress,
Braylin was in need of a new
liver after hers failed due
to autoimmune hepatitis.
After recovering, Braylin,
with assistance from Amy
Chio and Casey Pierson,
designed this plush, volt
green runner.

The six stars around
the lace eyelets pay tribute
to Braylin's liver donor,
who passed away at age
six. The rubber straps in
the back read "Brave," for
"Braylin the Brave."

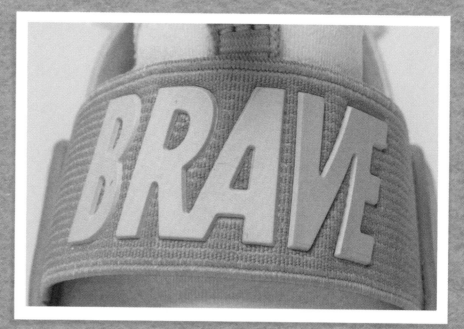

THIS PAGE:

Nike Air Huarache Run Ultra
Doernbecher Kermit designed
by Braylin Soon

OPPOSITE PAGE:

Nike Women's Free 5.0
Doernbecher designed by
Missy Miller

cat faces

all around

ruber soal

I was feeling. I kept thinking, what if I lose my kid? What if he's different? What if he's not the same Isaiah? Eventually we took him to the beach for four days and broke the news. At first he had no fear. Later that night it started to process.

ISAIAH NEUMAYER-GRUBB: I was scared.

MELISSA NEUMAYER: He was clinging to me. Asking things like: Am I going to die? Will this make me different? On the morning of the surgery, thirty people, friends and family, showed up at the hospital.

ISAIAH NEUMAYER-GRUBB: They all had Batman gear on!

MELISSA NEUMAYER: The people at his school wore Batman gear, too, the teachers, the principal, and they would send pictures to my phone for me to show him. We had family and friends all over the U.S. doing the same thing so we could show him pictures before he went into surgery.

ISAIAH NEUMAYER-GRUBB: To make me feel brave. I had no choice. Before my surgery I asked the doctor if I was going to die. Mom said all the air left out of the room.

MELISSA NEUMAYER: There comes a point when you're so scared that all you can do is pray. Some friends gave me prayer beads with a Batman symbol on it. But I came to a point where I thought, if this is the last time that my kid is going to be on this earth in the way that he is, that I'm certainly not going to miss it by being afraid, and I'm certainly not going to allow him to be afraid. This was his journey, his life. That's when you really have the reality that these kids are not possessions, they are their own people. We talked a lot about that, Isaiah and I. We talked about when he was in surgery, if he felt like he needed to let go, that I was okay with that. He didn't quite fully understand, you know what I mean? We had talks about what peace meant, what death meant. We had talks about fear, and how fear is not going to change anything. Like, gosh it sucks that I'm afraid, but it can't control you, you can't let it stop you. I think that decision to let go and to not let the fear consume us helped my whole family. Because we just lived and that's what we did. I don't know how to even describe it other than we just lived. We woke up every day, and our normal was different. But Isaiah is one of these kids that . . . I don't

know . . . he's like sunshine. You can feel his presence when he walks into a room, everybody can.

ISAIAH NEUMAYER-GRUBB: When I woke up from my surgery I was screaming at the doctors. I wanted to go home. I could barely walk. I needed help walking. My head hurt real bad. It was hard to see straight.

MELISSA NEUMAYER: He came home two days after his surgery. Mind you, he was in the ICU, he was supposed to stay there for a couple of days, and then he was supposed to go up on the regular floor for a week before they would release him. He was so adamant that he wanted to go home, and the doctors were like, "He's just that type of kid that's not going to heal here." They told Isaiah, if you get up and you walk and you eat and you drink something, then we'll let you go home. And this was day two, and he did. Doernbecher let him go home that day.

MICHAEL DOHERTY: There's a little hallway in the hospital that has a display of the shoes that are created every year and the stories behind the shoes. And there's a whole wall of the kids that have participated so far.

MELISSA NEUMAYER: We had walked by the showcase in the hospital that was full of Freestyle Project shoes and Isaiah was like, "Oh my gosh! These shoes are so cool! I want to do that someday!" That seemed so far-fetched, you know what I mean? It wasn't even in our thought process.

DR. DANA BRANER (Physician-in-Chief, Doernbecher Children's Hospital): If there was no financial interest in this for the hospital, no funds raised, this would still be the best program I could ever imagine. Because it honors these kids in a way that is completely unique and completely appropriate. It turns these normal kids, who have had setbacks in their lives, into the superstar that I believe is hiding in every child, and it presents them to the world. Our staff nominate kids for the program.

TRACY BRAWLEY (Doernbecher Spokesperson): The kids are nominated and selected based on a set of criteria—their age, gender, background, medical condition, and health status. The nominations are reviewed by the Doernbecher Foundation staff and then recommendations are forwarded to the Freestyle selection committee for final selection.

MELISSA NEUMAYER: When the doctor called and said that he nominated Isaiah, we were through the roof excited, you know? But still, it was far-fetched because there are a lot of kids that go into the bucket, and Nike sifts through them all and they choose six.

ISAIAH NEUMAYER-GRUBB: I found out that I was going to get to do the Freestyle Project one day when we were out at lunch. I was eating tater tots. Those are my favorite. When my dad and mom kept telling me about it more I got really excited. I went home and started coloring ideas of what I wanted my shoe to be like.

TOM MILLER (Missy Miller's dad): It wasn't long after Missy's surgery, a nurse practitioner at the hospital got ahold of me and said, "Hey, Nike does this thing making shoes, it's a fundraiser for Doernbecher. Would you guys be interested in having Missy do it?" She wanted to nominate Missy. She didn't know that Laurie, our older daughter, had done that ten years earlier.

MISSY MILLER: I didn't know anything really about it, but I knew it was a big deal. The people from the hospital called on the house phone and told my mom that I was chosen. And when she hung up I was like, "Did they say no?" And my mom was like, "No, you get to do it!" And I was like, "Yay!" Not long afterwards we went to Nike. They brought me down this cool hallway, so I felt pretty special. It was like an employees-only kind of a top secret area where all the new designs were happening. There was this big conference table. And there were a bunch of shoes on the wall, new shoes, and clothing. There were four or five Nike employees in there that were like my own designers to work with. They just started talking to me about what I liked and it kind of went from there, I guess.

LEE BANKS: Normally it takes us about eighteen months to commercialize a product from start to finish. Typically, with Freestyle, our cycle is that we will get the nominations from the hospital in the February timeframe, as we start putting the teams together and get the products lined up, and then the Nike teams usually meet their designers around sometime in April. We go through the entire design process. In early summer the kids will see their samples for the first time, which is super cool. It's always an amazing day. And then we pretty much have everything wrapped up by mid-September because our auction usually lands anywhere in that late September to late October timeframe. And then we hope to be in retail around November. So you're really looking at about six months from start to finish. It's fast.

DR. DANA BRANER: When you tell people about this program and how it works, inevitably the first question is, "How do I get this program for my cause? How can we be a part of this?" And the answer is always, "Shut up, we want to leave this with Doernbecher."

LEE BANKS: We're in our fourteenth year. We've actually worked this project through most of our Asia footwear factory partners. They all know about this project now and the enthusiasm that they have for it is amazing. The factories know the timelines are crazy, so they prep for it. We've got a couple of factories now, and every time they send over their first samples they will actually include a picture of the entire team in Asia that worked on that product with a note to the kids saying, "Hey, here's your shoes. We hope you love them. If you want to change anything, please let us know. We're so excited to work on this for you."

MELISSA NEUMAYER: It's all top secret and Isaiah's pumped, right? He's like, "I can design my own shoe! I'm a famous designer now!"

DR. DANA BRANER: I'm wearing Isaiah's model as we speak. They are my favorite shoes, by far.

MELISSA NEUMAYER: We took him in to meet with his design team and, again, mind-blowing that he has a design team, you know? I'm blown away by this whole thing, and he's just jumping right in. He's got people coming up who already know him, shaking his hand. I'm standing at a distance just letting him do his thing. He was eight at the time while this was going on. He's just going with it. They bring out a bunch of hats and they're like, "What do you think of all of these styles of hats?" And they're like, "I want you to think about what you want on the hat," and he was like, "I already know, I want Batman and I want it to reflect." And they were like, "All right." It was like five, six people around him, asking him questions and listening to him and doing everything they can to make it happen.

MISSY MILLER: They looked at each person and their personalities and all that, and matched the shoe to what they thought would fit them. I did the Nike

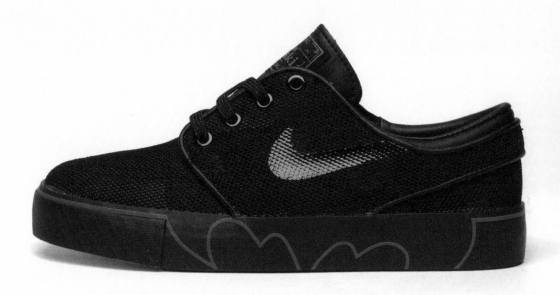

Free. They gave me just a plain drawing and I just col-ored a couple of designs. The sole is concrete gray, like a city sidewalk. On the heel, there's actually a hidden cross in pink. The New York City skyline is in the back-ground. I wanted the skyline because I come from the middle of nowhere. There's not much to do here, it's kind of just quiet. I want to move to the city when I graduate. I chose the the blue and pink, because it re-ally popped, and my sister's shoes are also those col-ors, so that's kind of cool. There are some designs on the tongue. A seahorse with some initials, L&M. I put that on the shoe in honor of Laurie. And then there's a hand with a needle, that's for diabetes. And then a heart to represent the heart surgery I had.

TOM MILLER: They had an acting program at Missy's school and she was really into it. Her goal in life at that point was to go to Broadway and be an actress.

In the insole of her shoe were the names of a couple of different Broadway plays.

ISAIAH NEUMAYER-GRUBB: On the back of my shoe it reflects and it says 12 on the heel of one shoe and 30 on the heel of the other shoe. That's my birth-day. And around the sides, on the bottom, there's like a bat signal. When you put a flashlight on it, it has the rest of the bat symbol. And then on the inside of the left shoe, it says "Isaiah," and it has "Grubb" on the other shoe.

MISSY MILLER: The designers at Nike put in a lot of thought and time and effort into my shoes. If you just look at my shoe, at the tip of the laces it says, "Missy." And there's just a whole bunch of different lit-tle things. The zipper on my windbreaker has crosses on it. The Nike check says "Missy" instead of "Nike."

ISAIAH NEUMAYER-GRUBB: We had to ask

BOTH PAGES:

Andy Grass design sketches for
the Kyrie 2 Doernbecher

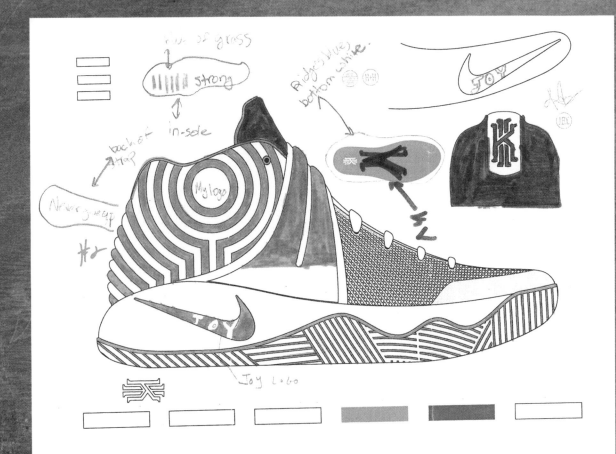

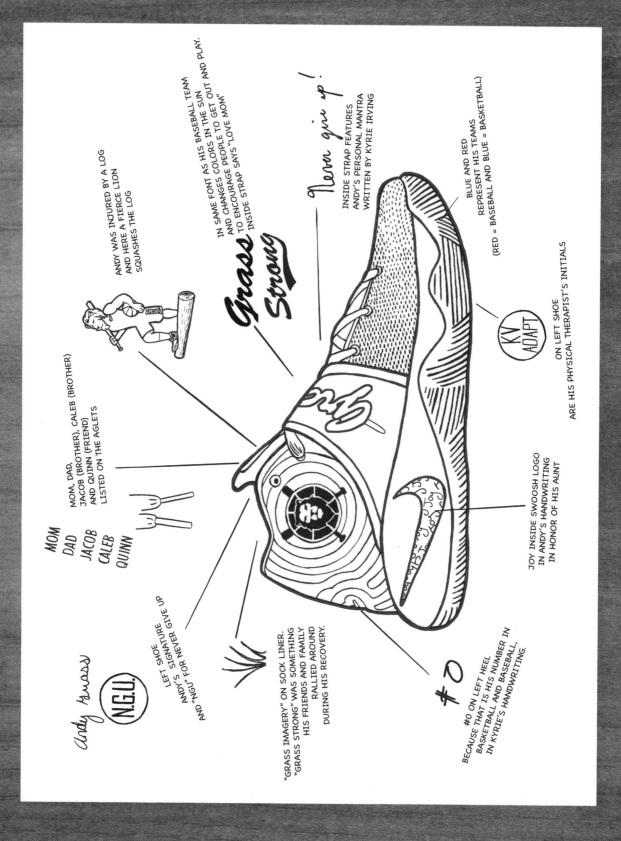

ANDY WAS INJURED BY A LOG AND HERE A FIERCE LION SQUASHES THE LOG

IN SAME FONT AS HIS BASEBALL TEAM AND CHANGES COLORS IN THE SUN TO ENCOURAGE PEOPLE TO GET OUT AND PLAY. INSIDE STRAP SAYS "LOVE MOM"

Never give up!

INSIDE STRAP FEATURES ANDY'S PERSONAL MANTRA WRITTEN BY KYRIE IRVING

BLUE AND RED REPRESENT HIS TEAMS (RED = BASEBALL AND BLUE = BASKETBALL)

Grass Strong

MOM, DAD, JACOB (BROTHER), CALEB (BROTHER) AND QUINN (FRIEND) LISTED ON THE AGLETS

ON LEFT SHOE ARE HIS PHYSICAL THERAPIST'S INITIALS

KN ADAPT

MOM
DAD
JACOB
CALEB
QUINN

JOY INSIDE SWOOSH LOGO IN ANDY'S HANDWRITING IN HONOR OF HIS AUNT

LEFT SHOE ANDY'S SIGNATURE AND "NGU" FOR NEVER GIVE UP

Andy Grass

N.G.U.

"GRASS IMAGERY" ON SOCK LINER. "GRASS STRONG" WAS SOMETHING HIS FRIENDS AND FAMILY RALLIED AROUND DURING HIS RECOVERY.

#0

#0 ON LEFT HEEL BECAUSE THAT IS HIS NUMBER IN BASKETBALL AND BASEBALL, IN KYRIE'S HANDWRITING.

THIS PAGE:

Andy Grass and Kyrie Irving

permission to use the Batman symbol. Nike had to call something Brothers or something—

MELISSA NEUMAYER: Warner Brothers.

MICHAEL DOHERTY: It is our objective to never say no to these kids. If we have to call Warner Brothers or Marvel or Disney to get permission to use the image or logo of a superhero or Muppet, we'll do that.

ISAIAH NEUMAYER-GRUBB: Why do I love Batman? He's important because he's awesome and he doesn't have superpowers like Superman or Green Lantern. He just makes his own tools and he pushes through. His biggest superpower is his brain.

LEE BANKS: Mark Smith worked with a Doernbecher designer named Ricky Rudd in, I think, our third year of the program. One of the most interesting conversations I had with him was after working with Ricky; he said, "You know, working with Ricky and getting his perspective on design and how things should be crafted and created really changed my mindset in how I approach design, and the simplicity that it can be." I think the experience really changes designers' mindsets because these kids will try anything because they don't know what the limits are, and that is really cool.

DR. DANA BRANER: Normally what happens is the morning of the release my wife and I wake up at 5 a.m. to get on the website. We are sometimes lucky enough to get the shoes we want, and sometimes not. There's usually a couple of trips to eBay after.

LEE BANKS: I have a connect so it helps. But a large percentage of my shoe personal purchasing budget goes to this program. I can't pick a favorite. That's like asking me to pick my favorite daughter, I can't do that.

DR. DANA BRANER: I have a few backup pairs. Last year I got Corwin Carr's Janoskis with the plane. And I got the Kyrie Irving model designed by Andy Grass. Andy was at the beach. A wave rolled a log on top of him, crushing him and collapsing both of his lungs. His recovery was always in doubt. But he was taken care of by just an extraordinary team of surgeons, intensive care physicians, sub-specialists, and most importantly nurses and therapists at this hospital. And he's back playing baseball now. And through it all, I had the occasion to speak with Andy's family quite a few times because he was in the ICU, and they were always wondering how can we give back to the hospital. Every child that we've seen come through this program, if you ask them what's the best part about the program, they're not going to say meeting the sports stars and being on stage, they're going to say it's really an opportunity to give back.

LEE BANKS: Andy is a huge baseball player in the local Little League team, and not the one that I was on as a kid where you stand in the outfield and pick grass. Like, these are the serious Little Leaguers, they go to the Little League World Series in Oregon. And so Raleigh Willard, the developer on his project, he gave me a call, he was just like, "Hey, what would you think about just contacting Easton to see if they would make a bat for Andy?" Out of the blue, Raleigh cold calls Easton and explains the story, and explains what is going on. Two days later Easton calls back and they were like, "Hey, we've done a little research on Freestyle, this is so cool, we would love to not only take Andy's color scheme and graphics and make a bat for him, but we would also love to make an entire run of bats for his Little League team and donate them to the team." So we sent them all of Andy's graphic files, and the colors from his Kyrie, and all of that kind of stuff, and sure enough they came back with a beautiful regulation bat that is Andy Graff's signature edition Easton bat. And they ended up donating about thirty of these bats to us so that Andy could have one and his entire team would be able to swing one next year.

SOPHIA HITTI (Nike, Doernbecher Freestyle Program Spokesperson): Kyrie wore Andy's shoes during a pre-season game at Portland. And we made Andy baseball cleats with the Kyrie upper.

MISSY MILLER: They gave me a pair of shoes signed by Kevin Durant.

MICHAEL DOHERTY: There's extra stuff that the designers and developers do without asking. They get another shoe for the sibling or they'll order shoes for the patient-designer's entire basketball team. They made a shoe for a dad who gave up his kidney for his child at Doernbecher. One designer was working with a girl who rode horses. The girl had a brain tumor. So the designer made custom riding boots using the American Olympic team boots as a model for the little girl to wear when she competes.

DR. DANA BRANER: The cult status of the shoes is alive and well in my household. Every year we are privileged to be able to go and speak at the event. I go with my daughters. And my daughters meet each one of the designers, and every year like clockwork they make sure to get these kids autographs and discuss their stories. In the eyes of my children, fifteen- and seventeen-year-old girls, these kids are literally superstars. They give them the same deference they would give any pop star, any sports star. These kids totally deserve it. And not just because of what they've been through, which is in almost every case arduous. And if you've had a chance to talk to these kids then you know they're eight and nine or twelve and thirteen going on fifty.

MICHAEL DOHERTY: The program just grew and grew and grew to the point where now we're at $17.5 million in fourteen years and we're about $3 million a year now in terms of the six hundred people who come to the auction. We hold the event at the art museum. Everybody gets to meet the kids.

ISAIAH NEUMAYER-GRUBB: The scar on my head is shaped like a question mark. It even has a dot at the bottom.

MELISSA NEUMAYER (Isaiah's mother): He calls himself the question man. He finds humor in things. It's how he deals.

ISAIAH NEUMAYER-GRUBB: My shoes sold out in less than one hour.

KV
ADAPT

Grass
Strong

Never give up!

THIS PAGE:

Patient-designer Andy Grass

THIS PAGE:

Andy with Raleigh Willard,
Footwear Developer NSW
Basketball/Football, Jered
Bogli, sock designer, and
Lauren Hirsh, sock developer

Nike Kyrie 2 Doernbecher
designed by Andy Grass

Andy with Lee Banks

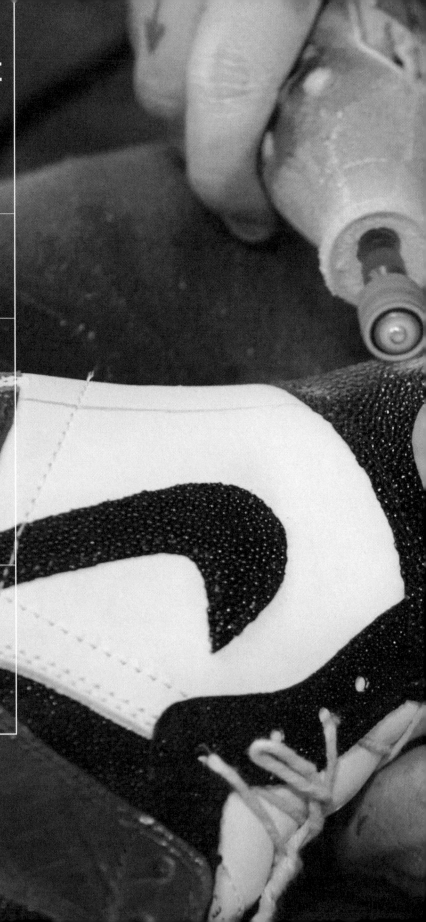

DOMINIC CHAMBRONE

A.K.A.
THE SHOE SURGEON

BASED IN
LOS ANGELES, CALIFORNIA

VITALS

Kids are audacious in their creativity. That's harder for adults, but Dominic Chambrone has held on to that kind of boldness. He's the most gifted bespoke-sneaker maker working today. Plans for his own line are in the making.

CHAPTER

19

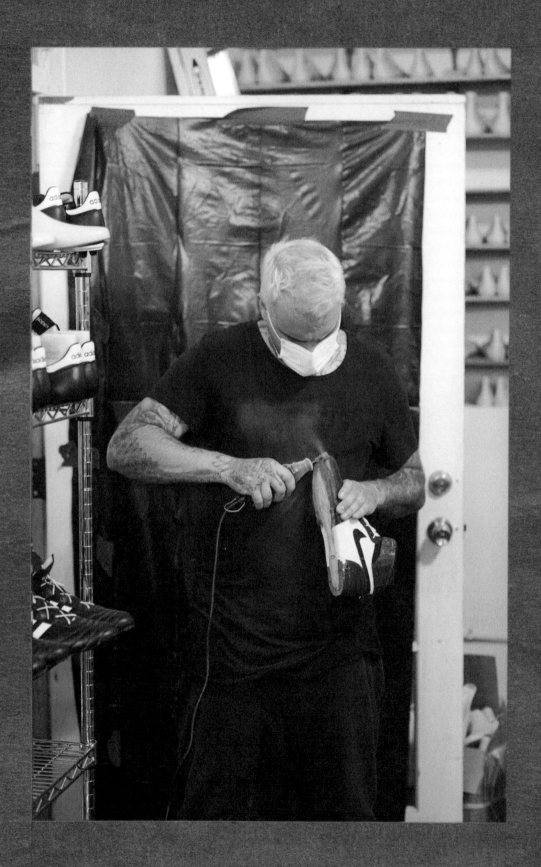

I. Pre-Med

I grew up in Sonoma County, California. You know, wine country. I was a quiet, shy kid—barely graduated high school, cheated my way through. My ADD made it hard to focus on anything. But I latched on to fashion—shoes, especially—because it was a way to get noticed without having to say anything.

In high school my whole crew had the same shoes, and to me that was just dumb. So one day I picked up an airbrush and put a camouflage print on a pair of all-white Air Force 1 mids. I wore them to school the next day and everyone went crazy. That kind of positive reaction provided this feeling of fulfillment.

I began customizing shoes for my boys. I didn't charge them. It wasn't about money. It was about making art. I started taking the swooshes off of sneakers and gluing them. The glue wasn't strong enough, though, so I sought out a shoe repair store for advice and ended up meeting Daryl Fazio. Older Italian guy—fat and bald and funny as hell. He used to play pro baseball. He taught me to use a patcher machine, fix purses and heels, put zippers in shoes, change boot soles, set rivets, sew, sand, cut, glue. Everything. For graduation, my grandma gave me a sewing machine.

I moved to Charlotte for about a year in 2005 when I was eighteen. Style was different there, edgier. A lot more people were wearing Uptowns. Customization culture was starting to get big. I could get a hundred bucks for doing a pair of shoes. I went to a high-end boutique that carried Gucci and I just said, "Hey, I want to customize a shoe for you, I want to show you what I can do."

The guy was used to having people just putting glitter on Air Force 1s, but they gave me a pair of all-white size seven Vans chukkas. I went to the drawing board and came up with an idea for a shoe made out of rustic leather with a hand cross-stitch and laser-engraved detailing. It was intricate and it made me imagine the possibilities. The guy who owned the store never did anything with the final product. It was hard to sell a customized shoe back then.

I moved back to California after a year and a half and got a job working the front desk of a gym. One day, one of the salespeople told me that they'd signed up a new member and the guy made custom boots. I connected with him and he became a mentor. His name is Michael Anthony. He lives in Sebastopol. He makes cowboy boots for George Lucas and Jay Leno. Beautiful work. We relate in a lot of ways because we both tend to be what's called "manic."

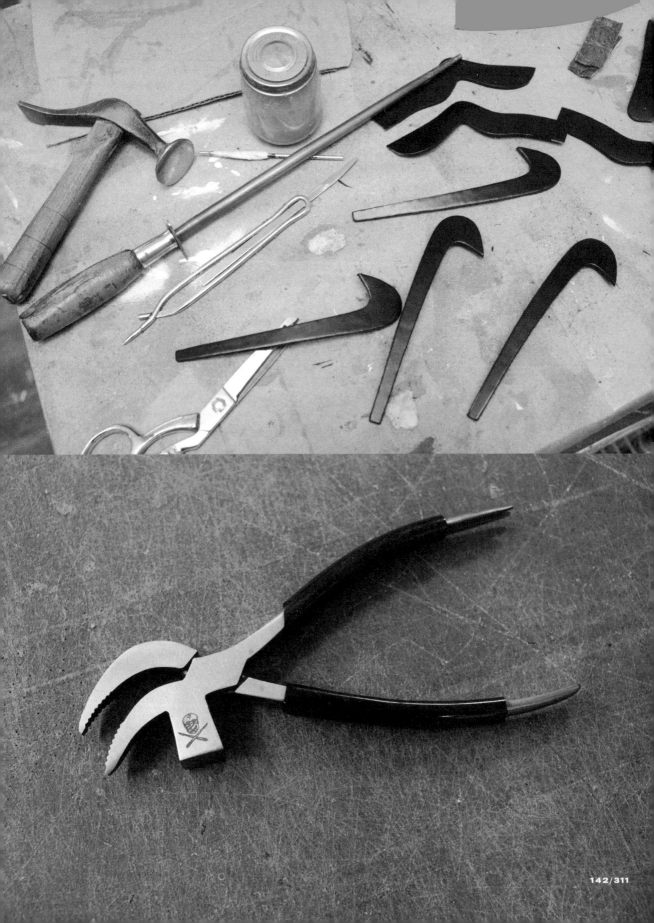

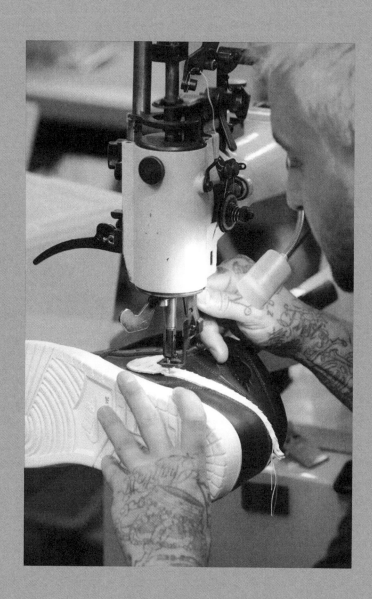

II. Medical School

I started networking. I reached out to Javier Laval at Android Homme. I make shoes with my hands, and they design shoes on a computer. So I reached out to him because I liked his designs and I asked him, "Hey, how do I learn how to design like you?" He offered me an internship, but it was in LA and I didn't want to make the move.

A year later he reached out to me again and asked me to customize shoes for will.i.am to wear to the VMAs. They were pink with Swarovski crystals. When I delivered the shoes, Javier introduced me to Justin Bieber's stylist. We became good friends and started working with each other a lot, because Justin Bieber wanted customized shoes for his tour and just to wear.

After that, things started moving really fast. I got an order to make two pairs of customs for the *Law & Order: SVU* episode "Personal Fouls." Chris Bosch was in the episode. I made a custom sole, and the shoes starred in the episode as the sneakers worn by the perp. The only hint the cops had was a footprint. They paid me more than $6,500. I was twenty-four years old and all of the guys I knew who were customizing shoes were poor. My mind was blown.

III. Concierge Medicine

Sneaker culture changed. A few years back, I made a pair of python Jordans and put them on Instagram. Some influencer saw and had another customizer make him a pair. That shoe became an epidemic. Basically anything with black python on it was selling. I got hundreds of requests, turned down a lot, and probably made a hundred. The popularity of those shoes really pushed the custom industry.

In 2012 I met a designer named John Geiger. The first thing we did together was dip his Air Jordan IVs in rubber, sort of like the Vans I've been doing more recently. After that I reached out and told him I wanted to make some shoes. So he suggested we collaborate on three pairs together. We did a Wheat AF1 midtop with a Gucci swoosh and a red suede AF1 moccasin. We also did a shoe called the Misplaced Check. It was an Air Force 1. We took off the original swoosh and replaced it with a bunch of swooshes that I made out of different materials. Geiger is a dream to work with. He has ideas that the brands would never dream of.

Sometimes an idea pops into my head and I feel like I just have to bring it to reality by making it, but I can't because I'm so busy with orders. Like, right now I have an order for seventy-five pairs of custom Air Force 1s for some guys in Japan. I want to step away from being the only one actually making the product, because you can only produce so much. And because I'm an artist, it's easy for me to customize a shoe and make it look cool. But I want to be challenged. I want to focus on more design work. And so I'm doing a lot of brand development work for startups and small companies, building and creating silhouettes and helping them get their shoes produced.

The direction the original brand is heading is by appointment only at the Shoe Surgeon's showroom. Imagine being able to come in for a four-hour appointment where the client gets to pick everything from the materials, thread, soles, colors, and even the design. They'll be able to get a haircut, drinks, a meal. We'll even have somebody clean the car.

THIS PAGE:

Yeezy BOOST 350 v2 Python

OPPOSITE PAGE:

Dominic Chambrone wears
Chuck Taylor All Star Premium
Leather Sneakers

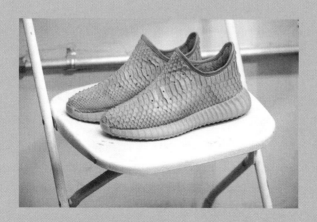

ALEXANDER WANG

BASED IN

NEW YORK,
NEW YORK

VITALS

Even major fashion designers
geek out over sneakers.
For Alexander Wang, whose
eponymous label has long
drawn inspiration from
athletic wear, collaborating
with adidas Originals was
both a thrill and a challenge.

CHAPTER

20

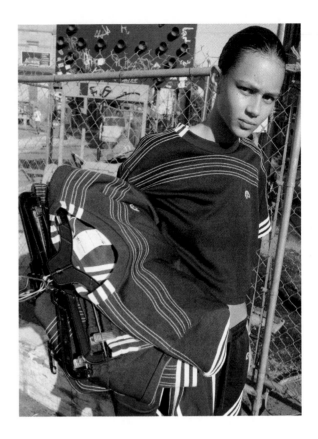

BOTH PAGES:

adidas Originals by
Alexander Wang

In innovation everything is so slick, so we really
wanted to do something with adidas that felt DIY. I
wanted the shoes to feel like they have the energy of
us just cutting apart shoes and gluing them together.

We did a skate, a runner, and a basketball shoe
to launch. The basketball takes the front from a very
traditional basketball shoe, but fuses it together with
BOOST. Soles are always three colors: white, black,
and gum. For the upper, we thought about the idea
of using stretch leather, maybe an elasticated cuff,
something that felt very naïve and brought all the
different elements together.

With the runner, we used a found bi-stretch 3-D
mesh and took a tongue from a soccer shoe; and for
the skate, the idea was to take a piece of leather and
just fold it on itself, so there's only one seam for the

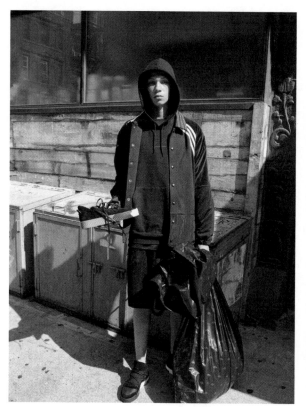

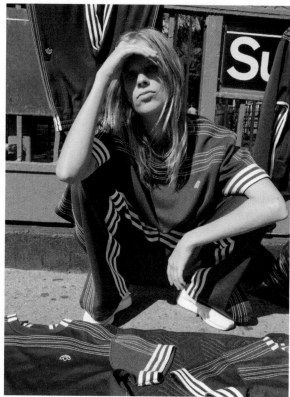

entire shoe. It was important to me to always kind of have this feeling: Is the shoe finished? Or, is it not quite finished yet?

In boarding school, my two outlets were fashion magazines and music. I followed hip-hop very closely: LL Cool J, Missy Elliott. They become style icons. I also became really into Japanese streetwear magazines. My parents moved back to Asia like over twenty years ago, so I would always have to travel through Tokyo to get to Shanghai, and every time I would stop in Tokyo I would pick up all of their street magazines like *FRUiTS*.

I feel like Japanese magazines are always the first, so they started covering models wearing their adidas Shell Toes with a Chanel jacket. I found that very inspiring: to challenge preconceived notions. What's

street? What's luxury? There was a naïve spirit, but now it's so covered it feels manufactured.

Growing up, there was always a favorite sneaker, and then when a new one came out, you wanted the next one. I wore Sambas a lot in high school. And Shell Toes in middle school. White on white with black stripes.

In boarding school, we had uniforms. Shoes were the only things we could pick. The first week you'd get a new pair and you'd want them to stay pristine white, and you wouldn't want the toe to get dirty. You're always rubbing off every scuffmark. But then by the time you go through PE class and everything— it's beyond saving. There are grass stains everywhere. You're over it. You've given up and let your friends draw all over them.

NIC
GALWAY

BASED IN

HERZOGENAURACH, GERMANY

VITALS

Wang calls his adidas counterpart, designer Nic Galway "super-sensitive to detail" and a "champion of new ideas." Galway also counts Yohji Yamamoto and Stella McCartney as key collaborators.

CHAPTER

21

I. The Origin of Collab- oration Is a Kneecap

Falling into this fashion world wasn't the plan. I went to art school, studied transport design. Before that, I was into BMXing and spent my entire youth riding and competing. I was heavily influenced by that, like when Dennis McCoy went from wearing slimmer canvas-style sneakers to a very big, bulky basketball shoe. We all changed styles overnight, too.

I also grew up in a town with one of the best skate parks in the world, the Southsea Skate Park, a very old-school concrete park. So, I was living on the south coast of England, pretending I lived in California.

We would get all of our information through U.S. magazines like *Freestylin'* and *BMX Plus!* and then we interpreted this California BMX culture through what we had in the UK. It created a very unique subculture.

When I quit BMXing I started rock climbing, and I used to make a lot of climbing gear. I've always been like that. When I was riding, I used to modify my bikes. When I was climbing, I'd make harnesses and backpacks. When I came over to adidas it was a completely new world. I was used to designing cars, medical gear, and climbing gear. I worked for a design consultancy.

I remember designing kneecaps. I remember one project for Johnson & Johnson where we did surgical tools. Then the subways in Hong Kong, and then parts for Land Rover. And Stanley knives. And London buses. You never knew what was coming next.

In a consultancy no one has their own projects. And no one knows what they're doing at the beginning, so you have to collaborate. From that, I was very used to being engaged in energetic discussions, and challenging people, and thinking, what if.

But working in a consultancy, I missed the feeling of being hands-on. Of actually building things myself. So I was at work there one day, and we had these trade magazines and there was an advert in the back of one for adidas. I remember writing a letter—pre me having internet—and they invited me to Germany for an interview.

I think that naiveté of not knowing how to design shoes was actually one of my greatest advantages. Suddenly, I was in my mid-twenties and designing footwear. The first shoe I ever sketched was the day I walked into this building.

II. Yohji Says

I first met Yohji Yamamoto in 1999 or 2000, and I'm still working with him on Y-3. I learned with him that fashion doesn't mean following trends; it's about having a vision. Yohji isn't someone of many words. He consistently used to say to me, through a translator, "It's too noisy."

What he meant by "too noisy" was that there were too many ideas in one design. I say it to my team now. He'd strip things back to what's most important. I've always carried that with me.

Besides working with Yohji, I had the chance to work with Stella McCartney. Our first presentation to her did not work at all. And it made me realize the

OPPOSITE PAGE:

Adidas
NMD CS1 PK City Sock

key to collaboration is getting to know someone, and to understand how they think, and to tailor the approach. There's no set path for a collaboration other than getting to know people and being open. Once I figured that out, it completely changed the dynamic with Stella. The next meeting was incredible.

One of the first shoes I did when I joined adidas is called the Mayhem, and that's the shoe Yohji really picked out as being the one he wanted to show. And I based it on climbing shoes. I used very basic unlined materials and wrapped the rubber onto the sides.

One design I definitely have fond memories of is the Qasa. It was a conversation with Yohji where he basically just said to me, I'm bored, you know? Everything looks the same, I'm bored. This was his statement to me, and I said to him, "Can I show you something?" And I showed him some mock-ups I had been working on a couple of years before for the idea of Tubular. And he said, "Yeah, that's it, let's make something."

I went back to Germany and quickly made the shoe out of neoprene and elastic, and bits and pieces from the ZX that was lying around the house. I didn't really draw anything. One thing I really loved was, I cut out the iconic heel mustache—you know, the bit that goes on the back of the heel of a Stan Smith or a Superstar, I cut out that shape and put it on the back of the Qasa. And then I had the piece of leather left over, which I cut it from, and I stuck it on the front of the shoe to make the cap. I like how quickly the shoe eventually came together, and the fact that it wasn't really drawn but rather it was made.

The Qasa showed a new confidence for us, which really opened the door to do Tubular and later NMD and all of the things we've been doing since.

III. Sneaker Space-Time

The NMD came on fast. It was a great team of people bouncing ideas backward and forward. And what I like about that shoe is that it references collective memory, rather than one particular shoe. When we presented it in New York, that's how we showed it. We showed the Micropacer, the Rising Star, and the Boston. The NMD's roots are there.

When I started in 1999, I was a young designer in a big

brand, and now I lead a big team in a great brand. I love the fact that I look around me and there's so many young designers who now make things and cut up materials. In the past, that was unusual. Now it's really the habit of my team.

It's culture's place to decide whether a shoe becomes a hit, not a brand's. And whether it's Tubular or Qasa or Yeezy or NMD or EQT, what's important to me is that what we put out into the market is creating a dialogue with the consumer. It's asking them questions and inviting them in. I don't try to design shoes to be hits; I try to design shoes that create that conversation.

I say to my team, you should know what's going on in culture around you, but that can't be your influence, because if it is you're not leading; if it is, your design is probably too late.

I hope people will remember the first time they saw a Yeezy or an NMD or a Qasa.

We can talk about Run-D.M.C. creating a conversation around the Superstar or about Bob Marley and the Gazelle. But with the NMD, we intentionally didn't package it with somebody like that.

When it was designed, the team had a very clear idea of this modern nomadic lifestyle, this person who travels, surrounds themselves with the most up-to-date kind of items, but they also carry a history. So why do people carry a traditional notebook with them? Because it's personal, you know? Or why do we go to places like Ace Hotels? Because they mix the past and the future together. That was the mindset.

It's easier to look backward than forward.

Yohji says it's nice walking backward into the future because if you look backward you can see that the future is never really this futuristic thing, but it's always a progression of innovation and technology. I also believe that every time there's a giant shift forward in innovation, there's also a fondness for what's been lost.

I really love that: the role of culture versus technology. Technology is a linear thing; culture plays with that. Culture allows us to do things that aren't logical, and I think that's really important to sneaker culture.

I believe the future will be a mixture of the fond memories of the past and the best innovations—and it will always be surprising.

Whenever you think there can be nothing more, someone comes along and just resets everything.

THIS PAGE:

adidas Originals Tubular
Doom Primeknit

adidas Y-3 Qasa

adidas NMD R2

TIFFANY BEERS

BASED IN

PORTLAND, OREGON

VITALS

If Nic Galway's design trajectory, from prosthetics to NMDs, seems unlikely, consider this plastics specialist from rural Pennsylvania who went from problem solving with Pringles lids to designing a self-lacing sneaker for Nike.

CHAPTER

22

I. Beers and Cheddar

I knew I was going to have to work all my life. There was no trust fund that I knew of. I picked plastics engineering as a degree because a town nearby to where I grew up—in Townville, Pennsylvania, population 300—was the tool and die capital of the world. The degree had, like, a 120 percent job placement rating and very few females. I wanted a guarantee that I'd make a living.

For college projects, we built a lot of containers. Many people were going to work for plastics factories. I went to work as an innovation quality lab technician at Erie Plastics, working on mold qualifications for Sharpie pens and Pringles potato chip lids. The internship was supposed to be for seniors, but I was a freshman. I also talked them into hiring me to work full time while I attended classes my sophomore through senior years so I could apply what I was learning immediately and have three years of work experience that my classmates wouldn't have when we graduated.

I worked there for the next three years, doing a lot of innovation with materials and studying dimensional stability. At one point there was a problem with the Pringles lids not fitting. We ate Pringles for years. I still to this day won't eat another cheddar Pringle.

After graduation, I went to Rubbermaid and designed boxes for a couple of years. Then I went into factory optimization. I survived a huge round of layoffs. But when I saw everyone around me being laid off, I lost interest in staying.

I'd played a lot of sports growing up and even volleyball in college. The Nike NDestrukt was a really important shoe for me. With all that in mind, I filled out an online application to be a product design engineer at Nike.

THIS PAGE:

Nike Air Mag 2011 Remake from *Back to the Future*

OPPOSITE PAGE:

Tiffany Beers

II. Hyper Drive

I started working on airbags. Jordan Brand would say, we need a new air-bag for the AJ XXI. Running would say, we need a new, articulated airbag for the Air Max Moto. I did airbag design for a year and then I applied to work in the Innovation Kitchen.

The first year, working with legends like Tinker Hatfield and Bruce Kilgore, was really intimidating. I was the twenty-seventh person to get a job in the Kitchen and the fourth or fifth woman. There's hundreds of people in there now.

I'm always problem solving so I'm rarely short on new ideas. New experiences and constant learning fuel the best ideas for me. Many of mine are not initially grounded in reality because I literally believe anything is possible.

I think this is a great place to start but the true craft is taking that idea and making it real and impactful.

From the very beginning, the HyperAdapt was one shoe that I had asked Tinker, "Can I just prototype in my size?" Because when I'm building a size 10, a men's 10, it's really hard to get a good perception of what it feels like. Normally, you build for whoever the main decision maker of the product is. I'm a women's 7, so I built the HyperAdapt in a women's 7.

Right away in 2012, with the first motorized units, I was running in them, wearing them, dealing with them. At the time we had a remote on your wrist, a bracelet basically, that you controlled the shoe with. That bracelet could also control your iPod, so I didn't know if I was tightening the shoe or turning up the volume, which was really annoying. Other than that it was amazing. By 2030, people are going to realize how irritating footwear actually is. People tolerate laces, but, actually, they're super annoying. The idea is that footwear will become more like a part of the body. Part of me versus something I put on.

I'd say I work on about ten different models at a time. I think right now I have fourteen models. For about a year or two, during the really meaty times of the HyperAdapt, I was maybe only working on two models. Between managing electronics and everything else that went into that thing, it was just like doing ten people's jobs.

OPPOSITE PAGE:

Nike HyperAdapt 1.0
"Metallic Silver"

III. Kitchen: Always Open

Making a new prototype can take just minutes. It depends what the idea is. If it's a brand-new drawing—say it's a completely new concept, before you have a physical prototype—you can still do it in less than a week.

Lately, I've been comparing it to *MythBusters*. No matter what they build, even the obvious, they'll learn something from it. We tend to want to think our way through it too much instead of just building. The faster you iterate on prototyping, the better.

We used to do one hour, one day. Build a prototype in an hour. If it works, if the idea is still valid, build a sample in one day. Then, build a more refined one. If that still works, take three days and build it even more refined. And by the end of that, usually the three-day sample is wearable, and then the week sample is definitely wearable. And then you get people really wearing it, and literally in two weeks' time you've gone through four rounds of iteration and you know if it's a solid concept.

A dynamic test is a performance test where people tell us what they think of the shoe. Several people, really quickly. But a long-term wear test for running takes about ten weeks. For basketball, it takes eight weeks. But we do have accelerated versions. On the HyperAdapt, we did accelerated testing. So we basically took two weeks and we brought in people every hour of every day to test the shoe so the same shoe was constantly under scrutiny.

Normally you have runners come in because running is the fastest way to check durability. You have them run out in the elements. They'll hit concrete, they'll hit wood chips, they'll hit grass. Rainy or dry, whatever. Then it comes back and the next person takes it out. And the next.

Other problems work themselves out in dreams. I mean, a lot of times I'll wake up and be like, *oh my god, that's how you do it!* Like, the parachutes that go across the throat of the shoe. We wanted something visual so that the user could see that the shoe was getting tighter. But the problem is the throat actually gets smaller when the shoe is tightened and this is the opposite of what we wanted for a visual effect. We could not get it to work, and for whatever reason, I was dreaming about it, and I thought of a braid or a finger trap. I woke up and I was like, *oh, that's what it is.* So, I got on McMaster-Carr and overnighted a bunch of braided material. That's your brain working in the background.

OPPOSITE PAGE:

Nike Air NDestrukt

DANIEL BAILEY

BASED IN

LONDON, ENGLAND

VITALS

With an eye on the conceptual and the sustainable, British designer Daniel Bailey argues that a sneaker revolution may be here sooner than you think.

CHAPTER

23

I. Catching a Buzz

Concept Kicks started as a conversation five years ago with Omar Bailey, a really good friend who happens to have the same last name and is also a footwear designer. We were chatting about the fact that there wasn't really a platform for designers and developers to show what they've added to the product. I thought these guys should get a little bit more shine for their involvement. At the time, I was living in Belgium, working on this super innovative new jet ski concept called the Wesp.

But I mainly design footwear. I do Concept Kicks, and then there's my designer alter ego, Mr. Bailey. My logo is a light bulb and two pens, it kind of looks like a skull and crossbones. I met Omar when I was at university. He had his independent design agency, took me on a few trips, and I was like, man, this is what I want to do. I didn't realize there were so many parts in this industry. I was working with him on brands large and small, and then kind of started doing my own thing.

Through Mr. Bailey, I'm collaborating with a German sustainable footwear brand called ekn footwear. I'm trying to improve the way people see sustainable footwear—it doesn't have to look super-duper ugly! So we're playing around with vegetable-tanned leathers and microfibers. We've got a recycled plant–based neoprene that we're using. We've got this one shoe called the Bamboo Runner that you can lace from the back. And then we've got some interesting one-piece constructions.

I also developed a shoe called Mahabis Slippers, which won Most Innovative Shoe of 2015 at the Drapers Footwear Awards. They have a removable outsole, so you can wear them inside and then you just kind of slip the outsole on and you can wear them outside, so you can just go about your day and do stuff.

Once, I got to work on a project for NASA. Actually, it was General Electric. With Android Homme, we created a shoe to commemorate NASA's forty-fifth anniversary of their moon landing. Years ago, I was talking to this woman; she was an aerospace engineer, and we got to chatting about anti-gravity, and I thought it would be so cool to design a concept shoe that floated.

When I was in college, I got to know Javier Laval, the owner of Android, and he saw that design. Nothing really happened. But when he was approached by General Electric, he hit me up and was like, "Look, I would love to work with you on this. I loved the design you did; let's see if we can

THIS PAGE:

Buzz Aldrin wearing the GE x Android Homme x Mr. Bailey Moon Boot Sneakers

GE x Android Homme x Mr. Bailey "The Missions" Moon Boot Sneakers

OPPOSITE PAGE:

Daniel Bailey

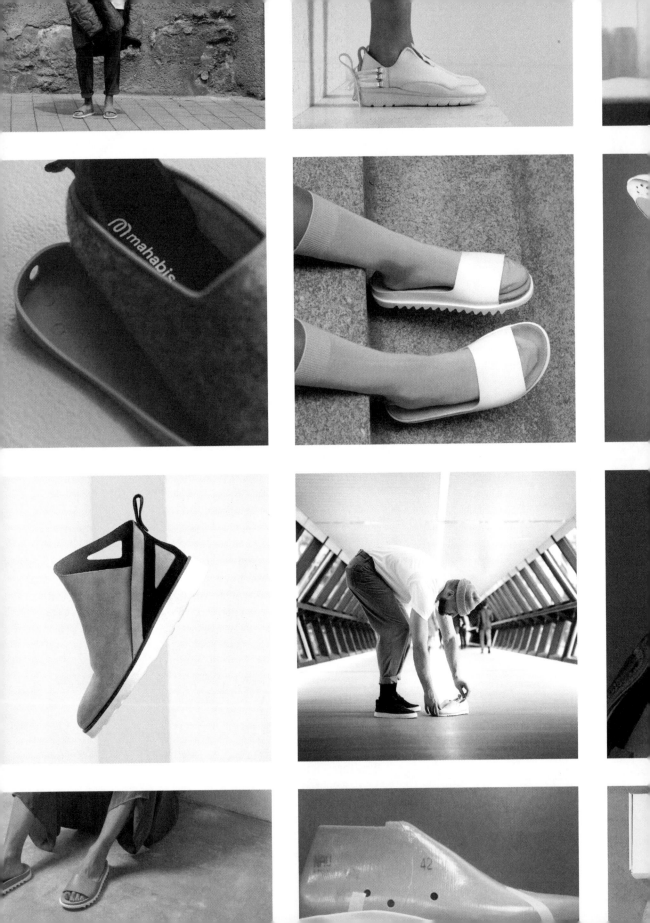

incorporate that into the shoe that we're doing." The shoe sold out the minute it came online. They only made five hundred pairs or something. I went a bit mad on that one. I just completely made up all of the names of its elements on the drawings. I didn't know what I was talking about. There's a propulsion cell with a weapons-grade thermal suppression alloy. There's no such thing, you know, but it sounds cool. I saw Buzz Aldrin wearing a pair and I flipped out. I was like, "This is better than anyone I could imagine wearing my shoe!"

II. Declaration of Independence

We get a lot of ridiculous emails on an almost daily basis. Because everybody wants to have a shoe brand, right? The worst emails always start with, "Yo, I've got the best idea! I haven't got any money, but, yo, together we could change the industry." That's the format—guaranteed. I used to respond to all of my emails and I just can't do it anymore. Honestly, most of the time when people hit me up, they're either just randoms or students. I haven't had any failing celebrities reach out quite yet.

I haven't really bought anything in a long time, but there's a brand out in LA called No.One, and I really love their whole set up. I was fortunate enough that they sent me a pair anyway, but I would have totally saved up and bought those shoes—they're like $600 or something. But I love the fact that they're making their own shoes in LA, and they're doing it their own way. A lot of people feel that way about the Jerry Lorenzo Fear of God boot, which I can respect as well.

I think sneakerheads, in general, are really going to have to start giving new brands a chance. That's the new wave if they really want the hottest stuff, the newest of the new. They're going to have to support independent brands doing interesting, different stuff, and not just from a design perspective, but from a materials standpoint, too. Sneakerheads are really doing themselves a disservice if they don't just give newer brands a chance.

OPPOSITE PAGE:

LEFT TO RIGHT: Mr. Bailey x ekn Footwear PALM Slide in Brown, Mr. Bailey x ekn Footwear BAMBOO Runner in White Leather, Mahabis Slipper, Mr. Bailey x ekn Footwear PALM Slide in White, Mr. Bailey x ekn Footwear BAMBOO Runner in Gray Vegan, Mr. Bailey Trillium Boot, Daniel Bailey with Mr. Bailey x ekn Footwear Kudzu in White Leather, Mr. Bailey x ekn Footwear BAMBOO Runner in Black Vegan, Mr. Bailey x ekn Footwear PALM Slide in Brown, BAMBOO Runner prototype, Mahabis Slipper packaging

TOM SACHS

VITALS

Bailey's NASA sneaker was a
one-off project. Artist Tom
Sachs's obsession with
space exploration has
materialized in his work for
over a decade. That includes
three major space-themed
shows—and two major
sneakers with Nike.

CHAPTER

24

I. Foot Fetish

I've always been sexually attracted to people based on their footwear.

I think it's the foundation; the figure. The body needs the earth. It's the most fundamental thing.

I'm extremely judgmental of how people wear their shoes. It might be a super visual thing, but how people wrap their bodies is a form of intelligence; it's the way they communicate who they are as individuals. It's like a tribal connection thing. You can tell if you're going to like someone by the way they dress because it's an expression of how they look at the world.

II. From Westport to Mars

My sneaker history is part of my introduction to consumerism, which is a big part of my work. It was the first time I wanted stuff. When Nike Cortez came out I mowed the lawn so I could get them. I was into soccer so I was really into Pumas; Pelé played in Puma Kings. My parents wouldn't buy me Puma Kings because they were superexpensive. They were leather, really nicely made—the best soccer boot you could get. I got those supercheap adidas nylon cleats that every kid had instead. They were $11 or something versus like $100 for the Pumas.

I never got kicks until I bought them for myself later. But like I said, it was the first time I was into stuff, and it started as a performance thing because they were actually better: lighter, more comfortable, more breathable. It got me into obsessing about things from an external standpoint. Like everyone else, I was subject to advertising. If Pelé was playing on Kings, I wanted them, too, because he was the greatest player of all time. That was the beginning.

Sometime afterward I made a collage of all the sneakers through which I identified my character or my identity. For years I only wore adidas Samba because they're great for soccer and skateboarding.

Later on, when I moved to New York, I only wore those gray New Balance, like the old man shoe, which was kind of like a normcore gesture before it had a name. Since 2011 I've only been wearing the Mars Yard shoe, my shoe, the shoe that I designed, that Nike made for me.

III. Ask Not What You Can Do for Nike

It might sound a little arrogant, but I feel like I can say it to you: People always say, "Tell me about the shoe you did for Nike." And I always correct them and say, Well, actually, it's a shoe that they did for me. This is a shoe for my Space Program and my team. They did it for me. If you asked Nike,

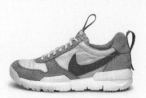

THIS PAGE:

Tom Sachs x NikeCraft
Mars Yard 2.0

BOTH PAGES:

Tom Sachs x NikeCraft
Mars Yard 2.0 packaging

they would say the same thing: they built the shoe to serve the athlete, because that's part of their culture. I follow that. I think the consumer culture thing that people are into is like, "What did you do for them, because they're so powerful?" But we must not say what we can do for Nike but what Nike can do for us.

The Mars Yard wasn't like other sneaker collaborations. Nike designed the shoe for our "athlete," a mechanical engineer at the Jet Propulsion Laboratory in Pasadena, California, named Tommaso Rivellini. He invented the airbags for the two Mars Rover missions. When people say, "What did you do for Nike?" they're basically talking about an artist decorating a Dunk. That wasn't something I was or am ever interested in doing, because there are plenty of people who do that. Of course the historical reference point is the BMW art cars—or car art, not art car, there's a difference. An art car is like when you glue lots of plastic animals to your car and drive it to Burning Man, and then car art is when, like, Frank Stella or Alexander Calder paints a BMW and then they race it.

IV. Sweet Little Lies

Consumerism's gigantic lie is specialized shoes. And if you look back at the history, men in the 1950s had two pairs of dress shoes and one pair of athletic shoes, and now you've got like, your aqua socks for windsurfing, a tennis shoe, and a basketball shoe. At a certain point people started buying brand association, like, do you buy the Piccard Deepsea Rolex because James Bond or Jacques Cousteau had it? Or a North Face parka because someone climbed a mountain in it? Or Air Jordans because Michael Jordan played in them? You might not be as good as any of those guys, but you buy the associations, the fantasy of that. So that, linked with specialization, created a huge opportunity for people to feel comfortable with having specialized equipment, and now we're living in this ecstasy of racing bikes, performance-grade watches, and people on the shooting range with really fancy customized submachine guns that completely telegraph that you're a dentist and not a soldier because the soldiers don't have that kind of money to spend. They go with what

they're issued, and maybe they do a little customization but they're usually too busy doing push-ups and studying martial arts to stay strong and focused or learning another language, like Farsi.

I can say all this because I'm not a peer critic of it, I'm a participant. I'm guilty of all of this, or I should say I'm subject to all of this as much as anyone else. Even though my job is as cultural producer, when I see the James Bond ad for the Omega watch, part of me wants that watch even though I only ever wear a G-Shock DW5600E. But that doesn't prevent me from wanting those other things. I've had Rolexes, but those things go through me like a bad taco. I know we're talking about sneakers, but I'm purposely trying to broaden the discussion because I think these are the issues sneakers represent. There's so much around the culture and the meaning.

The amount of young men who stop me on the street to shake my hand since I did the Mars Yard is astounding. I mean, people in the art world might not give a shit, but people in the world, in the real art world, are really into it because it's something they're passionate about. Art is an alienating thing, and sneakers aren't because you can have them.

V. Ground Control to Major Tom

The Mars Yard thing started with a conversation between two guys from Nike, Sandy Bodecker and Richard Clarke. We were talking about this thing called TSA, Tom Sachs Airlines. It was around the time that the Transportation Security Administration (TSA) was starting to get really shitty. One of the original ideas was this jumpsuit that you get into, a travel outfit and shoes to go with it. We designed it all. In the end it felt like it wasn't significantly different from sweatpants with a pocket sewn here and there. It wasn't enough of a thing.

At the same time, I started working on the second space program show. It was around 2007. We were going to back to the moon. We got this project going out of the Park Avenue Armory and we were getting

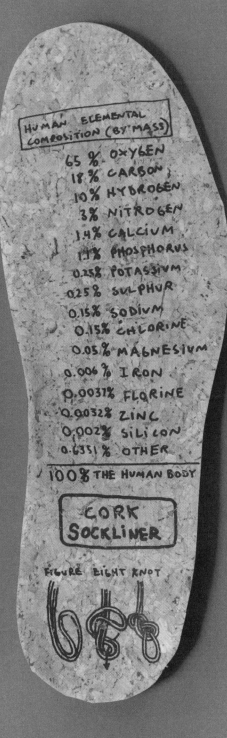

THIS PAGE:

Tom Sachs x NikeCraft
Mars Yard 2.0 cork sockliners

FOLLOWING LEFT:

Original Mars Yard

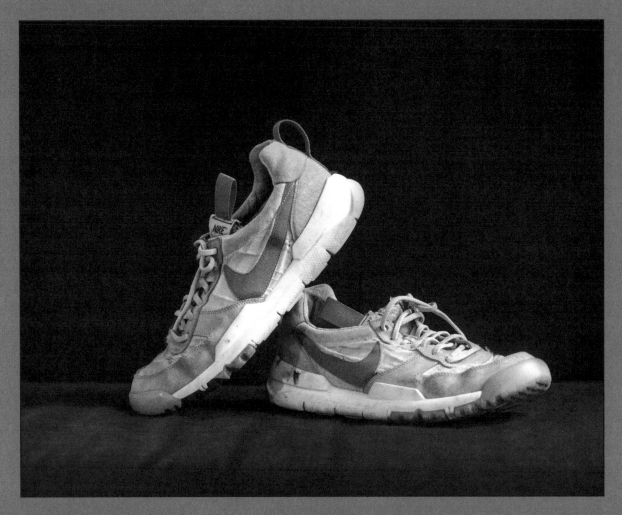

funded by the NEA. It was a gigantic project. One day I got a knock on the door from this guy who said he the father of a friend of a friend. Someone from the studio brought him in so I gave him a tour because, you know, we do that. I could tell by the way he was talking about my spaceship that he was more than just a friend of a friend, that this guy really knew what he was talking about. And we have parts of the spaceship in the studio, and I look down at his jeans and his Patagonia jacket and his sneakers and hairdo and I was trying to size him up. Because, I don't know, I always think it's I tacky to ask, "What do you do for a living?"

Turns out his name is Gregg Vane and he's from the Jet Propulsion Laboratory, and he's like the head of the solar system exploration. He said, "Tom, now that Obama is in office and Bush is gone, Obama has

dismantled Bush's Aries program to go back to the moon. We're pushing all the money towards going to Mars, and we're going to Mars with this thing called the Curiosity Rover from our science laboratory. This vehicle is the size of the Mini Cooper which means we can't bring samples back to study so we're going to send the whole laboratory to Mars and study it there. We think that you should send your astronaut to Mars. We'll help you reconfigure your lunar space program to work on Mars with some real science." So it started this whole residency where I would go back and forth between New York and Pasadena to Jet Propulsion Laboratory, and three guys from JPL would come to me. Adam Steltzner who was the guy at Mission Control, the Elvis-looking guy. Dr. Kevin Hand who is now working on Europa. And Tommaso Rivellini, the guy who invented

the airbag for Spirit and Opportunity to bounce their way down to the surface of Mars in the mid-90s.

All those guys came to my studio. We worked together on Europa again, and on one trip I was visiting Tommaso and he gave me a sample of Vectran material, which is the airbag material. It's superstrong; the same stuff they use in Flywire. I brought the sample to Nike and suggested using this Vectran in the upper, which in fact we wound up doing.

During the process of this I started working on the storytelling of what the shoe is for. We called it the Mars Yard because all of these guys were working out on the synthetic Mars yard in Pasadena, where they have all of this lava rock that they buy at Home Depot, and they try and get the Rover stuck in the sand so that they can get it out autonomously. We wanted a shoe specifically for that surface.

It's dumber than the aqua sock. It's a shoe specifically and only for working in the Mars Yard in the laboratory in Pasadena. By the end of the project we had outfitted their whole team with these sneakers. It's just like the spaceships that go to other planets, they don't really use paint unless there's a really good reason, otherwise you just use the native material—so the Mars Yard shoe is all native colors. The midsole is polyurethane as it comes out of the machine before it's stained. The sole is natural rubber, just like this kind of gum color, like a Samba. And the Vectran is naturally gold. The nylon shoelaces, which are very thick so they can be repurposed for something else in an emergency, are a natural sort of off-white. And only the swoosh, which is an advertising icon, is bright red so that you could say, OK, this is a branded product, made to the performance specifications of championship athletes worldwide.

My championship athlete is Tommaso Rivellini. He's like my Jordan. I made the shoe for that one man—because I want to be him. It's like using Pelé or Michael Jordan, but for scientists. If I could be one it would be Tommaso because he's an artist.

We made fewer than two thousand pairs. Everybody at JPL got a pair. My team did, too. The rest we sold at the Armory show and Colette and other snobby sneaker places. I don't have a single perfect pair. I mean, I've had probably a dozen pairs and I've destroyed every one.

VI. Tom, It's Ground Control. Again.

The Mars Yard really started at a party in Paris in 2009 when I was talking to Mark Parker and basically bashing Nike really hard for making crappy stuff. At one point, Parker was like, "You know, Tom, you're really good at talking shit, but you haven't really designed anything. So I'm going to put the challenge to you. Show me how to do it, man."

I thought, we stumbled upon this amazing material from NASA. I was such a show off, so proud of myself. I got this elite material. I got elite-level NASA people. I thought, that must make me world class. So I got all that, made shoes, and they failed. The Vectran didn't hold up for everyday use.

When Parker suggested re-releasing the Mars Yard, I first thought, Ew, gross, crude, crass commercialism. but then I realized it was an opportunity to fix something I was embarrassed by. So, I got to readress it on the 2.0 and there were a couple tweaks aside from changing the Vectran.

The upper is now poly, which doesn't sound exotic, like Vectran, but it's the best. Vectran is cut with a laser. It sounds cool, but it was bullshit. The tongues ripped out because I specified a box stitch, but the factory didn't do it. So I made a box stitch for all my friends. That's really absolutely secure, it's behind the label. The outsole is taken from the Special Forces Boot used in Iraq and Afghanistan that Toby Hatfield designed, but our affluent users live in cities, so we adjusted it, making it concave instead of convex, so it works better on slippery, polished gallery floors and wet, diamond-flecked Tribeca streets.

Fitzgerald said the true measure of genius is man's ability to understand two simultaneoulsy opposing ideas at once. I work on it. But you can't just muscle through. Machismo's a trap. You have to be patient, you have to wait.

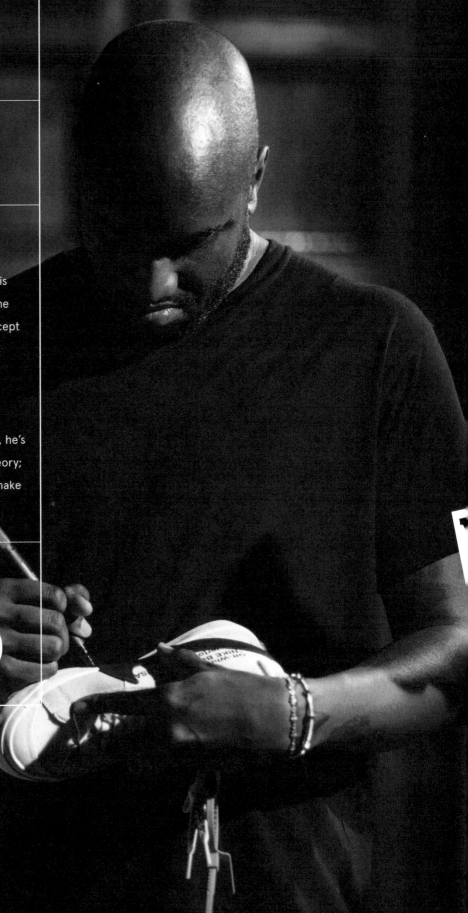

VIRGIL
ABLOH

NEW YORK,
NEW YORK

VITALS

Off-White mastermind,
Abloh, calls Tom Sachs his
idol. So, it's no surprise he
brings his own high-concept
thinking to sneakers.
For Abloh, an architect-
turned-designer, there's
humor and mythology to
consider. But, like Sachs, he's
never cold about the theory;
he knows it's his job to make
people feel.

CHAPTER

25

We can just jump right in because I have this crazy thought:

We're at a point where it's postmodern sneaker design.

We're past invention, primal use, iteration.

There's things to play with that are beyond the object itself.

When I approach sneaker design, my newest vantage point is looking at the sneaker as if it's an object, a sculpture; it's almost like an Oscar, you know?

It's like a tombstone.

It's a thing itself—but it also represents something else. You can play with all that and add to a sneaker's story.

My sneaker history started at a critical point in history. I was born in 1980, sixty minutes from Chicago. So it's the Jordan era, you know? Jordan was our basketball player. But in large part, Don C., Kanye West, they were key components of making Jordans transcend into what sneaker culture is now. I think that link between the real era and the era where those things became fashion items is largely due to the people I'm affiliated with.

I've assisted on a bunch of sneakers that I don't speak about—sort of the early work—because it was collaborative. I believe in the team effort. Those are Kanye projects; my projects, I speak about, but with his projects, he's got to be the one—it's his shoe. I think it's weird if someone else speaks about his design.

We can start with, say, the Jordan 1 I've been working on. I'll give you the confidential information, like super strict NDA. In large part I'm going to say that is, like, the first shoe that is my own that's out in the market.

It has the ideas of trying to make something provocative while preserving the history. Sort of unlocking something in the design. And when I say postmodern, that's how I view everything: it's like everything that I grew up with was modern, and now it's my turn to sort of add to the story.

That Jordan [I'm working on] is beyond design in so many ways. It's iconic. It's cemented. There's almost nothing you can do to get another emotion out of it other than cutting it. Doing something like that almost seems painful. But the only way to get something provocative out of that shoe, to me, was to use an X-Acto knife.

In doing that, there's more of a sculptural approach, more of an artisanal hand. It's a Jordan 1 in the Chicago colorway, but there's a whole bunch of hidden details within it that give it the feeling of the current moment: that the coolest sneakers you can have are actual, real Jordan 1s from '85 that are beat to shit.

It takes me ten, twenty minutes to figure out what's good for a shoe. I don't believe in overthinking. Actually, I believe in overthinking, but I believe in decision-making fast.

People forget that there's an air pocket in the Jordan 1. Maybe they don't forget, but it's not a visible air pocket. You don't always know that it's there, so that's where writing "air" in quotes comes from. Everything in quotes represents a lifetime of thinking for me and here, writing the word

OPPOSITE PAGE:

Virgil Abloh

"Everything in quotes represents a lifetime of thinking."

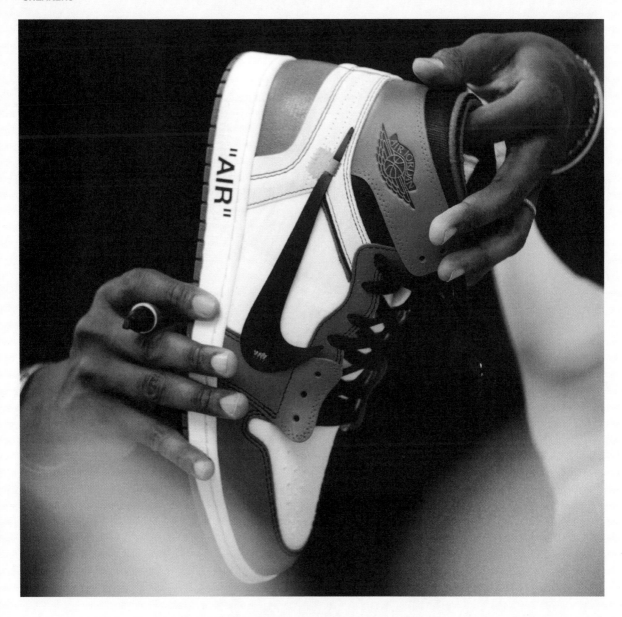

THIS PAGE:

OFF-WHITE x Air Jordan 1

"air" in quotes is humorous, you know? It's personality.

But I have to do it in a very specific way. I'm coming off the first wave of postmodern design, which is very jokey, very tongue in cheek, and I was looking for a more sophisticated, artful way to say the same thing, which is where the generic and sterile nature of Helvetica offsets that sort of messaging. But again, the humanity of the emotion—that's why this is not a colorway; it's not anything as obvious. We've seen that already.

My goal was to get to the same feeling as when I got my first pair of Jordans at Marshalls. Like, how you'd put it on your nightstand and fall asleep looking at the shoe.

RACHEL MUSCAT

BASED IN

PORTLAND, OREGON

VITALS

The adidas Originals Global Icon Director is the creative consigliere to the boldface names steering her brand's top shelf collabs. Pharrell, Kanye, Jeremy Scott—they all lean on her.

CHAPTER

26

I. Wings, Shackles, and Furry Uppers

Conversations with Jeremy Scott never start with him saying something like, "I want to make a whole series of sneakers with wings." It's more about like, what's he leaning toward? Or sometimes, it's a material that inspires him. Collaborations are really about being disruptive.

Whether it's a Yeezy or a Jacquard Stan Smith or a collaboration with Pharrell and Zaha Hadid, we really need to find a creative solution to make these products happen. I'm probably someone who is much more willing to push the boundaries. I'm always trying to find my way to "yes."

I think you can probably see that in my career, in terms of what partners I've worked with. To start with Jeremy Scott, and then to the end with Pharrell and Kanye, I'm definitely someone who thrives on bending the challenges of creation.

adidas began working with Jeremy Scott ten years ago. When we started, the meetings were over lunch or dinner at a Whole Foods in Portland. Then, all of the sudden, he got hired as the creative director at Moschino and the setting changed to these quite lavish offices in Milan. You know, it's a really special thing to work with artists and designers from those humble beginnings, to then see them get to that next level.

Jeremy Scott started working with the brand around the same time as Stella McCartney and Yohji Yamamoto. The first shoe we did with Jeremy was the Dollar Bill. It was a metro style sneaker. He supplied the materials he had them from a fashion show. Then we put wings on high-tops. He did camo. He did some shoes that had shackles around the ankles. But the Teddy Bear—I remember seeing the design for the Teddy Bear shoe for the first time and then all of a sudden having to work with teddy bear factories to produce a sneaker. That's not something that you normally do. We did a panda version and a gorilla version as well. It's good to have some fun with what we do, to not take it so seriously.

I have about three hundred pairs of sneakers. I have to say it would be hard to keep one pair of everything I've worked on. I'd need an apartment just for my sneakers. You have to be an adventurous spirit to rock the Jeremy Scott Teddy Bears. But what I love is that those shoes represent originality. What we forget sometimes is that we're not just catering to one consumer. You've got such a wide breadth of them. Everybody is into something different.

When I was looking at partners, from Jeremy Scott to Palace Skateboards, it was really looking at what they can offer in a unique way. I really believe that every collaboration I've worked on has allowed the next partnership to come to life.

Even as I talk to you about this I'm having this visual of A$AP Rocky wearing the Wings in one of his first video clips. Right afterwards Jeremy did a commemorative Wings shoe for him, with Jeremy and A$AP working together. Jeremy has a very good radar for what is coming and who the next industry muses are going to be. He's started relationships with Pharrell and Kanye. They're all very mindful of how important creativity is to us.

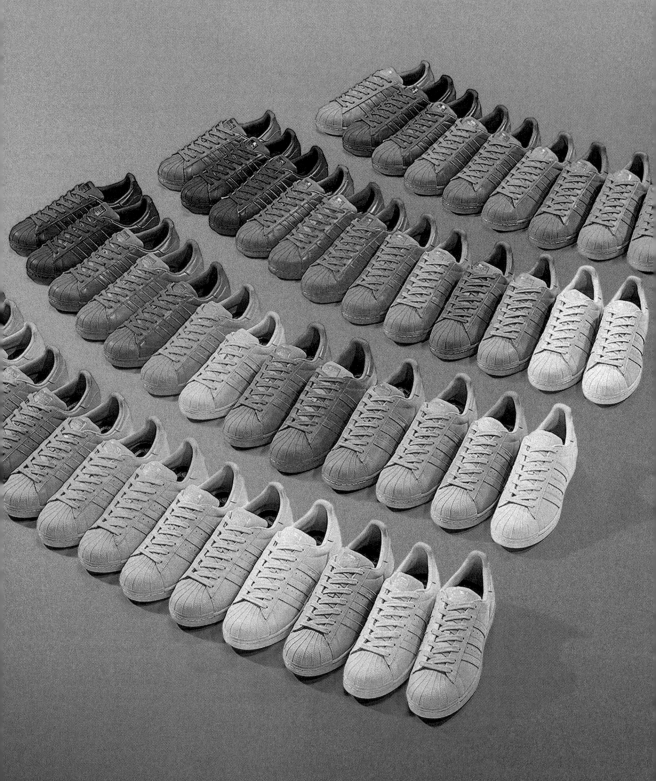

II. Producers Produce

Pharrell makes everybody in the room he's in more creative. He manages to somehow be very open to ideas, but also very specific about what he wants. We wanted him to do something with the Superstar. He liked the sneaker, but that obviously doesn't mean it's a natural fit for collaboration. When we have a partner working on one of our classic silhouettes we want to make sure there's a real connection. We never want it to be, "Here's your shoe, now sign your name here."

When I pitched him the Superstar he came back to us and said, "I want to do fifty colors." That is not a normal way of building a collection within the sneaker world. Usually it's like four or six colors. Supercolors was definitely something that I had to look at creatively, not just from the design side but also from the business side. Like how do you put fifty shoes in a stockroom in all of the foot sizes?

We had a three-month window to get those shoes sampled and signed off. So we had these suitcases of shoes that we presented to him before he went on stage for a show in Düsseldorf, Germany. His team built a natural color wheel because that's how he talked about choosing all of those colors. One of the most iconic pictures that we have as a brand is that image of Pharrell sitting in the middle of all of those colorful sneakers. It became our most Tweeted photo of the year. These are things you can't plan for.

Not long afterward we unveiled the Human Race NMDs. As they got created Pharrell started playing around with the idea of the human element, linking to equality and a message about the way he connects with different cultures around the world. We're on this journey with him to bring that to life.

OPPOSITE PAGE:

Pharrell x adidas Originals
Superstar Supercolor Pack

III. Yeezus of Herzogenaurach

Kanye: I think he's always been a fashion designer and a shoe designer, to be honest. The question for us is how do you allow him to use the resources that we have? He's pushed us to try new things. He's challenged our processes. His own dedication to the creative process is what is most inspiring. At the beginning of his relationship with adidas, he came to Germany for a week to attend our big marketing meetings. He took the stage and talked to the audience really about being an equal, about wanting to get his hands dirty and do the work. Straight after that meeting we went back to the office and continued to work on Yeezy until four in the morning every night for about eight days. He was the first one to get in the office at eight a.m. That maybe isn't as visible to everybody. But he is that dedicated to really making this come to life. I'm actually transitioning to working on the Kanye project full-time. Game on. I'll say he's a genius.

I love what I do because of the people I work with. I think there's something to that. You always get the younger generations asking, "How do I make a decision about my future?" You just have to enjoy what you're doing, and I believe then the rest comes. That's really something I've followed in myself. What is it in me that's making me want to do this? What's making me want to get up every day?

People like Jeremy, Kanye, Pharrell—they don't stop, they don't observe the weekend. Saturday and Sunday are workdays. They go really hard, but the reward is special. I was messaging with Jeremy Scott last night about his fashion show, and it was like nine o'clock here on the east coast and he was in Milan, which meant he should have been asleep, you know?

JOHN C. JAY

BASED IN

TOKYO, JAPAN, & PORTLAND, OREGON

VITALS

As Wieden + Kennedy's longtime Global Executive Creative Director and Partner, Jay developed worldwide street-cred with the creative set; when Nike broadened its gaze from athletics to art, music, and the culture surrounding sport, Jay provided the introductions.

CHAPTER

27

I. If I Can Make It There, I'll Make It Anywhere ... Except Maybe Portland.

You have to understand: I was a die-hard New Yorker. I mean, I grew up in Columbus, Ohio. So I'll never forget the day I made up my mind that I was leaving New York. It was 1993. I was at the CFDA luncheon. Back then it wasn't the mega event that it is now. I thought about my decision all morning. The luncheon was over. I opened the doors to leave the event and standing there were my two dear friends, Jimmy Moffat and Steven Meisel. I said, "You're not going to believe this but I'm leaving New York." They go, "Where?" I couldn't bring up the guts to say it. I just told them, "Oh, West Coast." And they said, "Oh, in LA?"

"Well, not exactly," I said. "Portland, Oregon." Their faces just fell. At the time they didn't know what Wieden was.

I had been the creative director and marketing director for Bloomingdale's for a dozen years. It was a heyday, when Bloomingdale's was really a cultural force in New York. I was shooting campaigns all over the world with legendary photographers like Herb Ritts. I was looking for an opportunity to contribute to culture, of course. More selfishly, I wanted a challenge. I wanted to up my game. At night I'd turn on the TV and see these . . . these things.

TV things—TV spots. They just absolutely didn't look like commercials, they just didn't look like TV, they didn't look like advertisements. They were extraordinary statements about culture—Spike and Mike; Revolution. That's what made me interested in Wieden + Kennedy.

Those Spike and Mike commercials are a touch point in history. Here you had a company that was just growing, up in the Northwest, who had hired an African American as a spokesperson in Michael Jordan. Then you had Spike Lee at the time making his first film, and it was unapologetically about blackness, it wasn't afraid to talk about issues of race. Then you have creative people at Wieden putting the two things together. It was not about just selling something—it was about this moment, and a moment in basketball, a moment in race, a moment in politics, a moment in American history, a moment in sports, and certainly a moment in shoes. Everything came together and that was what made it so powerful. It was unlike anything else on television.

OPPOSITE PAGE:

John C. Jay in his Portland, Oregon, studio

II. Pee Wee and the Destroyer

I never interviewed with Dan Wieden. I never even went to Portland to check things out. I had no agency experience. I arrived on Monday and on Thursday, Dan Wieden gets a call from somebody. "My son tells me that we're losing relevance on the streets of New York. Do you have any solutions, any ideas?" And Dan says, "Well my friend John just joined us from there. Let me talk to him and we'll get back to you."

When I was at Bloomingdale's we used to take "inspiration trips." All creative people must do their networking so that they don't depend on strategic planners or research people. You have to go up there and earn trust. The first thing I did for the brand was to help them earn trust on the streets so that we could talk honestly to people in different subcultures all over New York City, in every borough.

That was our introduction to Bobbito Garcia. We met Bobbito through a freelance director that we used on the project; he and Bobbito were friends. That was one of the first interviews that I had my team do. After that we started talking with great street ballers, legendary people like Pee Wee Kirkland, Joe "the Destroyer" Hammond, and Albert King. Albert is Bernard King's brother. Things took off from there.

We created a campaign called NYC; it was a salute to New York City. The idea was to have outdoor billboards that were in only certain boroughs and TV spots that played in only New York City. We had footage with Bobbito doing the voice-over. At the time we had a competitor making a lot of noise culturally on the streets with their shell toes, and a lot of people were talking about sneakers, and a lot of people were talking about collecting. But they were either music guys or fashion guys or whatever.

Bobbito played ball. That was the important thing. I'll never forget when I was presenting his video to Nike, the top marketing guy elbows me to give me a hint at the presentation: Don't forget to talk about his ball. He is a legendary street baller, not some marketing dude. Yeah, he's a DJ, he's a hip-hop historian, but the fact that he played ball—that was what was important. The whole video may have been somewhat about shoes, but it was more about basketball. Because our NYC campaign was not about sneakers at all, there was hardly any product in it, it was all about what makes New York City ball unique.

Years later, toward the end of the NYC campaign, we were shooting a commercial called "East Versus West." This was at the height of the hip-hop wars of Tupac and Biggie. Ultimately those two deaths forced us to shut down the campaign because we didn't want to look like we were trying to do marketing off of a tragedy. But as we were making the commercial, we were interviewing legendary ball players—both street and professional. And Bernard King was there.

He was in makeup downstairs and he brought one of his friends from the neighborhood. I was just chatting with his friend. And he said to me, "Oh man, Bernard is so hyped today." And I said, "Oh, you mean because finally after his whole career, he's doing a Nike commercial?" And the guy just kind of pulls back and looks at me like strangely, and he goes, "No, that's not why he's excited. You know who's downstairs with him? Joe 'the Destroyer' Hammond is here." Sure enough, Bernard King was high as a kite because he was able to be in the room with Joe Hammond. Those are the kinds of stories we wanted to tell in the neighborhoods all over New York to show our respect for the culture of the game, the neighborhood, and the legends.

III. Turning Japanese

One of the core skills of Japanese culture is to objectify anything. They can look at something and take it out of context, objectify the object, and they can make that object and improve it. Japanese culture will challenge what is original because they will take something and make it better.

I left Portland to open up Wieden + Kennedy Tokyo just as the pop culture in that city was becoming an enormous world influence. The scene in Harajuku was so powerful and so influential at that time. On any Saturday you walked down the street there would be people from Amsterdam and Paris and London and Brooklyn, just all together. Tokyo became the

epicenter for all of these people to hang out. Mark Parker was coming to Tokyo a lot on his own for creative inspiration. He'd just hang out and get to know a lot of different creative people. One of the people I introduced Mark Parker to is Hiroshi Fujiwara.

Hiroshi is the ultimate culture sponge. In the '80s he won a trip to London. When he got there he fell in with the whole post-punk movement and became friends with Malcolm McLaren, Vivienne Westwood, and Boy George. He followed his friends from London to New York, and '90s hip-hop was just burgeoning at that time. So he brought all those influences, ideas, albums, and information back to Japan. Hiroshi became one of the primary cultural influencers in Harajuku. When I asked him, "Could that phenomenon happen again today?" he said, "No way. What happened to me, what I did, cannot be replaced because the internet tells you anything within ten seconds." Whatever is blowing up in Madrid, if it's really interesting, it will be shown in Tokyo or New York within minutes. Being the cultural carrier pigeon is a much more difficult thing for any one person. I introduced him to Mark Parker. And since then he's been behind some of Nike's most remarkable collaborations.

Have you seen the Air Force 1 we designed together? I wanted to celebrate opening the Wieden office, so I had make sure that these shoes were Tokyo. On the back of the shoe in Kanji, Tokyo was made up as two letter forms, so left and right together, when you put the heels together it says Tokyo. And then Hiroshi wanted to make it all white, and it was his idea to do it in the pony skin. Rarest of the rare.

IV. Connector-in-Chief

I introduced Kanye to Mark Parker. I met him at Art Basel and we flew back to New York together on the Nike jet. He had a bag of sketches and scripts and designs. I found him to be charming, very smart, open, and generous. He'd been thinking about style and design for a long time. And I was just in Shanghai supporting Kaws's launch at the Yuz Museum and an old friend from Nike reminded me that I'd brought the company KAWS, too, and Tom Sachs.

The fact sneaker culture expanded into other subcultures like skate makes sense. It was bound to happen as hip-hop became the most powerful force in suburban America. Hip-hop isn't just a music form, but an art form and a dance form. It made sense that you would see graffiti culture on a shoe.

Think about Tom Sachs, who did the Mars Yard, a very special, very elevated, very interesting collaboration with Nike. That shoe was interesting because he's not on the street, he's not a graffiti artist, he's not from urban, he's not from streetwear. He is highly respected in museums and galleries, and to do a collaboration with a sports company, with a sneaker company, was big risk. I think it was one of the most interesting collaborations in recent years.

But I think there's too much hype on this collecting thing, and too many nonsense collaborations. That's all the commerce part of it, you know? Which is fine and dandy, but the further away we get from the origins of people like Bobbito, the less and less the truth is understood and the less cultural information is transmitted.

THIS PAGE:

KAWS/Original Fake x Nike
Air Max 90

OPPOSITE PAGE:

John C. Jay in his studio

Hiroshi/Tinker/Mark Logo

RONNIE FIEG

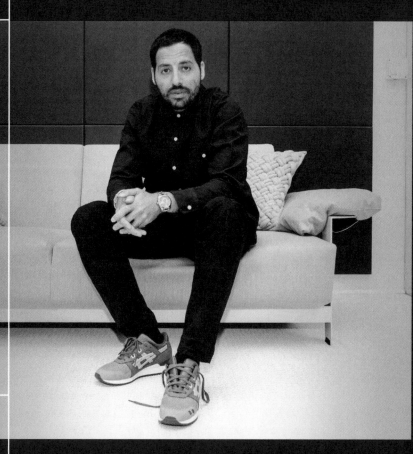

BASED IN

NEW YORK, NEW YORK

VITALS

Like Jay and Muscat, Fieg is master at reaching outside of his brand to strengthen it. As a store owner and designer, his uncanny ability to collaborate, broadly, stylishly, and with perfect timing, has made Kith an unstoppable force.

CHAPTER

28

KITH

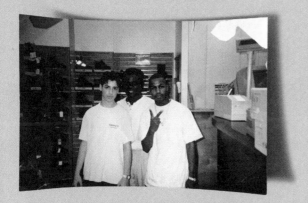

Started in the Stockroom, Now I'm Here

It started for me when I was in fourth grade. I went to public school in Queens. I had a few friends growing up that always had the freshest pairs of sneakers. My friend Joey Gardano, his father, may he rest in peace, took Joey shopping once a year. I always tagged along. Joey's father had money and used to always bless me with whatever pair he was buying Joey. Joey had parents who spent money on those sort of things. I didn't.

I had to go out and work to get it. When I was thirteen years old, in 1995, I got a job in the stockroom of a chain of shoe stores called David Z. My mom's cousin owned the place. I worked my way up the chain: stock to sales, to assistant management, to management, to part-time buyer/management, and then, eventually, to full-time buyer, and finally to general buyer/general manager for the entire brand. By the time I was thirteen, I knew I was going to work in footwear for the rest of my life.

Here's a funny story about my Bar Mitzvah. My father bought me the Air More Uptempos as a late gift in 1996. It was the first shoe my parents ever bought me that was over $100. That was a big deal. He bought them in the Colosseum in Jamaica, Queens, but they didn't fit, so he had to go back and argue with the guy to exchange them because I'd worn them a couple times. My whole family was involved. When my sister got her first credit card, the first purchase she ever made was for me—a pair of Flight 95s, the Jason Kidd's.

I've collected my entire life, but I haven't met anybody else who collects like I do. I didn't even start by collecting sneakers. I collected boots: Dolomites. Remembers Dolomites? My AOL IM name was DoloKing. Then I started collecting Wallabees. And then sneakers. I first pair I ever bought with my own money was the Air Max 95.

The David Z store was on 8th Street between 5th and 6th Avenues. The epicenter of culture was on that block: Village Cobbler, Gray's Papaya, a store that used to sell Parasucos, one that sold Iceberg. I would spend my entire check on that block. Nostalgia is important. Every time I wear a pair of Wallabees, I think about what I had to do to have them back then. Every time I open a pair of Air Force 1 white-on-whites there's memories. Timberland construction boots, there's feelings.

It's kind of crazy to be going to school and working forty hours a week. By sixteen, I was working full-time. I remember seeing Biggie in the store, buying Wallabees and wheat construction boots. Jay-Z used to shop with me. He'd buy a pair of construction boots every Saturday and then leave his old pair and sign them for me. I used to sell them in school, which was pretty cool. Anytime I hear "Ready to Die" or "Reasonable Doubt," I'm right back in that era.

THIS PAGE:
Young Ronnie and
rapper AZ at David Z
Air More Uptempo
OPPOSITE PAGE:
Ronnie Fieg

"Everybody knew Ronnie since he was a kid. We all support him now because of it. I used to buy Timbs from him—he was like fourteen years old, going down into the basement of David Z. I really take my hat off to Ronnie. He's done the impossible." —Jon Buscemi

I dreamed about making sneakers since I was kid, too, but one thing about me is I don't sketch. I don't draw. But I do know how to build a shoe from scratch. I've learned by going to multiple factories. In 2006, I got to do my first collaboration with ASICS. I always liked the underdog brands and nobody was really doing work with them. I identified with doing something under the radar because that kind of individuality is one of the keys for me. We worked on three shoes called the 252 Pack and they ended up on the cover of the Pursuits section of *The Wall Street Journal* and that was like getting my foot in the door. All my other collaborations stemmed from that.

I guess these brands see my passion for footwear. I guess the competitiveness of brands is off the table when they work with me because they know I'm not trying to piss off any one brand by working with another. It's more for the love of the game.

2016 was the most important year in Kith's history and my career. It was our five-year anniversary, and I wanted it to feel like a celebration. So we lined up a lot of major partnerships to create moments that were impactful on both the consumer and the industry as a whole.

Our biggest moment last year was most likely Kithland, our debut fashion show. I'm not sure if it's fair to call it a "fashion show" as it strayed left from what a conventional show is. We showed ninety different looks, we covered two full seasons, we had four different live musical performances. It's not what people were expecting, but that was also the goal.

After Kithland, I could feel a shift in the energy around us, and I could tell that people were beginning to understand the trajectory of the brand. It was one of the greatest moments of my career, and I'm excited to outdo it this year with our second show.

On a collaboration side, I'd say Kith Aspen was another pivotal moment for us. On the product side, it was amazing to bring all of these iconic brands together under one roof to create next-level product through a unified vision. Getting to see adidas, Columbia, New Era, Timberland, Samsung, Kapital, and others all mesh together so well was something special. This unified narrative evolved into something even bigger, as we flew out my friends and family to

Aspen where we test drove all of the product in the environment it was designed for.

Again, bringing together all these different names and backgrounds to really bond in one place was very significant. It was special. These are the moments and experiences that will define Kith, and we will continue to push these boundaries in the future.

As for right now, I'm excited to begin the next phase of life with my wife. We were just married in July. I couldn't be happier.

Q&A

1. Where do you keep your collection?

Nobody knows really where my
collection is. It's spread out
in a bunch of different storage
facilities.

2. How many states are we talking about?

I can't really give you that info.

3. How many pairs do you keep at home?

I would say around three hundred.

4. What's on your feet now?

White and silver Spiridons.
I wore the OGs yesterday.

THIS PAGE:

Jay-Z photographed by
Ronnie Fieg at David Z

OPPOSITE PAGE:

Ronnie Fieg x ASICS
GEL-Lyte V "Cove"

ERIK FAGERLIND

BASED IN

STOCKHOLM, SWEDEN

VITALS

Fagerlind and his partner, Peter Jansson, turned a quiet corner of Stockholm into Scandinavia's sneaker Mecca. Their collaborations have global reach and their stores are now open in five countries.

CHAPTER

29

SNEAKERSNSTUFF

I. Air Is Oxygen

THIS PAGE:

Erik Fagerlind and Peter Jansson

Puma SNS Basket Hemp

New Balance 577 x Sneakersnstuff 'Erik' "Round 1"

OPPOSITE PAGE:

Sneakersnstuff storefront

When I was in fifth grade, '88, '89, all I knew was I needed a pair of Nike Air. Living in Sweden, I didn't really understand the difference between, like, Nike Air basketball and Nike Air running. So, after I nagged her for a long time, my mom got me a pair of Nike Pegasus. I was so happy.

Jordan V was the big thing when sneakers started to really matter to me, but they were so expensive here that I couldn't afford them. On the way to visiting relatives in Australia, though, we had a layover in Singapore, where you could buy the Jordans for like a third of our price.

So I nagged and nagged and eventually my mom caved. This was the same year the Kuwait War broke out. Normally, the flight would pass straight over Kuwait, but it had to be rerouted and we got super delayed. I was so scared somebody would break into my bag and steal the new Jordans, so I ended up packing one shoe in the suitcase and one in my carry-on. I figured nobody would steal one shoe.

Of course, our bags got lost and it took another ten heartbreaking days before we actually got confirmation that our bags were coming. So I got home with just one shoe. I remember bringing it to basketball practice. I had a picture of me with my one shoe, like, look what I've got.

II. Pay Day

We decided to open in 1998 and we opened in 1999. Me and Peter [Jansson] met working at a sporting goods store, because that's where you could buy sneakers in Sweden in the '90s. We went to New York together in '96 or '97 for two weeks without really having that much connection outside of sneakers. We called it our sneaker safari; we wanted to go to pick up shoes that we knew didn't exist here in Europe. Friends caught on to that, and started to ask, like, "Hey, can you bring me a pair of shoes?"

At that time there weren't many pure sneaker stores, even in the States. It was a lot of mom-and-pop shops. There were a lot of Foot Lockers, obviously. But we went to Fulton Street; we went to 125th Street. We stayed at a YMCA with shared bathrooms. It was terrible. No windows. Doors that wouldn't close.

We decided to open the store, actually, on one of our flights to New York. Those trips were how we built up our stock to open. Once we opened, we had lists where people could request styles, and we had SneakerDetectives@Sneakersnstuff.com, an email address where people connected with us, looking for specific shoes. People would email us from all over the world asking for stuff. From Japan and the U.S. and Hong Kong, but not many Europeans at all.

We couldn't afford proper rent in a retail area, so we opened in a more residential area of Stockholm. We wanted to spotlight our shoes in our window, a red Air Force 1 mid, but we couldn't afford a spotlight, so we

rigged one with a regular lamp and a cardboard box. By coincidence, a restaurant and bar opened near us and a lot of media went there. "We want to tell your story," they said. "You are sneakerheads and you're opening up a store in the middle of nowhere." A lot of people read that story. People were waiting for us to open.

Early on, we knew we needed to open the weekend after people got paid in March, even though the store was just about done in January. In Sweden, people get paid on the twenty-fifth of every month, so the weekend after that is a big thing. People get loose, get drunk, and spend money. The other thing we thought about: in January, February, and most of March, the weather is shit. Not sneaker weather. So we figured the last weekend in March is the first date available for normal people to buy shoes. The date we set was March 26.

We opened, and we had a great day, we had a great weekend; it became a great month, and I think we sold more within the first two months than we projected to do the first year.

III. Lucky Number 136

The first shoe we collaborated on was around 2003: the Puma Basket Hemp, painted with gold because we had gold in our logo at the time. We did 136 pairs and they were all individually numbered. 136 was our street address. It was a big deal.

But it turned out that Puma produced more. We went to the trade shows in Las Vegas and there was a guy who had our shoes in the showroom and at the hotel. He was like, "Yeah, you should come by our room." And we see our shoe, like forty pairs, but unnumbered. We asked this guy, like, hey, where did you get these? And we thought we could dig deeper, and it turns out that Puma produced like 100 or 150 more pairs unnumbered that they sold through different channels. You could do that then because the internet was still very young. You could get away with that as a brand.

We called them on that, and that led to another collaboration, a more proper collaboration with Puma, this time in reindeer leather, which was very unique to us.

IV. Much a Shoe About Nothing

We've tried to tell a story with every collaboration. Obviously the first ones we did meant a lot personally. Going to the New Balance factory in Flimby, England, and looking at it, and getting materials put in front of you, saying, how do you want this shoe to be put together? That was a moment in time you cherish.

The first shoes that we did with New Balance was a 577 in yellow, white, and blue, which to me was a little bit of an internal joke. Because the Swedish flag is blue and yellow, but so is the flag of the Canary Islands. And my father-in-law is from the Canary Islands so it was a

tribute to him, which is an untold story, to be honest.

After that we had a session in 2013 with Reebok where we did twelve shoes in one year, and each shoes had a unique story. For one shoe, which was a burgundy and aqua Reebok Question, the unique story was that there was no unique story; we called it the Shoe About Nothing.

I think the most complex of the Reebok stories was the Shaqnosis one. The shoe did terrible; nobody even went to buy it, but the story was awesome because we did a tribute to Shaq and colored his shoe in the colors of all the teams that he played for, which is like six teams. Lakers, Orlando, Boston, whatever, they're all there. It became, like, a rainbow-looking shoe. Everybody in America thought the shoe looked like a gay pride clown shoe. We made something like 1,400 pairs.

We wanted Shaquille to be involved with this, and Reebok came back to us and said, sure, he'll do it for $50,000. And obviously we didn't really have $50,000 as a budget to get Shaquille. So we made a play where we said, we're producing that shoe in his size, and then we will make the story of us going looking for Shaq, trying to give him this pair of shoes. If we find Shaq, that's awesome; if we don't find Shaq, that's awesome too. And that's the story. So we started this storytelling through Twitter.

We went looking for Shaq; searching for Shaq was the whole thing. And it got to a point where we got a lot of recognition in the U.S. One time I was coming into the U.S.,

SO

DID YOU

FIND

SHAQ

YET?

and border patrol there is always intimidating. The guy starts asking me questions about what I do, and I tell him I have a sneaker store in Stockholm. If he doesn't believe me, I have the shoe with me, a size 23 or something. The shoes were always with me. I didn't want to end up with just one like I did with the Jordan in Singapore. Anyway, I tell him I own a sneaker store in Sweden and he looks at me and says, "So, did you find Shaq yet?" We finally caught up with him in Atlanta. He was very polite and said he'd wear the shoes on All-Star weekend, but he never did. I don't think he loved them.

V. Hey, Baby, What's Your Number?

It's a bit unusual, but we've always been transparent about the numbers of our limited releases. There is the risk that you throw out a number and people don't really understand—a thousand pairs might seem like a lot to some people, but a thousand pairs in terms of production is nothing. To get a brand to produce a thousand pairs, that's way below their minimums on production. I like to think we've always been willing to share the numbers because it's not us against the consumers; it's us with the consumers. We are consumers, we love sneakers, and we love the people who love sneakers. For us it's natural to talk about numbers.

VI. Pippi Longstocking's Lawyer Is a Total Mofo

We did a Reebok Pump Fury and called it Legal Issues. It's inspired by Pippi Longstocking, you know, the Swedish children's book character? The author is Astrid Lindgren.

So, the publishing house that holds the rights for Pippi Longstocking is extremely protective, and they file lawsuits wherever. So once the shoe was done, we looked at it like, yeah, this is cool, this is a cool-looking shoe, this will do extremely well in Asia. But we can't really say it's a Pippi Longstocking shoe. And then we just figured, all right, let's just say that we have something but legally we are advised not to say what it is. We'd just let people guess.

VII. Fake It Till You Make It

We almost went out of business in 2004, and it took three to four years after to clean up financially. But I think we always wanted to expand, and by 2011, it was finally like, okay, where else should we build stores? We knew our model would work best in big cities and Scandinavia has no big cities, so we thought, New York, LA, Tokyo, London, Berlin.

We settled on London and opened in 2014. Paris opened in 2015. Berlin, 2016. New York in fall 2017.

We've been fortunate to do this for almost twenty years now. We started out when I was twenty-two. I didn't know anything about building a company; I didn't know anything about financials. I loved sneakers, and we bought shoes; we sold them for twice the price. Then we bought double the shoes, and we sold those for twice the price. And that's how it kept going for a long time.

But there have been periods over the twenty years where I had to learn things in order to keep going. I mentioned the financial meltdown that we had; it was the greatest learning experience. We owed Nike and adidas so much money, and they still delivered to us. Up until then we didn't really do numbers. We didn't really look. We had no idea what we were doing, to be honest. But brands were extremely supportive, I think because we helped their credibility in the region. I remember being in trouble and Reebok coming to us and saying, "Guys, we need you to stay alive."

TODD KRINSKY

BASED IN

BOSTON, MASSACHUSETTS

VITALS

Fagerlind has journeyed for Reebok, but nobody's Reebok journey has been more profound than Krinsky's—from the mailroom to the Vice Presidency.

CHAPTER

30

I. Pumping Up

When I started selling shoes at Foot Locker as a kid in 1987, there was no such thing as sneaker culture. Now it's all affluent suburban kids. Then it was the drug dealers, the rappers, the wealthiest guys on the block who had all of the access. If I got twelve pair of Pumps or twelve pair of Jordans, it was the same twelve cats that were always telling me to put them on hold. Sneakers became one of the levers that you used to show that you were making it. Whether it was jewelry, sneakers, a fresh adidas tracksuit—it was all a statement of the fact that you could afford it.

I kept my job at Foot Locker when I moved to New York City to go to college. After spending four years in New York studying film and television at Ithaca College, I moved back home to Boston. I was working on a few scripts and was sure the move would be only temporary. This was the early '90s. It was a tough job market. To make ends meet while my career ambitions sorted themselves out, I was still clocking in at Foot Locker.

One day in 1993 I just decided I really wanted to work at Reebok. I just really passionate about the brand. They were doing this temp pool thing, looking for admin people. I took a typing test and completely failed it. So I went up to the building and did an interview. The HR person said to me, "You can't work here; you can't type." And I responded with this Jerry Maguire speech about why I had to work at Reebok. The HR lady was like, "All right, we'll give you a call." I drove away thinking I'd never hear from them again.

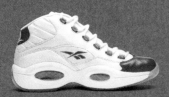

Two weeks later I was still at Foot Locker when Reebok called to offer a job packing up T-shirts for the Super Bowl and delivering mail. When I got there, I hustled—met everyone I could, learned everything I could. Every single day when I delivered mail to people's desks, I would introduce myself. I met a lot of people playing hoops during my lunch break. One day on the basketball court, one of the really senior guys asked who I was and what I was doing. Then he gave me one piece of advice. He said, "In this industry, product is king."

It took about a year, but I escaped the mailroom with a promotion to associate of product development. I worked under all of these old-school engineers. Back then we didn't have the capability to email our tech packages—that's all of the detailed drawings and dimensions of shoes—so every day I'd sit at the fax machine with literally 450 pieces of paper and send blueprints and designs to the factories. Every time I'd find a blueprint, I'd go ask one of engineers about it. I learned everything about how sneakers get made.

II. The Answer Gets a Question

We started working on the Question, Allen Iverson's signature shoe, long before we'd even signed him. It was '95 or '96 and he was still at Georgetown. I collaborated on the project with two other guys. We did a lot of work at this one guy's house in Quincy. There was a little room off the

kitchen, and we built a shrine to Allen in there. This is back in the day before Google, so believe me, it was hard to get all of that information on a second-year guy from Georgetown. We had someone go down to D.C. to get Georgetown programs so we could clip pictures of Allen for the shrine. We pulled whatever articles we could find; there were VCR tapes with game footage and highlights. This was all in an effort to bring Allen to life for our designer at his house. His wife was unimpressed.

Our little team wanted Allen bad. We got in the boardroom one day, and the chairman at the time was like, "Listen, Iverson may go to Nike, he may not come to us. There will be another Allen Iverson." And that's when me and Que Gaskins stood up and said, "No, there won't be another Iverson." I was twenty-five at the time. I didn't even know what I was doing in the boardroom, but they all looked down the table at me all at the same time like it was a TV commercial, and they were like, "A, who are you? B, what do you mean?" And I was like, "None of you guys know me, but I can tell you right now that there won't be another Allen Iverson. Not in five years, not in ten years. This is the guy for our industry." And they listened. We anted up the money, and we did the deal. And then when we finally went down to D.C. to meet Iverson at David Falk's office, we actually had a prototype. We presented it to him and he lost his mind.

Along the way we had this one idea that every single year he was going to wear the Question for the All-Star Game. We decided that the colorway that he would wear in the All-Star Game would honor the city that was hosting the All-Star Game. In 2000, the All-Star Game was at Golden State and it was Allen's first. We made a yellow shoe with a blue toe. And I went to his house and I was like, "Yo, are you good with this?"

And he was like, "Yeah."

And I was like, "It's a little bright."

And he was like, "No, I'll wear it."

We had 15,000 of them made. Every retailer in the world ordered it. And then I saw him the day before the game at the shoot around and he wasn't wearing it.

I was like, "Yo, people all over the world are buying this shoe. Why aren't you wearing it?"

He said, "The guys are giving me a hard time. I'll wear it tomorrow."

I didn't sleep at all that night. The next morning, I get up and I go to the arena a couple of hours before the game, and he's still not wearing it. He's at the shoot around and he's wearing his other shoe, his black Answer. I thought I was going to get fired. I was in charge of the shoe; I was in charge of the brand's relationship with the guy.

I go in the locker room. I'm begging him—*begging him*, and he won't change. Kobe and all of these guys were giving him a hard time for wearing a yellow shoe. I go and I get his mom, who I was close with. I go, "Anne, you've got to talk to your son." This is how desperate I was. I was like, "You've got to talk to your son. You've got to get Allen to wear this shoe."

THIS PAGE:

Reebok Answer 1 DMX 10

She tried, but he wouldn't wear it. I had like seventy-five voice mails at the office when I returned—all of the retailers wanted to cancel their order.

We just rereleased it this year, and we called it the Unworn. That was the gift and the curse with Allen. He always did whatever he wanted, and I think in the end it caused some headaches, but it worked because his irreverence is what everyone loves.

III. How To Survive An Arms Race

The sneaker wars were very, very alive when I started. The competition between Nike and Reebok was fierce for a period of time. A lot of consumers were loyal to Nike or Reebok.

They signed an athlete, we signed an athlete. We launched a shoe, they launched a shoe. When we unveiled new tech, so did they. It was a great time to be a sneaker consumer. There was just so much newness, so much innovation. There were so many great personalities in the '90s NBA; it was one of the golden eras of the sport.

Anytime you're in an arms race, spending a lot of money over an extended period of time, you've got to assess the ROI. I think we had spent a lot of money; I think we were certainly tired of the arms race; I think we weren't sure we really wanted to compete and spend and spend and spend.

In 2002 Paul Fireman, Reebok's chairman at the time, said to me, "We've got to do something different; we've got to get more relevant." When we got to the early 2000s, we felt like we needed a new move. Culture was changing. Music was becoming more influential to youth, and not just music as an art form but the style around music. Hip-hop pushed culture. We saw fashion really coming more from streetwear. We felt like we could capitalize on that shift—still stay grounded in sports but have a musical influence. So we came up with RBK, which was about the intersection between music and sports. We figured if Allen Iverson can sell a sneaker, why can't Jay-Z? He's moving culture more than Penny.

The first musician we signed was Jay-Z. Then we inked 50 Cent and Pharrell. Allen was heavily involved. He was the first real athlete to have one foot in hip-hop culture and one foot in basketball. That made us feel more comfortable about this positioning of music and basketball, and sports and music. RBK became a very, very popular thing in the industry.

We put Jadakiss and A.I. in an "Answer It" campaign, with Jada rapping about the shoes over a beat that sounded like a basketball bouncing. We had Jamal Crawford and Kenyon Martin wearing the S. Carter basketball line.

We had an RBK store on South Street in Philly in 2003. I rode in the car, on the way to the S. Carter launch with Jay. As influential as he was, I remember him saying, "I wonder if this is going to work." We pulled up at the launch and it was total pandemonium.

I looked at Jay and I was like, "Yeah, I think this is going to work."

THIS PAGE:

Reebok S. Carter

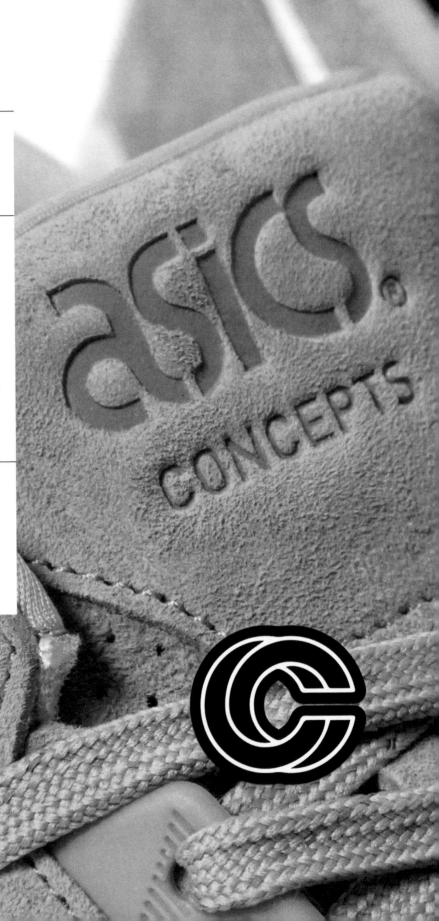

DEON
POINT

BASED IN

CAMBRIDGE,
MASSACHUSETTS

VITALS

Another blue collar
Bostonian swaps the daily
grind for lifelong passion.
As the Creative Director of
Concepts, Point is an ace
storyteller, finding inspiration
for collabs from Dubai to
Dade County.

CHAPTER

31

I. Security Measures

I was a foreman in the Laborers' Union in Boston for about six years. I was a Nikehead for sure but rocked Gucci heavy. I copped everything. I didn't want any of my people flyer than me. Green Monster 95s—that's my grail. I almost copped at Flight Club a few years back but they wouldn't have been wearable.

Back around 2000 I just got sick of missing out on kicks. This was pre-internet so if I was out of town or not around they would stockpile drops for when I came back. But if a celebrity or someone above my mediocre caliber was looking for something in particular, my pile got jacked. So I said, "Let's work over here [at Concepts] on Saturdays for free." I didn't need the money. I just wanted to be able to buy all of my kicks.

Concepts had always been a hidden gem, but back then there wasn't much going on with the brand. You had to be in the know, and once you found it you kept it to yourself. Concepts had a clothing line in the '90s that was focused around skate and sports. It was ahead of its time.

In 2005, Tarek Hassan—the owner at Concepts—asked me to come take over when Spongie left to start Laced. The offer was a fraction of what I was making. I went home and mulled it over for a couple days. I looked at it from the angle that I could create something. Everyone told me I was tripping but now and then you have to take a leap of faith. Now I handle the creative direction of Concepts. I work on all the shoes as well as oversee any aspect of the brand. I try to be everywhere at once, which I've come to realize is not possible, but I still try.

II. Home Game, Away Game

My job involves a fair amount of travel—buying trips. Honestly, I use those trips to inspire me more so than anything else. When I was younger I was moving fast, so now I try to appreciate my surroundings. Try to become fully immersed in the story behind the shoes. My first trip to Italy inspired the Holy Grail pack. So for me it's absorbing the culture and communicating it through my lens. For instance, when we took over Art Basel to launch the Coca ASICS, we wanted to bring the inspiration to life in a way where the consumer would become fully immersed in the story behind the shoe.

The ASICS Eight Ball we did [in early 2015] was based on the cocaine epidemic that ramped up through the '80s. Cocaine was still being considered a luxury drug. A man from Massachusetts who was affiliated with the Medellin Cartel had brought in over 85 percent of the cocaine to the U.S. We wanted to dive more in-depth. The Coca [at the end of 2015] was based on the coca plant, which is obviously an integral part of the process in making cocaine. The richness of the green was already eye-catching, so I wanted that to be dominant. It wasn't enough though, so we added cream on the stabilizer to offset the gum but also to resemble the coca plant in the paste phase. The white on the medial side is encased in clear

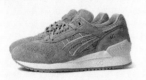

BOTH PAGES:

Concepts x ASICS
GEL-Respector Coca

plastic to resemble the final stage of kilos before distribution.

To distribute the shoe, we rented a mansion—actually, the largest single-family residence in South Beach. We then built the inside out to tell the story from start to finish. We picked customers up at a location undisclosed until the day prior, in thirty-minute intervals. They boarded the bus and were instructed to put on blindfolds and then driven to the mansion. We gave them strict instructions of what was allowed and forbidden throughout the tour prior to being shown the shoes.

Once the blindfolds were removed, they were met with a red corridor filled with trees and a man with a German shepherd barking nonstop. This was to take over their hearing while their vision was just getting reacclimated. From there, they passed through a customs room where they were to empty their pockets and receive the white laces that were added to the shoe later. Then into a giant airplane hangar where a helicopter was taking off with deafening sound.

On the other side of the curtain the noise lessened to allow for '80s-themed instrumentals—think Grand Theft Auto Vice City—while models in bikinis lay upon exotic cars, posing for pictures. From there a few more rooms, including a nightclub, dining room, and finally outside to waterfalls without a roof so the light took over your senses after being in the dark. I've been told it was the best pop-up ever.

THIS PAGE:

Concepts x Nike SB "Grail" Pack:

Nike SB Stefan Janoski Max "Mosaic"

Nike SB Dunk Low "Grail"

Nike SB Dunk High "Stained Glass"
Concepts x ASICS
GEL- Respector "Coca"
release event in Miami, FL

OPPOSITE PAGE:

Concepts x Nike
Blue Lobster Dunk

Concepts x New Balance
997 "Rosé"

Concepts x Nike Free
Trainer 1.0

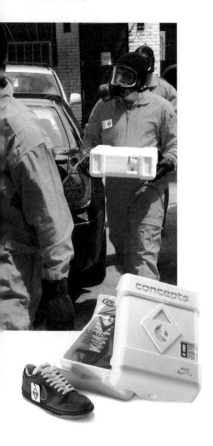

III. Collabs for the People

I wouldn't say there are really any designers I love working with. Design dudes are weirdos. They love themselves too much. I'd love to do a shoe with NASA or Louis Vuitton. Otherwise, a lot of our collaboration ideas come from what's right here in front of us. Boston has such a rich history. Back in the 1900s there were more shoe factories here than anywhere in the world. Reebok is here. New Balance is here. Bodega has an amazing space and really energized the city upon arrival in 2006. I think between both of our stores, all the bases are covered.

Our mindset has always been creating product that is timeless. We value the ability to create; it's something we're fortunate to be able to do. A true collaboration is only achieved when all parties elevate the platform. At the end of the day our consumers can all create customized product on their own through various companies' ID programs. We owe them more than just coloration and a stupid name.

We've always loved the art of storytelling, and that's something I believe we have really dialed in on. I'm a very humble guy, but I will say when it comes to execution of ideas, packaging, or buildouts, nobody is fucking with us. When other brands copy our formula, we will always find a way to stay ahead of the curve.

Every new collaboration challenges us to top the last. The Blue Lobster Dunk sticks out to me because of the sophomore jinx. The shoes came individually bagged and the boxes looked like Hazmat foam. There were T-shirts and skate decks. We had spent $60k of our own money on that campaign. A slight risk at the time, but we believed in the process. In terms of overall look I think the Rosé is the best New Balance ever made. I can say that because that wasn't my design; I maybe added a couple minute changes.

I've learned to separate my personal taste when buying for the store. I'll be buried in a sweat suit. We don't jump into trends because our brand has integrity, so I leave that to the other guys. When I first approached Gucci in 2007 they laughed me out of the room, but we knew there was potential to sell designer brands next to a $65 pair of Vans. Once they came aboard we locked in Balenciaga, Margiela, and others. We were the only independent store in our world taking risks like that. Now it's the norm.

I rarely ever wear any of the sneakers I've worked on, so it's tough to say what my favorite Concepts collaboration is. The ones I love most I've never worn. The NB Rosé, the ASICS Coca, the Concepts Nike Trainer 1.0, I'd rather see other people wearing them than myself.

DEREK CURRY

BASED IN

LAFAYETTE, LOUISIANA

VITALS

With some brotherly love from Point, Curry's excellently named store, Sneaker Politics, overcame growing pains to become a major player with a distinctly Louisianan point of view.

CHAPTER

32

Politics

EST. 2006

I. Getting Schooled

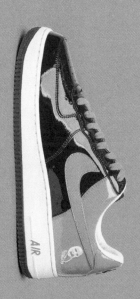

About twenty years ago I had to leave college and join the army. I didn't have a choice—it was the army or I was going to jail for a while. After three years in the army I realized I needed to take my life seriously. So, I went back to the University of Louisiana at Lafayette to finish my degree, and I also started working in the stockroom at Finish Line.

While I was working there, we got in a shipment. It was supposed to be all white-on-white Air Force 1s, but in it was a whole bunch of the Halloween patent leather Air Force 1s. I convinced my manager to sell me all the pairs and I was trying to hustle them on NikeTalk, where this guy hits me up and he's like, "Dude, how did you get these? I want them so bad. I work at a sneaker store in Boston and we're not getting these. Is there anything I can do? Trade you, buy them, whatever?"

So I'm like, "Man, I never really do stuff on the internet, here's my phone number, just call me." So my phone rings later that night, and it was Deon Point from Concepts. We ended up talking about life and trading the shoes: He had the Foot Patrol [Nike Air] Stab, which was one of my favorite shoes at that time. I wanted them so bad but had no outlet down here to get them.

Deon and I stayed in contact and I kept buying stuff from the store. After I finished my degree, I got accepted to Rice's MBA program but decided to open my own shop instead. We didn't have anything small and special like Concepts down here, just big retailers like Finish Line. I had to drive to Houston to get the sneakers I really wanted. I had some money saved from some things I probably shouldn't have been doing. And I asked Deon, "Man, you think I could open a spot like yours?" He's like, "Yeah, dude, one hundred percent. Do it." So I just pulled the trigger.

II. The Sneaker Lobby

Man, for the first two years I ate a lot of Lean Cuisines. Times were tight. I would work in the store by myself, and when a customer would ask for something I would walk to the back to get it. Actually, I had to run. I had to hurry up because as soon as I left the floor, whoever I left out there might be stealing everything. My first employee was this dude who always skateboarded around the shop. He was really just hanging out with me at the beginning, kind of helping out. Finally, he asked for a job and I was like, "Dude, I can't really afford it."

He was like, "Man, I'll help you out for cheap."

I was like, "I can cut you forty dollars a day."

He was like, "All right, sold."

He still works here.

Early on, I had a few accounts. I had New Balance and Reebok. I had Greedy Genius. They were big at the time. Rappers were wearing it, so it worked. But Nike and adidas didn't answer my calls or emails. I had talked to a rep who came by the store, and he was like, "Look, I'll keep you on my radar.

We do business with these other guys in Louisiana and we're kind of not looking for anyone new right now." And I was like, man, this is crazy. I actually got a decline notice from Nike that's framed in my office right now.

I told all this to Deon and he'd say, "Oh man, it's so hard. There's so much involved in it. There's so much politics." I just heard the word "politics" so many times from him that I wanted to call the store Politics. But there was no chance in the world at getting politics. com. So I came up with Sneaker Politics.

We almost didn't make it. I couldn't survive with just the accounts I had. When I was almost out of money, Deon invited me out to Vegas for a trade show so he could introduce me to some people. I spent my last dime on the flight. Deon let me sleep on the floor in his room. He told me, "You need to meet these people face-to-face. Once you talk to them and tell them your story, they're going to be so open to it." Deon was right. I got out there and got adidas and Nike to sign. Two weeks later, sure enough I get an email, account info, everything. And then the trucks started showing up. It was a blessing.

III. Swamp Things

We've become well known for our collaborations. A lot of times a brand gives you the silhouette they want you on. Like, we're doing a shoe with adidas right now, a Primeknit Gazelle. You stay local, shed some light on something special. Right now as I talk to you, I'm driving over a swamp I see every day, but when I bring people down from Philly and California, I always notice their faces when we're driving over; they're like, "Dude, what the hell? This is insane." So we try to shed light on local things that surround us. The Gazelle is for the opening of the New Orleans store and it's influenced by Mardi Gras. There's purple, green, and gold on a Primeknit upper. The gum sole references the color of the dough used for king cake.

We also did a quilted leather women's shoe with Reebok in a deep cabernet shade and called it the Storyville. It was inspired by the neighborhood that served as the red light district in New Orleans in the late nineteenth century. We did a shoe with Saucony called the Cannon to commemorate the two hundredth anniversary of the Battle of New Orleans. We built a *True Detective* sneaker with the New Balance 999. We called it the Case 999 and did a photo shoot with the shoe for our website—it was like a crime scene with those freaky Carcosa devil's nets. The whole thing had a real eerie *True Detective* vibe, which kids picked up on instantly.

The Rougarou was the first thing we ever did with Reebok; it was on an InstaPump. The shoe was based on the legend of a man-eating beast that dates back to the first French settlers in the region. The sneaker is covered in dark brown fur. The original design called for real pony hair and Reebok was like, "Dude, you can't do that, that's insane." When we got the sample they were like, "Dude, you sure you want to go with this?" That shoe sold out within the first thirty minutes.

V. Vows

I've always been willing to do anything to make this work. So, I let dudes text me at whatever time they wanted. Some guys from Houston would be coming through town at like three in the morning and they'd be like, "Yo, can you open up?" And I would wake up and go meet them at the store because I knew these guys were going to spend like $500, $600. Those guys would give my phone number to somebody else like, "Yo! This dude, Derek, will open up whenever, just give him money." I still give out my cell phone to this day because of that. That kind of got me where I am today. Customer service, man.

But you become friends with these guys, honestly. There's a bond. Sneakers were my whole childhood. Bo Jacksons, Deions. My mom would take me to the mall a half hour away from home at six a.m. to get Jordan Vs before school started. I'd be late; my mom checked me in. These other guys all understand that.

So I get texts at four in the morning. I get texts from dudes in jail. I get texts from everyone wanting to know if I'm getting the next pair of retro Jordans. I get calls from guys who just want to talk releases and strategy; guys who want to know if I think they should get something now or wait until the next pair they want comes out.

I get calls from guys who just want to talk about their lives. I even got a call once from a customer I didn't know that well. He asked me to be in his wedding.

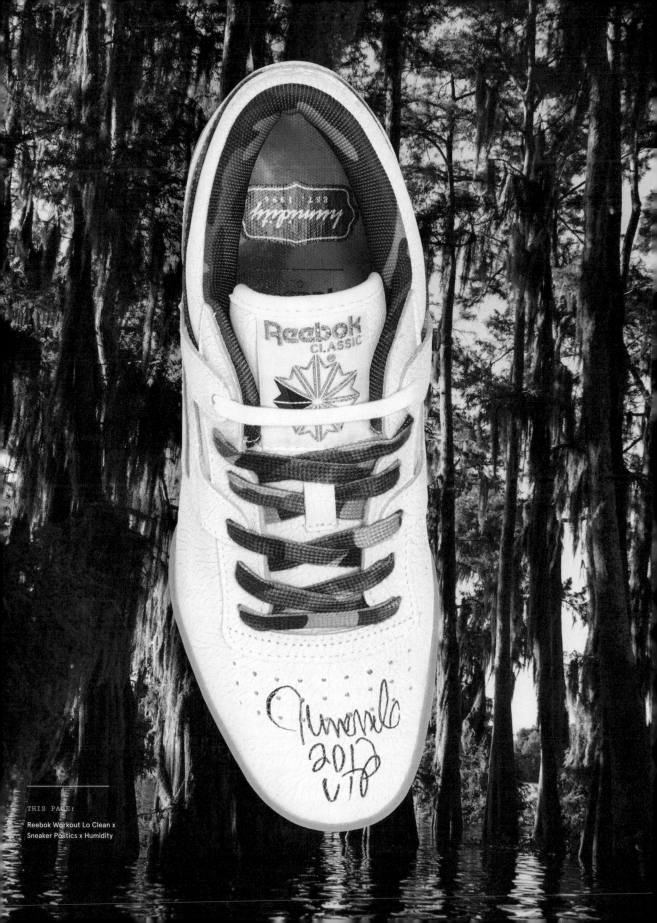

JUSTIN
SNOWDEN

BASED IN

LOS ANGELES,
CALIFORNIA

VITALS

Guys like Point and Curry
need collectors like Snowden
to survive. Here's a candid
peek into the heart and
mind of one we met while
shopping at Undefeated
in LA.

CHAPTER

33

I. The Loyalist

Have I scored anything good lately? Yeah, man. I've been out of control. I had to pull the plug on it for a while. Got the Pusha T, the Oreo UltraBOOST STs, the NMDs with the tri-color stripes. I got Yeezys, but those were re-sale and they weren't cheap. I didn't get the Bapes, though. Those were nearly impoassible. Those are releasing in Europe on the twelfth. I just looked today. So I may try to get those over the weekend, I'm not sure. Like I said: I tried to pull the plug.

If I have anything going for me right now, in my quest to temporarily stop buying sneakers, it's that I'm definitely not friends and family. I don't even have a connect because I don't hit one store so many times I become familiar with the employees. I work down the street from Blends in Beverly Hills; one guy in there knows who I am, and maybe some of the dudes at the adidas Originals store on Melrose. But I haven't pushed it to where I have someone paging me when they get a new shoe or anything like that. I almost don't want that. It's a blessing and curse.

You've gotta go where you can get 'em. I have some lucky places, though. Spots I check on an everyday basis? It just depends, man. I'll sit and search for where I can find the shoe. And wherever I can get the shoe, I don't really care. I mean, I would rather give my money to a mom and pop store. Like, I very rarely will buy a pair from Foot Locker or Champs. I like the boutiques.

I don't travel much internationally. You almost don't have to. You just have to know where to look. Everything is within a click. If I know the store in Madrid or whatnot, I'm able to find what I need. If other people don't know about it, I love it, because then I'm able to get them without them selling out. Everybody knows a site like Sneakersnstuff—they have a great selection. But so many people know about it that it almost guarantees you won't be able to get a pair even if it's on their website.

I only buy adidas. I probably have four hundred pairs. The only Nike I'll buy is the Jordan IIIs. I like them to play hoops in.

I went to Catholic school, so our shoes were the one outlet that we had to show our personality. You could not get the same shoe that some-one else got. Whoever got it first, that was their shoe. And if you got the same shoe, the kids would talk about you. We called that "biting." Nobody wanted to be a biter. I don't know what pushed me toward adidas, per se, but back in the day I got a pair of Crooked Tongue adidas right when they came out, simply because on those you can change the tongue color and the lace color. So it was like having six pairs of shoes for one shoe price. I stuck with adidas because growing up in LA, there was this phenomenon that we called "mixed emotions." You can't wear Nike shoes and an adidas T-shirt, or a Fila jumpsuit with K-Swiss. It all had to be one thing or the kids would talk about you and say that you had "mixed emotions."

II. NMD or DSM?

You never really know what you're going to fall in love with, and if I fall in love with something, I'm going to go after it. And then I just have to figure out the finances later. My non-sneaker-collecting friends think I'm absolutely bananas. Especially because I don't wear them.

Yeah, you heard that right. I don't wear them. I have a room and two closets in my house devoted to my sneakers. I display them like art. I wear the Gazelles or the Superstars, or something that I know I could get another pair of if I messed them up. If I were my friends, I might say I'm bananas, too. But you've got to do what makes you happy, and for that split second when I get something that I know is limited I'm extremely happy, so it's worth it.

Recently I had to delete all the sneaker websites from my phone, because I'd sit and go through them all day every day to find out when things are dropping. Also, sometimes you don't know when things drop and they just appear on the website, and if you're too slow you miss the opportunity to get the shoe. Lately, adidas.com will just drop things, so you've got to check that all day.

And Champs, they've got an exclusive NMD, and if you weren't in the store on those particular days you just missed it. There was a wool version of the NMD which they only released as a very limited pair for whatever reason. It's like different websites will get the shoe and just

drop it. And like I said, if you're not checking you miss out. So I would be checking—I limited it to maybe ten websites. All day I would just sit there and check them. It was obsessive.

I'm forty-two. My sneaker habit has hurt my ability to carry on adult relationships, for sure. That woman I was with when you met me, she wasn't my wife. We'll call her a good friend. She has become an adidas head because she's always with me. When I see something dope but they don't have my size, I'll check to see if they have hers. If they do, I make her get them; of course I've got to buy them. But she gets upset because we'll be eating or going places and I'm constantly on my phone. Not to mention she just sees how much money I spend, and she doesn't want me to spend so much money.

Because I hate to shop online, whenever I find something there she's the one who does the purchasing. So she gets tired of doing it. If I order something from overseas, I'm calling her all day like, did it come? Did they send an email when it shipped?

We make, like, little wagers, like I can't buy a pair for six months. It's not just shoes; it's clothes, and it's everything adidas. I always keep the receipts in the pocket of things that I buy. Last week I broke out a jacket that had been sitting there for four years that I had never worn. You pull out the receipt, and it's a memory trigger. It takes me back to that day, reminds me about what was going on in my life.

III. This Is Beautiful. What Is This? Velvet?

Oh hell yeah, man, I get serious sneaker envy. Especially if I see a goober rocking something I took an L on, let's say, UltraBOOST Uncaged, and you know that he has no idea what shoe he has on, but yet somehow he was able to get his hands on this shoe, and you weren't able to get them. It's like, grrr—it's just like, you kind of growl. I growl, at least.

You can identify a goober by the way he's dressed, you know what I mean? If you put on some Lee jeans with some UltraBOOST Uncaged, and some weird sweatshirt, I can tell you care nothing about fashion. When you put on your UltraBOOST that you spent so much money on, they're clean, number one; number two, you're going to rock something fresh with them as far as your gear. The envy also happens when you see somebody in a pair that was just released, and they just beat them up and they're just horrible looking.

IV. Sell Out?

Do I ever foresee a day when I'm like, "You know what? I'm just going to sell my collection and buy a new house?" Yeah, maybe. That may happen, man. But it's going to be really hard.

```
5/31/17 1:12 PM  RECEIPT EXPIRES:08/30/17
Reg: 1   Trans: 28342   Cashier: 00557176

ITEM            PRICE   RETURN VALUE

CG4088          200.00          200.00
UltraBOOST      CBLAC /10=

            Subtotal   200.00
            Tax 9.75%   19.50

              Total    219.50

                       220.00
Cash

Change
Cash                   (0.50)
         Sale Item Count = 1
```

JOSH HERR

BASED IN

PORTLAND, OREGON

VITALS

Snowden wouldn't have a closet-full of adidas without guys like Herr, who understand the significance of classic design, but also know when to get into animal prints with Pusha T.

CHAPTER

34

I. Keith Haring and Me

I was never the kid sketching out dream sneakers. I was really lucky because our principal at Lancaster High in rural Pennsylvania had previously been a photography teacher, and so we had an amazing high school arts program—everything from sculpture to ceramics to jewelry making. I just lived in that wing of the high school. We had a huge agriculture program, too. My parents were constantly having the conversation with the teachers about potential, you know, like, "He has so much potential." And I was like, "Yeah, but I don't want to do that." Why would I put time into that? It's not what I'm interested in. It always felt silly to me. And they said, "Okay, if you want to do this art thing, let's go look at a school." The closest state school that we could afford that had a good arts program was called Kutztown University. It's a really small school in rural Pennsylvania. If you blink your eyes you're out of it as soon as you're in it. But the thing I remember is Keith Haring was born there; I remember thinking, "Wow, all right. Keith Haring came from Kutztown and he went on to do such amazing things in pop art, pop culture. I can have a voice, too."

I always really, really loved photography and graphics. I majored in graphics. I've always loved design as a form of communication and information. Branding is trying to boil down a lot of complex emotions and thoughts and ideas into the most simple black-and-white small thing that you could. It taught me a lot about communication and balance. I think about that a lot as we design ranges like the Alphabounce where we have thirty colorways, and you really have to figure out the system of what that season is and how it all fits together.

II. Dear Stan . . .

My favorite shoe is the Stan Smith. I feel like I don't even get a choice in saying that, that's how much I feel that way. It's the pure essence of what we stand for as a company, right? It's bravely simple. There's innovation in the construction that I just totally took for granted. I mean, adidas invented and patented the T-Toe with that shoe. That's just something that had like a pure function to it. It's timeless, it's crafted. It's just the perfect shoe. It's so ingrained into your mind and our culture. It's constantly referenced so much, even by other brands who don't even realize how much they're taking it for granted. And it's the shoe that you can just wear all of the time, and to any occasion. If you've got a couple hundred bucks and you need to buy a starter kit shoe package, that would be my suggestion for a first buy.

OPPOSITE PAGE:

adidas Originals Stan Smith

III. Creating Cool

What makes a shoe cool? Two things: Who is wearing it and how they wear it. Shoes are a soft good. The coolest shoe in the world doesn't have context until the person wears it, you know? It's still a utilitarian object. But how people wear it, and their attitude when they wear it, how it makes them feel—that's as big of a reflection of the shoe as the actual product itself. That's something that we think about a lot in the creation process.

IV. I'm Your Pusha Man

Pusha T is every rapper's favorite rapper. He's the man. During All-Star weekend 2013 in New Orleans, we sat down with him to talk collaborations. I've done quite a few collaborations, and I like to be super prepared. I'll have ten options and a full presentation built out. My marketing person at the time, Jimmy Manley, was like, "Let's just go in and let's just let the conversation happen." And I was like, "'kay," but only because I've been following Pusha so closely over the years.

When we sat down, the conversation was just so seamless. We pulled out a bunch of different shoes we were looking at. We were talking about re-launching the EQT series, which is near and dear to my heart as well. And we were looking at the Micropacer, the New York, the EQT, and—I forget what the fourth was. I had prepared samples of all four, and he chose the EQT. It was a unanimous vote across the board.

The EQT Grayscale was an interesting shoe. Equipment as a franchise was born here in the U.S., in Portland, Oregon. Peter Moore led that frontier back in the early '90s. Equipment at the time was about the best for the brand, and being the best. It was supposed to be the pinnacle of performance, no bullshit, just straightforward product. And so when you're looking at EQT and trying to recontextualize that for what we are as a brand today, well, that's BOOST and Primeknit.

So a bunch of the designers felt like, Well, we've got to do a BOOST and Primeknit EQT. That's about the point I came in and I worked with Push to recontextualize the shoe in a lifestyle sense, and that meant using exotic materials.

We were able to find the supplier to supply us with some real carp skin for the shoe, which to my knowledge has never been done before this series. Carp skin is actual fish skin. Actually, I took a whole bunch of exotic materials to show Pusha and really, really was hoping that he would choose the fish skin. He has really good taste. Anyway, I'm not sure how we neutralized the odor from the fish skin, but the other challenge was that carp really aren't very big fish. It gets tricky when you have to make shoes running up to size 14. The feet get bigger, but the fish don't.

THIS PAGE:

adidas Pusha T "King Push" EQT
Grayscale

MOORE

I. Misfits and Blisters

I was a graphic designer in Portland. The guy who rented the space under my loft was a photographer. I went down there one evening and he was photographing these strange-looking running shoes. And I asked him, "What are these?" And he said, "Don't waste your time. It's just a bunch of runners who put these things together and try to sell them. They drink beer and run around; they're a collection of misfits."

Those are my kind of guys, so I called them directly. At first they didn't have a job for me because they didn't have any money. But then *People* magazine ran a photograph of Farah Fawcett Majors wearing her Senorita Cortezes on a skateboard. They wanted me to make a poster out of that and give it to their retailers. That was the start.

Nike was a niche brand: a running company, purely about running. Then we branched out to tennis shoes and basketball shoes. It was a loose operation. Rob Strasser was our VP and director of marketing. Phil Knight ran the company. Knight was not completely convinced that he wanted to be deeply involved in basketball. He was a runner first and foremost, and he was a tennis player.

To give you some insight on how we functioned: He went to Wimbledon to sign Jimmy Connors. Days later, Gloria Connors calls Rob and says, "Hey, what's going on? Your guy canceled the meeting with Jimmy." Rob had no idea. Anyway, Knight comes back from Wimbledon, and Rob says, "I got Gloria Connors all over me; what happened?" Knight replies, "Oh, I signed a kid named John McEnroe."

Anyway, '84 –'85, we had something like seventy NBA players. George Gervin, Bobby Jones. But those players didn't make any difference in sales, and frankly the shoes weren't much—just cup-soled leather basketball shoes that had a swoosh on them. adidas was already the leather basketball shoe company. I think they were probably making about $650 million a year in sales. They weren't small, but they weren't the $20 billion monster they are today. Converse had all these great players—Larry Bird, Magic, Isaiah Thomas, Dr. J.

Shoes weren't sold by personalities. They marketed themselves via the sport, and via what the shoe could do. Back then "high performance" meant it didn't give you blisters.

THIS PAGE:

Nike Senorita Cortez

OPPOSITE PAGE:

Michael Jordan and Peter Moore at photo shoot

II. Air . . . What?

Rob Strasser was a legendary character and great, big guy. I'm talking, like, 370 lbs, at least. And probably 6'4". He had a big face, big hands, big everything. He was a complete sports junkie. In his dreams he would have been the star quarterback. He had a real instinct for what kids wanted. When we were talking about new shoe ideas, he would always say, "If I'm a sixteen-year-old kid, can I get laid in these?"

Jordan wasn't the obvious path. UNC was a Converse school. We knew Jordan because he beat Georgetown in the NCAAs with that shot, but that was all we knew about him. Sonny Vaccaro brought us his name and we got some highlight films and watched what he did. When you play for Dean Smith, it's tough to be the standout, you know what I mean? Jordan didn't have much playing time under his belt, but what playing time he did have was so impressive. Sonny talked to everybody in the basketball world. Everybody said Jordan was the guy.

We came up with plans to do something special. With basketball players we usually did posters. For Jordan, we needed plans to make ads. Rob went to Phil Knight and told him we wanted to sign this guy, and we were going to go up to $1 million to sign him. Knight wasn't convinced. He hemmed and hawed, but he didn't say "no."

Rob kept pushing. We invited Jordan to Beaverton to show him what we could do. We had signed big-time runners, even tennis players, but we had never made a presentation. We intended to show this kid that we were going to make him into a star by building a brand around him. But he didn't want to come to Portland, much less Beaverton.

So we met with Jordan's agent, David Falk, at his office in Washington, D.C. Rob warned me about Falk. He said, "He thinks he's got giant hands. When he shakes hands, he's going to have his fingers spread as wide as

he can possibly spread them. Don't think he's going to hit you or something, he's just shaking hands." Sure enough, the guy reaches out, gives me his hand, and his fingers were spread out as wide as they possibly could be.

We all sat down and Falk says, "Rob, I've got an idea. I want to marry Michael to your airbag technology." We had this thing called "Air," but it was frankly nothing like what it is today. You couldn't see it and we were actually considering dropping it.

Then Falk said, "Air Jordan." My immediate reaction was, "Air Jordan? Like an airline for that Middle Eastern country?" But Rob got it. He thought it was great. There was no such thing as research like there is today. If there was a good idea, we did the good idea. It was going to be the Air Jordan.

On the flight home the next morning I started sketching ideas on a couple of cocktail napkins. At one point I looked up and the pilot was out in the cabin saying hello to everybody, and he had his United Airlines pilot wings. That triggered an idea: I sketched the pin with wings but replaced whatever was in the middle with a basketball. That's what the original Air Jordan logo was: pilot wings. We tended to drink a lot on flights, so by the time we arrived in Portland it was an ingenious idea.

Jordan eventually came out for a visit. His mom and dad were with him. Michael didn't say much. Pop Jordan did a lot of talking, and his mother did a lot of affirming. We explained that we wanted to build something around his personality. He was a great basketball player, but the first time you saw a young Michael Jordan smile, I'm telling you, man, the room melted. So we showed him what we had designed for him. The clothing line. The shoes. Everything was red and black. He didn't like that. We had to explain to him that the NBA wasn't going to allow him Carolina blue. That he was on the Chicago Bulls and their colors were red and black.

THIS PAGE:

Nike Air Jordan I

Nike Air Jordan II

III. Ferrari-Style

When we got to talking about the design of the Jordan I with Michael, he told us, "I want to be low to the ground. All of these shoes have too much cushioning, too much space between the floor and your foot. I want to be close to the ground, I want to feel the court."

In reality the shoe was rudimentary—a cup sole stitched to a leather upper. Those shoes shocked the world, though. Everybody in the NBA was wearing all-white shoes. The Celtics wore black. And here was color.

Before making the second shoe we talked a lot about footwear design. When Michael talked about sneakers he talked about cars: Ferraris and Porsches. We were building his image and had to make sure we were staying true to the story. The first shoe was flashy and we sold millions. Overnight, every other shoe company comes out with a black-and-red shoe.

We decided to go in the opposite direction with the second one. I listened to the way these Bigsby & Kruthers guys—who owned a store in Chicago and were dressing Michael in Armani—were talking about what they wanted him to wear and started thinking maybe we should make a shoe that mirrored that elegance. We decided to have an Italian shoe, made in Italy, styled completely different, very clean, very beautiful. All white with just some red trim. The look of an exotic skin on the upper. They had this injection-mold heel piece in the back that was really beautiful. The sole was really rich and soft.

It was light years ahead of everything else, magnificent, a beautiful piece of work. But the factories in Italy were late, there were no shoes to sell, and Michael missed most of that season with an injury—though he did wear those shoes when he scored 63 points in Boston.

If you talk to a shoe collector and say, "I can get you original Air Jordan IIs," watch his eyes.

IV. You're Fired

You can believe this story or not believe it, I really don't care. The only person left alive that can verify it is [Phil] Knight. Tinker [Hatfield], who'd studied architecture at Oregon, started his career at Nike as a space planner. You know, they figure out how to divide the spaces up—offices and whatnot; what department goes where, how the spaces work. Now, Tinker had done some work on shoes in Bowerman's little lab down in Eugene as a pole vaulter.

But he was really a space planner and that is the worst job in any company, trust me. Knight couldn't stand space planners because all he would get were complaints. So Knight told me to fire Hatfield.

I left Knight and I told myself, I'm not going to fire the guy just because his job is a bad job. So I told him to come to my office at Nike Design and I'd find some things for him to do with fixturing for stores. So that's how he got started with me. When we decided to bring Air back, I told Hatfield that we were going to make this thing the real deal. Because we could put a hole in the heel now and show the bag. Some guy had figured that out. So I said to Tinker, I want you to get together with that guy, and I want you to design some shoes for running, for basketball, for this, and for that with this visible Air bag. And I told him that I wanted a totally different look. So he did that; he gave me some sketches and I went in to Knight and I said, "Here's what we think that we ought to do with this Air stuff." And Knight said, "I've never seen drawings like this; they look pretty good." And I said, "Yeah, okay, great, so we're going to start doing this." And he said, "Okay." He said, "Who did these drawings?" I said Hatfield, and he said, "I thought I told you to fire him." And I said, I didn't fire him, I just moved him. And he said, "Maybe I should fire you."

After Hatfield did the Air package, I told him that I had other things that I was doing and I had no time for designing Jordan anymore. So I wanted him to start designing Jordan's next shoe. He did the Jordan III. And then I left.

ANKUR AMIN & BERNIE GROSS

BASED IN

NEW YORK,
NEW YORK

VITALS

When Amin, his head designer, Gross, and partners Jason Faustino and brother Nick Amin opened Extra Butter, first on Long Island and then on the Lower East Side, the store felt like an oddity: a shop that specializes in sneakers inspired by movies? But Extra Butter has distinguished itself by creating product and packaging that tells a story every bit as compelling as the films that inspired them.

CHAPTER

36

I. Golas in Gujarat to Break- dancing Bernie

ANKUR: An immigrant story: 1981. My parents moved to the United States from Gujarat, India. It was total culture shock. I was eleven. I didn't know the language. We landed in Elmhurst, Queens. The neighborhood was in transition from Latino to Asian. We were thrown into this socioeconomic warfare. I had trouble assimilating. I didn't know the language or understand what was going on around me. School was torture.

Back in India, my father owned and operated a big general store. When he got to Queens, he got a tip from someone in the community about a job at a shoe store, working an $8 an hour gig at Sneaker Circle on Queens Boulevard and 63rd Street. The owner was an Indian guy who owned multiple shops and he was in over his head. The place was run like a free-for-all.

My dad was really good at retail, no matter the product. When he started at Sneaker Circle he brought some systems to the place and made sense out of the business. After only a year there, my dad and uncle were able to scrounge up $40,000 through relatives and compel the owner of Sneaker Circle to sell the place. That became my uncle's store. I'd go down there and help him on the weekends. Eight colors in Puma suedes; four or five colors in the shell toes; a few colors in the Bruins and Cortez—that was our whole game. In India, there were no American sneaker brands. Do you remember Gola? That was the international brand there.

A year after Sneaker Circle opened my parents bought Renarts in North-port, Long Island. It was a very sporting community. There wasn't a lot of urban traffic, so we sold sport-specific. In basketball season we stocked more basketball shoes. We sold lots of soccer cleats.

After graduating from college, my brother and I took over the family business. We grew Renarts into a two-store operation. Then we added another stand-alone sneaker store. In 2004, we hired Jason Faustino, he's my partner now. He had been a customer first. He'd show up every week and I would be like, "What are you doing here every week?" He was just looking for some drop.

We had a lot of help from a rep at Nike, who made a lot of fun things happen at our store. We got some cool product that, believe it or not, I wasn't really up on. I didn't know that this was a thing in New York City. And New York had a culture, a subculture happening back then and Jason brought me into that world. We went to shops like Classic Kicks, Clientele, Reed Space, and Alife. I couldn't believe the energy! Jason would take me out there, and I was inspired, I was engaged. We hired one of Jason's old breakdancing friends, Bernie.

THIS PAGE:

Sneaker Circle

OPPOSITE PAGE:

Renarts

II. Lights, Cameras, Sneakers

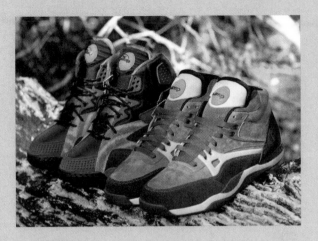

ANKUR: I started talking to Jason and Bernie about what we might want to do. We talked about names and concepts. We were really inspired by Bodega in Boston. Jay and Oli were doing something really unique. I remember the first Bodega webpage. It was a clip of an overhead shot where Al Pacino is like in this little a valley, right? He's looking around and he's saying, "What is this? Where are we?" Something like that. And that's it, and they had it on a loop, and that's the only thing on the entire site. I was like, this is so cool.

BERNIE: Yeah, it was very cryptic. You kind of had to know what you were getting yourself into. There were hidden links. I mean, they still have hidden links and hidden messages in their newsletters to this day.

ANKUR: In 2007 we opened our doors. The first two years we were in this sleepy town in Long Island called Rockville Centre. We blacked out the windows, black canopy, no signage on the door, and no business for the first few months. The Rockville Centre community was like, what is this place? What do they do down there? And they would peek in and peek right out. But that's the way we conceptualized it anyway. We figured the guys who are hunting for this product will find us, and they did. And then the first collaboration was with Reebok.

BERNIE: We came up with a concept and aesthetic that was movie-based. That idea made it so much easier for us to conceptualize different ways of telling a story and translating it on to a product. In 2010 we released our first collaborations with Reebok, a Pump AXT and a Pump OXT. Both models didn't really have scope at that time. The only two Pumps that existed back then were the Pump Dual Runner and the Pump Omni Lite. But it's in our fashion to always want to take on an underappreciated or underutilized model, or a shoe that we think is going to be relevant in the years to come.

The story that we told was inspired by the Mel Brooks film *Robin Hood: Men in Tights*. That's actually Dave Chappelle's first major film role. And he plays this character, Ahchoo, he's Robin Hood's sidekick. There's this scene where they come across the king's knights, and they're about to get robbed and beat up, and Ahchoo says, "Time out! Got to get pumped." And he bends over and he pumps up the shoe and then he continues fighting. We wanted to pay homage to that and our love for the film, to Dave Chappelle, to the fact that that Reebok is relevant in film history.

One colorway was inspired by Ahchoo's particular outfit, and then the other colorway was the general *Men in Tights* motif. Back then, the culture was really just caught up in making sure the product was clean and elevated-looking. Everyone would post their pictures just on a white background. That doesn't really sound that special now because it has become an industry standard. We wanted to go a different route. So we made a promo video, a short film of us parodying *Robin Hood: Men in Tights*. J. and I are in the video as a couple of knight thugs, trying to rob this Ahchoo character.

This opened the door for people to realize we had a very particular way of storytelling in mind. There's a vein of elitism and stodginess out there. We wanted to convey, hey, if you have a love for a shoe and you have a love for a story, you're allowed to show that.

We had no idea if people even cared for an Extra Butter shoe. And we were concerned that we'd committed to too many pairs. We did about four hundred on the AXTs and two hundred fifty on the OXTs. I mean, still now, that's so little. I think the AXT was gone within two days, and then the OXT was gone in the first six hours.

III. Grindhousing

IV. Edibles and Outer Space

When we first opened up our Lower East Side location in Manhattan in 2013, we actually did our grand opening with the launch of our ASICS collection inspired by *Kill Bill*. It was called DL5, or Death List 5. And that was actually a concept that J. and I had been sitting on for five years. We were just waiting for the right moment—we needed ASICS to become relevant again and for them to want to work with us.

ASICS wasn't one of those brands that really mattered for quite some time, but it started picking up steam and we ended up growing a relationship with the right people within the brand. And we actually bribed them to come out to Long Island and see a pitch over some sushi and sake. That was actually a good call by Ankur to really drive the story. And obviously there's some DNA of ASICS in the *Kill Bill* films through Onitsuka.

ANKUR: With that collaboration we told the story of Beatrix Kiddo's revenge on these five assassins. A five-shoe collab was unheard of. One shoe was represented Vernita Green. One shoe was Elle Driver. A third was O-Ren Ishii. We released them in the order they were killed in the film series.

BERNIE: We absolutely crushed it.

ANKUR: For the twenty-fifth anniversary of the Reebok Ventilator . . .

BERNIE: They challenged all of their top-tier certified accounts to tell a story through the model. We were looking at what was going on in New York, and one of the more fascinating stories in 2015 was food carts were just everywhere. And so we decided to tell the stories of the halal guys. J. and I were just talking maybe through BBM at one in the morning. And we were like, "Oh, you've got to get the seasoned chicken and the lamb and the hot sauce and white sauce." Every single time that we show somebody that shoe all we have to say is halal or street meat, and they immediately get it. Even the way that we packaged the additional laces, they came in little cups, just like how you get your white sauce and hot sauce.

I should also mention that I left Extra Butter for a minute to work a job in experiential marketing, which is a huge resource for what we do with activations. When this story came about with the Reebok Street Meat it was a professional and a personal goal of mine to make sure that we get an actual food cart involved. So we got one. We custom wrapped it with some EB and Reebok graphics. We made a fake menu. And we showed up at random locations throughout the boroughs. If you knew what you were looking for, you found us and I was in the cart in an apron, and handing out pairs of sneakers.

By the time word got out and hit Twitter and Instagram people were waiting by key corners through-

OPPOSITE PAGE:

Extra Butter x Reebok
"Men In Tights"

THIS PAGE:

Extra Butter x
ASICS "Death List 5"

THIS PAGE:

Extra Butter x Saucony
"Space Race"

out Manhattan, Queens, Brooklyn, just waiting for me to show up. That's fun. Anyone can just show up to a brick-and-mortar location and line up, put down their name to reserve, and walk away with a shoe that's from the shelf, but those are the types of stories that I think people want.

ANKUR: That's not the only food-inspired shoe we've done.

BERNIE: The Saucony "Space Snack" was actually a concept that I had pitched when I was still working at the agency. So there's this bounty of history of the company behind Saucony before it was even called Saucony.

They were originally called Hyde Athletic Industries. Small company from Pennsylvania, and they were commissioned to build the first space boot for extravehicular travel. In other words, the space walk. And so the famous National Geographic image of the first astronaut outside of the spacecraft, he's wearing boots that Saucony made. We wanted to tell that story because it kind of lined up with a fifty-year anniversary of that first space walk. And so we worked with Saucony, and again we wanted to kind of bring other models that weren't really necessarily circulating within the sneaker community. It was the Shadow Master, and then the Shadow 6000, and then the Grid 9000. The trifecta told a larger space program story. The Grid 9000 was inspired by the ASA suit, which is the entry outfit that they are wearing when they come back into the atmosphere. That was an orange motif and it had some cool NASA-inspired patches you could take off and put on some of the other Velcro spots on the shoe. The next shoe was the Shadow Master, which is the Space Snack. That goes back to our childhood memories of going to the Vanderbilt Museum and Planetarium on Long Island and going to the gift shop and just dropping money on dehydrated ice cream. I mean, it's such a novelty thing. As I'm talking about it right now I can feel the texture in my mouth—like it's melting.

V. Living the Dream

ANKUR: My dad and my uncle are amazed with what we've done. They never knew this world existed.

BERNIE: I mean, if you want to expand on kind of the upbringing and immigrant story, my mom is Chinese and Guatemalan. My biological father is Filipino; my stepdad is a Russian-Polish Jew born in Coney Island. Jason, our partner, he is first-generation Filipino, and I think both sets of our parents were just a little nervous about us really taking the risk and going full-time, and really delving into our passion. I mean, I know for him—his mom is a doctor, his dad is an architect, and for him to play around with sneakers? My parents thought I was crazy leaving agency life.

ANKUR: But I'll tell you a sad story. My love for sneakers got killed instantly because my father had a store policy that if it's sellable, you're not buying it. Old school, right? "Hey, I would rather sell it to a customer, I don't want to deprive a customer, you're not buying it, sorry. Get something from overstock." So the things that you wanted that were hot in school, I never got to have it. So yeah, the Air Jordan I, the Air Jordan III, and I absolutely coveted the Air Jordan VII. I actually got it, the VII Olympic. The one he wore in '92 in Barcelona. I've never worn it. I still have it in my office. It's actually in front of me. It's pretty there. I look at it every day.

OPPOSITE PAGE:

Reebok Classic x Extra Butter
Street Meat pop-up food cart

JIM RISWOLD

BASED IN

PORTLAND,
OREGON

VITALS

Hired as Wieden + Kennedy's first copywriter in 1984, Riwsold became one of the ad firm's breakout stars. By helming Nike ads with Spike Lee, Michael Jordan, Bo Jackson, and even Bugs Bunny, Riswold spearheaded sneakers' cultural transformation: from sporting goods to conversation starters, objects of desire, and life's most essential objects.

CHAPTER

37

I spent seven years slumming around the University of Washington, picking up history, philosophy, and communications degrees. First I wanted to be a lawyer but got scared away from law school by the movie *The Paper Chase*.

"I'm not smart enough for that," I told myself. Then I wanted to be a Nietzsche scholar but was neither smart nor insane enough. "I'm not smart enough for that," I told myself again. Then I stumbled into the advertising program in the communications department. "I might be smart enough for this," I told myself. Effective advertising is nothing more than a dialogue between a brand and a consumer. Do lousy advertising and the consumer, hopefully, will tell the brand to shut up. Most advertising is shouting, vainglorious and one-sided: And on the eighth day, God created the Gillette Fusion razor. Shut the fuck up. Bad advertising is like the date who only stops talking about herself long enough to feign interest in you by asking, "Enough about me, what do you think about my hair?"

Bill Davenport and I were in LA editing one of those serious Nike spots and we saw Spike's first movie, *She's Gotta Have It*. In it Mars Blackmon finally gets to sleep with the woman of his dreams but won't take off his Air Jordans to do it. Bingo on a silver platter. Spike wasn't Spike Lee yet. Spike answered his own phone when we called him about the project. Spike lived in a tiny apartment in Brooklyn. Spike was a huge Jordan fan. What do you think Spike's reaction was when we called him and asked him if he would like to direct and star in commercials with Michael Jordan and get paid for it? Silly. Silly is good. Best thing: Spike told me I wasn't bad for a white guy.

I wasn't sure if Spike and Mike would work together. I never know if anything is going to work and that's ⅞ths of the fun. It was the first time Nike tried to use humor in its advertising, regardless of whether the spots were funny or not. Nike advertising was no-nonsense up until then: Show the athlete sweat seriously. Spike and Mike proved to us that people were more interested in athletes than the cushioning properties of athletic shoes.

"Michael's Dream" was done for Michael's first of many returns to basketball. We were told he was coming back and need a spot on air in about a week. I came up with the idea that the whole retirement-to-baseball thing was just a dream (thank you, Bob Newhart) and one of the lines in the spot was "I became a weak-hitting Double A outfielder with a below-average arm." When I finished reading the script over the phone to Jordan, he said, "Riz, why do you want to call me a weak-hitting Double-A outfielder?"

I said, "What else would you call a Double-A outfielder who hit .202?" There was a long silence and then he said, "Fuck you, Riz; I'll do it."

CLAUDIA GOLD
A.K.A. CLAW MONEY

VITALS

NYC in the Bad Old Days was
the right place and right
time for Queens-born Claw
Money to start making her
mark. From writing graffiti to
blowing up fashion's gender
norms to designing kicks in
a prescient way, Money's
impact endures.

CHAPTER

38

I. Anything But Those Thom McAns

It was the late '70s, early '80s, and I was a young girl from Queens and I really wanted to have nice sneakers, but my mom was really into buying Thom McAns. Like, oh god. My first pair was a fake four-stripe adidas. There wasn't that much of a price difference; it was like seven bucks more or something to have a name brand, and that was just way too much for my mom.

Eventually we moved to Long Island, where everybody was really into status, brands. And here I am wearing the wackest sneakers in the land. I developed a taste for the finer things, just through coveting other people's shit basically, you know? So I moved to Manhattan when I was seventeen. I figured out fairly quickly that if I shopped in the boys' department I was spending a lot less money. Everyone was confused as to how I had the sneakers. Like, I don't think girls were trained to shop in the boys' department; it was, like, a new technique or something. That's when I started busting out the Jordans. I was at FIT when I started writing graffiti, and I was sneaker queen of the land. I wore these pom-pom tennis socks with my Jordans. That was my thing.

I was in this double subversive situation—a woman writing graffiti. A woman wearing sneakers and being aggressively stylish with it.

II. Stretch and Bobbi and Claw Forever

My best friends at the time were Stretch (a.k.a. Adrian Bartos) and Bobbito. I met Stretch through a childhood friend who was classmates with him at Columbia. We became besties super quick. I became an unpaid slave for Stretch and Bobbito. I answered the phones for their radio show. I carried their fucking record crates up the stairs to the station.

I used to go sneaker shopping with Bobbi. He put me on to the good spots. He was meticulous about upkeep. He would clean his sneakers with a fucking toothbrush and, like, Windex and shit. I was like, "Oh damn, dude, is that how you're supposed to do it?"

I helped Bobbito with his book, *Where'd You Get Those?* I, like, literally forced him to shoot girl sneakers. You know the pink sneakers with the multicolored bottom? That's actually me wearing my shoes.

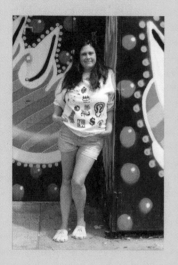

THIS PAGE:

Claw Money

Claw Money, Stretch, and friend

OPPOSITE PAGE:

Claw & Co. store in the Lower East Side, NYC

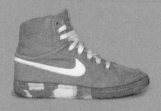

III. Money! Money! Money!

I can't even tell you what my favorite pair is. I'm the first woman ever to design a Nike artist series sneaker. It's a really big deal. Jesse Leyva, who was in charge of all the Tier Zero special projects, got ahold of me. I must have designed a gazillion sneakers, not that I showed them all to Nike.

They were, like, not really creating sneakers of that caliber for women. Sneaker culture is the midwife for these brands to cross over into female products. Somehow I connect more with men. I think the guys like me and respect me. And the girls . . . I wish the girls knew more.

I designed an Air Force 1, which was super dope and had charms and stuff. It was for the big Air Force 1 twenty-fifth anniversary; they were doing all of these releases. Then they decided they didn't want to do that because they thought my shoe would get lost in the shuffle. They wanted to make this big statement for women. That project was super great. There have been others—the Claw Money Blazers and Vandals with the Claw Money logo printed on 3M. That was pretty rad back in 2007, but I wanted the Blazers to be laser cut. I don't wear high-tops anymore, though. I'm into running shoes now.

Since then I've done collabs with other footwear companies—Vans, Fila, Uggs. I have a big footwear license that my company Claw & Co. is launching in the Pacific Rim for spring of next year. I love everything.

Currently, I'm selling my deadstock of Jordan Is. They need to go back out into the atmosphere, you know what I mean?

IV. Line Up for Good

I have all this crazy stuff in my storage. Stuff nobody has ever even seen. Crazy stuff by Troop. Ewing. Spalding. If you go in my store I have sneakers on pedestals as a testament to their amazing design and universal sort of toughness, or whatever it is. I both love and hate sneakers, and sneaker culture. If people waited in line to donate to Syrian refugees like they do for a new pair of Jordans, the world would be a better place.

THIS PAGE:

Nikes worn by Claw Money in Bobbito Garcia's *Where'd You Get Those?*

Claw Money x Vans Hadley

Claw Money x Vans Aleeda

Claw Money x Nike Blazer

Claw Money x Fila The Cage

OPPOSITE PAGE:

Claw x Nike Vandal Hi

Claw Money graffiti in NYC

Photographs by Keith Hayes

KISH
KASH

BASED IN

LONDON,
ENGLAND

VITALS

It was a love of football (and by football, we mean soccer) and a full-blown obsession with Britain's nascent hip-hop scene that hooked him on sneakers. Decades later, the still shoe-mad DJ, brand consultant, and street style guru possesses one of the planet's great sneaker rotations.

CHAPTER

39

I. Friends and Rivals

Sport and music are the reasons why I'm into kicks. With football you had the whole terrace culture thing over here in the UK and we predominantly wore adidas and Puma, and that sort of ilk. And also some Italian sports brands like your Fila, your Diadora, etc. You know what I mean when I say football . . . I mean soccer.

Football here in the UK is a lot like basketball in the States as it's a sport which can be played right outside your home. See, over here we're all about having a kick about in the street in a pair of trainers, right? When we're growing up, and sometimes we still do. And it was something that lent itself aesthetically as well as functionally to what was going on. We were trying to emulate our heroes. Like my one of my best friends growing up, Rob, he wore adidas faithfully and then suddenly he switched to New Balance one day out of the blue. And we both support the same football team which is Manchester United, and back then they were sponsored by adidas but weren't winning anything unlike in recent years. Liverpool were the dominant team. So basically I was like, hell no, why did you wear New Balance? Rob goes, "Don't you remember? Bryan Robson has signed a boot deal with New Balance." You see, Bryan Robson was the captain of Manchester United and the England football team at the time and we basically idolized him. So then I understood and was down with that switch.

And then there was the advent of hip-hop. I'm a hip-hop guy. Still am: I do a radio show. Back then I was b-boying, badly I must add. I could do robotics and a little bit of body popping. I wasn't about to bust a windmill, I wasn't as gymnastically inclined in that regard. But in the same way that my mate Rob was never going to play football like Bryan Robson, I was never going to dance like the boys in Rock Steady Crew. Still, when I saw Rock Steady wearing Vandals or MC Shan in his Pumas or Biz Markie rocking his Nike Air Safaris, I was like, "I *need* those." But where I lived, outside of London in a town called Aylesbury, they weren't available to me. That just made the desire even more intense.

But sneaker culture back then was all about being unique. Hip-hop style here became a cross between a lot of influences—casual terrace culture, Jamaican, punk, two-tone, etc. We had to come up with original stuff, apply your brain. You had to be creative. If there's a trend, you had to flip it. Put your own spin on it. But these days it's like, I see this queue outside Supreme and it's all these kids who want to buy the same thing. Interesting times.

II. Be Blessed for What You Have

I hunted.

I was the first person in my small town of Aylesbury to sport a pair of Nikes. Ever. My uncle was working at Eaton's, a chain store in Canada that had Nike runners on display that looked a bit like the Nike Oceana

THIS PAGE:

Kish Kash

but were cut differently. This was around 1982 on my first family trip to Winnipeg. They were, like, tan and brown with a herringbone gum sole, which came up on top of the toe. Sometimes I had access to the Nike catalog because I had friends who worked at a sporting goods store. Later on I also scored a pair of Reebok Phase 2 runners on the early because of this relationship. I remember everyone else rocking Puma Dallas and I wanted to flip it so opted for the G. Vilas. Then I recall seeing the Puma Californias in my local sports store and asking my mum if I could buy them but she said, "No, you've already got those." She couldn't tell the difference as they shared similar aesthetics to the G. Vilas. I specifically remember that. My parents are Indian. My dad was born in Uganda but he's Indian. "You have what you have, be blessed for what you have." That's what they believed.

I took my fair share of Ls, too. Just because I had access to the Nike catalog doesn't mean I was getting everything I wanted. I loved the ACG models. Didn't happen. Couldn't get them as even though they were in the catalog they weren't picked up for distribution in the UK. The adidas Spectrum, one of my favorite basketball shoes of all time, couldn't get them. That one hurt. The closest I ever got to a pair was on a school trip to Greece. They were in the window of a sports store in Athens, but the place was shut. I think it must have been lunchtime or some shit. Yo, it weren't happening. The coach is

about to go, and I'm just looking at these shoes. And adidas still hasn't retro'd them either, and I don't know why. It's just madness.

I had family in the States. Wherever we'd go I would be like, "Yo, take me to the mall. Take me to the sports stores, let's go." I needed to get some stuff that I can't get back home. On a trip to Houston I picked up the first Air Trainer SC, the Medicine Balls. I came back with those and people's eyes were buggin'. I was in the States again when the Jordan IVs dropped in black. I had them at least a good three months before they dropped in this country, you know what I mean? Mad. When I brought them back, I wore them to London. I remember the feeling of people staring at me, turning their heads sideways and asking questions—*Where did you get those? What are those?*

I had to wear a uniform to school and I stuck them on my feet because you were meant to wear shoes but as they were black, teachers didn't notice. And I was just trying to get away with it. And on the opening day of school I was wearing the black Jordans and dudes was bugging, and my man Juan, still one of my best friends to this day, he was like, "Oh, my days, where did you get those? Oh my god!" And then he sort of goes, "Yo, everyone, this is my mate, this is my mate. Look at his shoes, look at his shoes," like that. Because I had the shoes and then he was my friend.

I had dudes I looked up to as well. Even though he was only a year older, I looked up to my good

dude named Mark Preest. He was the adidas King. Even before the fans of Run-D.M.C. held their Superstars in the air at MSG he wore nothing but adidas. He didn't even have Made in France Superstars; he had ones that were made in other countries that had a better cut. He had Forums in colors that were eye popping. And he had Rivalrys as well, in a couple of colors which they still haven't retro'd. He had the Run-D.M.C. leather jackets. He was one I looked up to.

III. Kish Kash's Huge Stash

But Mark was a strictly do-or-die Adi head. I was into other brands. Still, when we were kids, he had more than I did. For me, the real accumulation began in earnest in the '90s, when I started earning my own cash. Once you start having your own money, you want to wear stuff, and then something else would come out and you would go, "Oh, I want to look fresh." Looking fresh and being on the early was absolutely vital.

Having a lot of sneakers has now become a thing. Well, it's not a thing. It *was* a thing. Now it's just regular, you know?

I'm not sure how many pairs I own. It's got to be few thousand, maybe. I haven't counted. I look at it as an archive. I look at myself as an archivist because there is consideration to what I have and why I have it. It's not just blanket, there are reasons why—aesthetically, in

THIS PAGE:

Nike Air Max ST

terms of memories, design, significance, whatever.

I've still got the first Jordan IVs that I got in '89. They're falling apart but I still have them. They're in storage, completely unwearable. If you look at them they would probably just crumble into dust, which is a shame. I used to wear them so loose. Accidentally I bought them too big actually and I wore them hip-hop, loose, like Flavor Flav, right? My heel used to rub so the whole inside of them has virtually gone through to the plastic heel support.

My bedroom is filled with boxes of kicks from floor to ceiling on one wall, plus the spare room and I've got a storage unit. I know where everything is. Basically the newest stuff is on the front of the pile. And the newest ones are the ones where you look for the rotation. And the newest obviously is subjective. It could be—it's the latest purchases, but they might not be the latest releases, you see what I'm saying? Like the Air Max STs that I wore for Air Max Day—they were released a couple years ago, in 2015, and I just found this colorway

on eBay that wasn't released in the UK. That's a dope shoe, there's no hype on it, right? This is another thing that it's about, taking something and just giving it relevance if it hasn't got relevance. Just going, "You know what, this is me, I like this shoe." I don't care whether others like it or not, because I know it's dope. That's the bottom line, it's personal you know what I mean? I'm confident in myself and my look. It's not defined by how rare it is, it's defined by how I make it look.

IV. On Eternity

The most valuable shoes I have, though, are the ones that have been given to me by friends. When you have people that go out like that, it means that much more. Especially in the environment that we're in right now where people will profit off of their friends. Or when people are willing to use their social capital to benefit you. It gives you a general comprehension of what friendship is and what true values are, if that makes any sense.

Like once I went up to the *Complex* office with Clark [Kent]. I go in there and they have the Krink Air Force 1 on display, the crazy limited ones. One foot was the dumb limited release and the other the crazy Hyperstrike Friends and Family version. These were the ones that *Complex* had published in the magazine to show what was coming up. During the middle of his interview Clark stops the two dudes who may have been Russ Bengston and Joe La Puma and were asking the questions, and he says, "Yo, those are Kish's size. You should hook him up, he's family." Like that. And they were like, "Huh, you think?" And he goes, "Yeah, hook him up, man. This is an OG sneaker dude, man. You've got to hook him up, they're his size." And then they gave them to me, which is crazy.

Another time, my friend Matt Langille, who held it down at Goodfoot in Toronto, heard that I had taken Ls on Kanye's first line of shoes with Nike. He had a pair in my size at Flight Club. He called his friend Chase in New York and asked him if he could go to Flight Club and pick up those kicks so that I could have them. The next time I was in New York they were waiting for me and I met up with Chase who gave them to me whilst we ate lunch.

And there was this one time a few years back for the thirty-fifth anniversary of the Superstar, where adidas issued a series of thirty-five versions to celebrate. There were differing scales of availability for each execution but the thirty-fifth was mystery. It was a friends and family release to be given out to those close to the brand but they had a few that they gave away in competitions like at this private event I was invited to where attendees could win a pair. At this draw we all discovered what the mystery shoe was: It was packed in a white leather suitcase, with a brass combination lock. Flip it open, there's a pair of white on white Superstars displayed inside. The whole thing is leather, the sole, the toe box, the lining, everything! Super decadent leather. With shoe trees inside them to help maintain their shape. Plus there's shoe polish, a shoe nourisher, a brush, a shoe horn. But even though I took an L it was cool as my dude Elsey won them.

So one day a few months after this I'm working at a record store and it's a hot summer's day, mad hot, like 90+ degrees. I'm behind the counter with the fans on and stuff, in the scorching heat melting and no one was coming in. Then the phone rings. "Hey, Kish, it's Gary" (Aspden who works for adidas). I'm like, all right mate, how you doing?

"Yeah I'm good, thanks, but just wondering if you can come by the office?" And I was surprised and said, "Oh, okay, cool." Gary says, "Yeah, I got something for you." I was chill and just didn't think nothing of it. I had done Gary a favor some months earlier and loaned him an old adidas leather jacket that I found in a thrift shop so they could reproduce it. So I go all the way from SoHo walking in the searing heat to the adidas office in Covent Garden, over a mile or so up the road or whatever. I go in the office and he says something like, "Oh, Kish, good to see you, mate. Yeah, we've really got to thank you, man, for what you did, because you really helped us out and we really do appreciate it." Then Gary goes, "Just wait here a sec." He comes out with a huge box, right? And I'm like, you joking? He had one pair of the secret Superstars left and he was giving it to me. And I was like, no way! I opened them up and I was like, damn! They were beautiful and my jaw dropped at his generosity and I thanked him profusely. I walked all the way back to the store in the mad heat laden with this huge box absolutely ecstatic. I will never wear them. The value is, well, whatever you want to pay for it, but I would never sell them. They were a gift from a great friend. They'll be handed down to my kids, even my kids won't be able to sell them. They ain't a college fund, this is some archive shit. Artifact shit. Family heirloom shit.

FRASER COOKE

TOKYO, JAPAN

VITALS

When Cooke settles on a collaboration for Nike as its Brand Energy director, the Kish Kashes of the world immediately need to find more room in their closets. Cooke always knows exactly where the heat is. And where it's going next.

CHAPTER

40

I. How to Win Friends and Influence Sneakers

The best collaborations are usually with people who are really, really personally interested in the core subject matter and, of course, are highly creative themselves.

I would say that the majority of the projects I've worked on have been us thinking about what we're trying to achieve, and then trying to brainstorm around who could be a good fit. Of course we're open as well, and if someone comes with something really interesting we haven't thought of, of course we'll consider it and try to find space for it. But yeah, mostly it's us thinking about what we want to do and then implementing it.

We had worked with Junya Watanabe from Comme des Garçons on creating shoes for the runway. That was more of a blue-sky kind of design exercise, creating something new that was never actually commercialized. There was Marc Newson for the Zvezdochka shoe in 2004. People come in and out of the mix. The cultural players shift over time. It's just a case of staying in touch with what's going on out there to know who's going to have a complementary point of view. We're not just trying to jump on what's cool. But there are certain moments where people have a relevance; we just did another shoe with Marc Newson, which is more than ten years later.

I think another one that's been good has been Gyakuso, the running collection with Jun Takahashi from Japan, who does the Undercover label. He's highly creative—more artist-as-a-fashion-designer. It's a collection that we've been working on since, I think, 2010, which is great because the longer you work with somebody, the more you get to know each other and there's a different kind of positive exchange.

We currently have a project that just came out with Arthur Hwang, who is an architect and a specialist in recycling and sustainability. I think we try to balance as much as possible. We make sure that we speak to our core street audience. But again, we're a very sort of innovation-led company so it's in our interest to still work with people from, say, fields of architecture or even dance. Things like that.

Marc Newson doesn't appeal to the same person as, like, A$AP Bari on a VLONE shoe, you know? That crowd's really, really young.

We still need to do more women's.

I can't really say who we're looking to collaborate with in the future because it's like giving out too much information.

We had a particularly good collaboration on the Air Force 1 with Riccardo Tisci, where he really, really loved that shoe. He described it as the Hermès Kelly bag of Nike. He was excited to work on it but also very nervous as to what to do to it, because he didn't want to distort something that he already held in such high regard.

OPPOSITE PAGE:

Fraser Cooke

FOLLOWING RIGHT:

Ricardo Tisci x Nike Air Force 1 RT

Marc Newson x NikeLab Air VaporMax

Nike LunarEpic Low Flyknit 2

II. Leaders Are Not Made by Followers

Honestly, from the product creation and collaboration standpoint, social media hasn't changed things a whole lot. The intent behind why we're working on stuff hasn't really changed; it's really to push things forward, to try to explore new areas that we wouldn't be able to otherwise explore, to work with people where we learn something and they learn something as well. That doesn't really change.

The social media thing has changed consumer behavior and also made everything much, much more mainstream, whereas it was once more niche and specialized.

Some of the partners that you work with have a bigger voice because they're very active on Instagram or something like that. But that's really got nothing to do with design. And we've got to be careful. You don't necessarily want to work with somebody who's just got a large reach but nothing much to say design-wise, which can be the case.

III. Taunting A$AP Bari and Other Advantages of Middle Age

I've been into sneakers for a long time. I'm fifty, so growing up in England, initially it would have been probably adidas because they were there in Europe more. Nike wasn't really there at that point. But for me I got quite interested in Nike pretty early. I used to be into skateboarding. We're talking back in the late '70s, so you would see some of the original Dog Town guys wearing, like, Blazers and I would see tourists coming over wearing Nikes, for example.

My dad lives in Canada, Toronto, and I went there when I was about fifteen and went to Buffalo, New York, and bought a bunch of Nike stuff you couldn't find in England. It was a Nike Legend low-top with a gray nubuck or suede swoosh and gum sole. In the UK all we had was a high-top with blue.

There used to be a store in San Diego that carried a lot of stuff that was from other parts of the country—just amazing stock. So we used to go to the Action Sports Retailer Show, which was kind of the beginning, the birth of the real boom of the initial streetwear industry post-Stussy. And everybody used to raid that place, and that was back in the early '90s. This is before the sportswear companies had started to do reissues. I guess that passion for those types of products led to that first wave of collaboration.

Really, it was born out of that formative process of trying to find those rare colors. There was a certain element that wasn't about real in-depth design, but more about begging Nike to bring back a style that wasn't in production anymore and do an interesting color or material and play with it. That's the streetwear side of the collaborative drive, I suppose, coming from that side of things. People like Hiroshi Fujiwara, or Stussy in the beginning, were too.

That's versus people like Errolson [Hugh] from Acronym who truly and completely want to reimagine a shoe.

IV. Land of the Setting Sun?

What set Tokyo apart—though I don't know about anymore—was Japan's island mentality of taking things from outside, bringing them in, curating, archiving, and being very detail-oriented. People like Hiroshi and his generation who are just a couple of years older than me, they were in London at the end of the punk era and the beginning of the hip-hop scene. They were skaters as well, so again there was the sneaker thing at its core, and it was hypercharged by hip-hop culture.

Naturally, people in Japan are very detail-oriented. Young people are very expressive in how they dress. They like to archive things and know what's behind a thing, whether it's denim or redwing boots or cars or Nikes. I think you can find, like, a lunatic here who is an obsessive collector of anything. And people do limited edition everything here. You get limited Kit-Kats and things like that. So, I think sneakers sort of took off here.

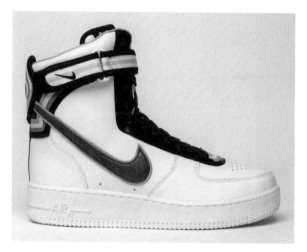

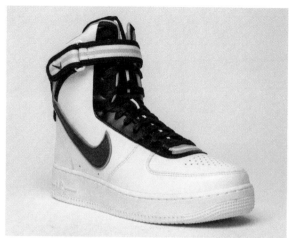

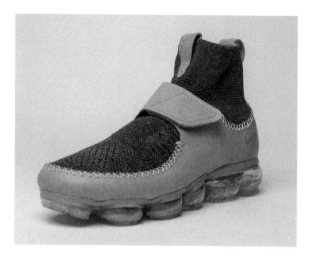

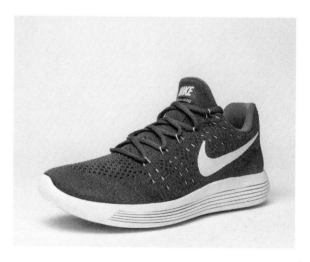

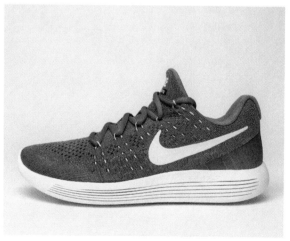

SAM HANDY

BASED IN

HERZOGENAURACH, GERMANY

Tokyo style, thanks to the work of Nigo and BAPE, hooked Handy on sneakers. High-powered design positions with adidas Originals and adidas Football followed. Handy's shrewdness is critical to the brand's understanding of what's cool—and what isn't.

CHAPTER

41

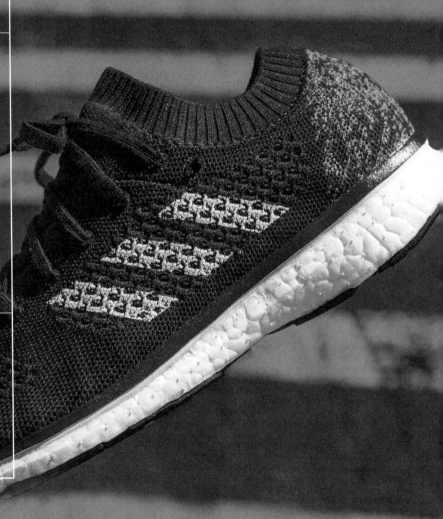

I. Zed's Not Dead

I remember being ten or eleven in a seaside town called Swanage in Dorset and drawing and thinking that I really wanted to be a guy who designed sneakers. But I distinctly remember thinking that there must be just, like, one cool American, and he gets to design all of the world's sneakers, that there's no way an English kid could ever enter the world of those big German or American brands. I pretty much gave up on that idea at that point and stopped drawing shoes.

My big cultural influence when I was growing up in the early '90s was UK rave culture, drum and bass, jungle, happy hardcore, that whole thing. The rave scene was all about running sneakers. Stuff like ZX 8000, ZX 7000, Air Max 90s, that kind of really interesting running tech war between Nike and adidas. I think that was probably the most interesting time in sneaker design. You had the Peter Moore [adidas America], Tinker Hatfield [Nike] thing and I think these were two people who really shaped what sports design looked like for a whole generation. It's a mega privilege to be able to create what sport looks like. And a huge responsibility.

I think that era of sneaker design was very experimental, very risk taking, and people defined a whole new language with Pump, Air, Torsion, Hexalite. It was also quite irreverent. The adidas shoes from that era are incredible, like the Jacques Chassaing stuff. I think that until now that was the most influential period for the adidas brand.

And then I grew up skateboarding, so lots of influence from US skate culture—Vans, Etnies, moving into that kind of puffy '90s skateboard sneakers thing. I was into running sneakers and skate shoes, and then I discovered streetwear culture from magazines like *The Face*. Brands like Bathing Ape, Stussy. It's an interesting one for me actually, because the Bathing Ape NMD came out this week, and NMD was the last shoe I designed in Originals before taking the drop in Football. And Bathing Ape was the first streetwear brand that made me fall in love with streetwear. I've seen those two stories coming together, a brand that I grew up loving and a shoe that I designed. It's pretty cool.

I'm hoping to get my pair next week. I've reserved one. If I don't get my pair I'm going to be kind of pissed because I did the shoe. I've only got one pair of NMDs, the first ones, the OG. I have a bit of the new sneaker rule, which is to only keep OGs and the OG colorway, and not have kind of anything else. I'll break that rule with this Bape shoe.

II. Rollin' with the Foamies

THIS PAGE:

adidas NMD R1 Bape

OPPOSITE PAGE:

adidas UltraBOOST Uncaged

The NMD—I got the job as head of footwear design for Originals, starting with fall/winter 2015. The first project I picked up was at the tail end of some of the first Tubular stuff, which I'm not the biggest fan of. But then there was a really big opportunity to build the first shoe in Originals that picked up on BOOST. The challenge was: how do you build an authentic BOOST product?

I had been making a few experiments beforehand with the idea of die-cutting BOOST. Taking a modern material and applying an old-fashioned manufacturing technique. So we were kind of die-cutting and buffing it. And came out with a really cool look where you just have a wedge of OG die-cut BOOST, not molded and sculpted like UltraBOOST, which are high performance, functional shoes. But when you treat it like an old material, there is this really beautiful chunkiness to the midsole.

BOOST looks like Styrofoam. I think the right way to explain BOOST is that it doesn't look like a material that you would make a shoe out of, and I think that's what's so cool about it. And at first people found it really odd, like, in the brand. People were like, man, who wants to wear a Styrofoam shoe?

Nothing in adidas is ever the product of one person. It's never the product of my idea; it's the product of a lot of different, very skilled, very cool people. I have this conversation with my team quite a lot, that it's highly unlikely that they'll ever get to be the guys who say, I designed that shoe from beginning to end.

I think the big difference between being a designer and an artist is that I don't think a designer sits there and geniuses up an idea all on their own. I think a designer needs to go into the world and see what's happening and create a mirror of the time they're living in, and then offer that idea back to people in an interesting way.

III. Real Talk

Spring/summer 2017 is my first completely Football season, away from Originals.

Right now, I'm wearing the black-and-white Ace laceless UltraBOOST. This is a special shoe for me because it's kind of the first time someone brought sneaker culture into adidas Football. It came from taking a football upper, the best football shoe we ever made, and dropping it on the best running shoe the brand ever made, and then you get a wicked sneaker out of the combination.

I think in twenty years I would be very sad if sneakers look like anything I can imagine, right? They should look like nothing I can imagine, or every designer simply may have wasted their time. I think the point is to create things that don't exist, invent things that no one has seen before.

Right now, everyone is a sneakerhead. Every kid knows what's going on. They understand performance and lifestyle at the same time. They also start to completely understand how brands' marketing messages work. So they start seeing through the marketing stories: they know when a colorway is dropping, they know when the next color launches, they understand the pricing strategy, they understand when a franchise stops looking like the way it started.

I don't necessarily know if in five years the answer is going to be to pump more product into this market. Maybe a little bit less product is what happens in five, six years' time. I wonder if at some point you reach saturation point?

But—the sneaker industry, I think, has got a good few years left in it.

I work with quite a few designers who may be on their first design job, their first time of seeing a fashion life cycle. So they're kind of like, god, this is going to go on forever. But it's boomed and busted three, four, or five times.

I think of the Dunk SB thing in 2003, right? Early thousands. It was the most important thing to have a pair of Heineken Dunks, and it's like, fuck it, I don't care, I want a pair of Chuck Taylors, leave me alone. It went from *I love my sneakers, don't touch my new shoes, they're super crispy, and I've got this brilliant boxed collection of dead stock* to it being more cool to be authentic and to go to a nightclub in a pair of, like, beat-up white rubber soles or Doc Martens. It flipped. And then everyone started wearing dress shoes, and then people went back from dress shoes into sneakers again, and at some point people will be like, you know what? I've got enough sneakers; I want to wear a pair of—I don't know, I want to wear a pair of brogues, right? It's happened multiple times. It will happen again. I imagine at some point sneaker hype will dissipate for a while, right?

JOHN McPHETERS & JED STILLER

BASED IN

NEW YORK,
NEW YORK

VITALS

Stadium Goods, with its chic
Howard Street NYC address,
is redefining the resale
experience; their deal to
distribute in China through
Alibaba has welcomed
billions more into their fold.

CHAPTER

42

I. Sneakers and Waffles

BOTH PAGES:

Stadium Goods store in NYC

JED: I started collecting, buying, and wearing at a very young age in Cambridge, Massachusetts. Before I knew it, I had hundreds of shoes. Jordan Is are my favorites and always will be. I went through phases of having the fever and not having it. I obviously have the fever now. I'm the type of guy who has ten of the same thing. I'm like Ernest. Remember when he opened up the closet and he had ten of the same jackets? That's me, but with UltraBOOSTs. Ten of the white ones, ten of the black. When I'm feeling adventurous, I'll wear some Common Projects.

JOHN: Now, I'm really liking the Atmos Air Maxes. I like a lot of the new Acronym-type mash-ups that Nike does. I like a lot of the special edition NMDs that they've made at adidas. I definitely wear a much wider variety of stuff.

For me, two shoes piqued my excitement when I was super young. One was the original Bo Jackson. The second was the original Reebok Pump. I remember just sitting in gym class pumping them up, and deflating them—again and again and again.

Air Max 95s were also huge for me. I remember running around New York City looking for those on the first release, and then actually getting my first job so I could buy two pairs of shoes in '97. One was a retro pair of the Air Max 95s in all white leather with the black and gray. And then the original was the Dan O'Brien 97s. I worked as a stock boy at the Hallmark on Twenty-Third Street hauling around huge, heavy boxes of greeting cards.

I waited in line once for a sneaker, first and last time, outside Niketown for these Stash Air Max BWs that came out. There were fights on the line. I got the pair, but what a mess. That kind of told me what I needed to do in the future. I needed to find a different way to get things. I'm definitely not a line waiter.

JED: We had mutual friends from college. We're both thirty-eight now. We've been friends for a long time. We've definitely been friends first, business partners second. Before this, I worked in nightclubs and for Team Epiphany. John helped perfect the digital for Flight Club.

JOHN: I got really serious about reselling six or seven years ago. Coming into this, a huge part was planning to have the inventory we needed to launch. It's not just about filling the wall, per se, but getting a deep enough inventory to sell volume online, too. There's a lot of different areas you can play in.

You can play in the really limited arena where you're going after these crazy, hard to get ones. When you come up with one, you win big, right? Or you can go after more of a geography play. Like, for a long time there was stuff that would sell out in New York that wouldn't sell out in Tennessee or Montana. Or there's the outlet route, getting stuff discount and selling it for retail.

JED: Having the most coveted pairs is a big part of this, but it's not the only part. There's also a lot of exciting product in the market that

might trade at a premium because it's sold out every-where, but not quite as hard to find. Like we do huge volume in NMD standard colorways and UltraBOOST standard colorways. Part of the idea is to cater to everybody.

We have thousands of sellers. Guys that are dropping off more and more and more. It's in the four to five thousand range, and that ranges from people having one pair of shoes listed to thousands of pairs. We call it a marketplace and we call them sellers, not consigners.

It's all really strategic. You have to save money and spend to get the right products. It's not just going to come to you by flipping shoes here. It's about developing real knowledge of the market and this economy. Then you come out on the other side with a resale business.

JOHN: At the same time I think a big part of why we do the store is exactly what you said. We need to be personable and have a really strong consumer face to show who we are to the world. That helps to tell the story that then is facilitated by a lot of the online transactions.

JED: It's a really interesting time right now. When we were kids growing up with Nikes, you would have never even been caught dead in adidas if you were on that wave, you know? And now—you can switch it interchangeably. That makes it a lot more exciting from a product standpoint. Things aren't always driven by the same loyalty as yesteryear. Like, for example, we did this event with some friends of ours who own a restaurant on the Lower East Side and in Brooklyn called Sweet Chick. They serve this Sriracha chicken and waffles dish and Fila did a Cage basketball shoe inspired by it. We did the retail launch for the shoe. Rakim performed. Before the event, if you asked me if the shoe would sell out, I'd have said no. But we sold out in twenty minutes. Sneakers are entertainment now. People buy for the experience.

II. Growth Hormone

JED: We opened in 2015 with 40,000 shoes. I'm more the business, finance side. I deal with investors, growing and scaling that way. John is more tech and strategy. We're the co-founders, he and I. We have a lot of other partners as well, including Yu-Ming Wu. In total, there's a team of about sixty now.

We weren't messing around. Now there's way more than 40,000 shoes. No comment on numbers, but way more. We have four different warehouses, very large warehouses. They're all in the Northeast. For safety reasons, I can't say much more about that. We just had a relatively big fund-raising round to grow the business. To do more stores, more online, get more stock.

JOHN: 4.6 million dollars. Interestingly, we have a partnership with Alibaba, so we can actually sell sneakers into China. It's not, like, the lion's share of our business by any means, but it's definitely a nice piece and something we really see expanding.

I wouldn't want to say where the next one is but we have the next one lined up and we're looking to launch. We're very much focused on international growth, for sure.

JED: Price-setting involves a lot of trial and error, and our guys just knowing in their gut what they think the prices should be. In a lot of situations there's already an established market from eBay and other data sources. A lot of times, we'll be the first ones to have a sneaker, and we have to set that price and kind of guess where it is based on past releases. But the guys who do that in our business, the guys who run the consignment team, just have a really good understanding of that market price and where it sits and how much things will go for. And our goal is not to set the price super high. We want to drive the transactions. We're trying to be as price competitive as we can. At this point, the word's out. We started with personal relationships and it spread from there. And honestly speaking, it's a business. If you're not turning over product, you're not going to have that line at the seller side. These guys are making money, and I think we offer a service that's really plug and play, just drop it off and don't worry about the rest.

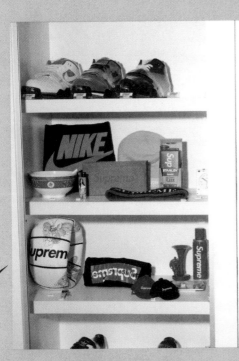
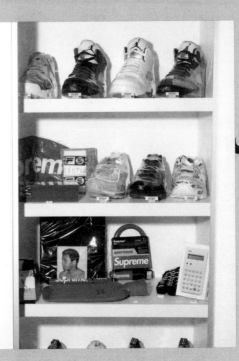

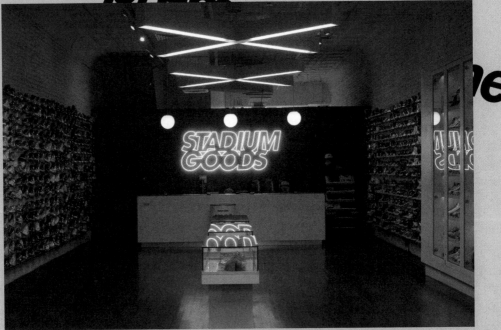

III. Clean Money

JED: Speed's important. Getting a release in fast. But it depends on the shoe. Sometimes you sell a lot more right around the release, other stuff takes longer. We try to be as fast as we can with it. We pride ourselves on being fast.

A lot of it is relationship-driven. People manage to get their hands on a pair a little early and bring them to us. Sometimes it's when brands have seeding programs and they release stuff early and give them to celebrities. Or sometimes stuff will just hit the streets a little beforehand.

JOHN: A lot of our value proposition and what we're priding our sales on is that you have this point in time right now where it's a lot more acceptable to shop after market than ever before. It doesn't have that dirty consignment connotation that it's had for a long time. And retail is changing so fast, so we're sort of in the middle of old and new, with a wide product breadth, but also the high level of service and presentation of traditional stores.

With the brands, there's definitely a lot of curiosity, since we're not the traditional point of sales. It's all been very positive and collaborative. With Nike, we just collaborated with them publicly on a branded communications event that they did at ComplexCon for the Air Force 1, and we actually provided the product as part of that launch—the background legacy product for them to push out a bunch of new ones. The idea was for us to sell rare pairs for ninety dollars apiece. That was the first time that Nike as a brand has ever acknowledged resale or after market in any way, so it was really exciting for us to be a part of that. They mentioned us by name.

When they want to pull legacy product, all of the original stuff that excites people, there's just not that many places that they could go to find that type of stuff. So they hit us up, let us know what they were doing, we got in the mix on it, and we provided a bunch of the product, and we actually went out and found some product that we didn't have as well paint this picture of all of the greats, all of the grails that had never been released prior.

There has been talk about design collaboration, too. I wouldn't want to get in to details about what that is but we've definitely talked to some of the brands.

IV. Inside the Trophy Case

JOHN: We're around a lot of shoes, but they can still blow my mind. A lot of these really rare one-offs that you didn't even know existed are pretty crazy. We sold this pair of Macklemore Jordan VIs with a shark embroidered on the back in this crazy dark pink color. I had never seen that shoe or known of it prior to seeing it come in. A lot of that happens, whether it's the player exclusives or celebrity collaborations or friends and family stuff that's pretty tightly controlled. There's the $30,000 Jordan-Kobe pack that we have up there now. It's a Jordan III and a Jordan VIII in Lakers colorways. Man, would I love to have those. I probably won't. I think thirty pairs total were ever made.

A lot of times when a shoe comes in, someone has a story to tell about it, and they have an idea of how many pairs there were. Other times, it's like, "Hey, this is a one of one." Once this guy came in with this pair of Nikes, a sample pair I'd never heard of.

JED: We definitely authenticate every shoe though. We look and touch and feel every shoe no matter what.

JOHN: It's a long list. Anything down to the smell, the alignment of stickers, the way the sole is printed on the rubber.

JED: We have a protocol.

JOHN: It's not something we would share publicly, but we always say that if we're 99.9 percent sure it's real we don't take it in. So it has to be 100 percent every time. We knew the seller on that Nike, but had some doubts about the shoe and we went crazy trying to find out if it was real. So we dug into it and sure enough it was something somebody had very quietly made at Nike. It was verified 100 percent even though it's something even people in the know had never seen or heard of. Those things exist, you know? They're around in the world.

Imagine what's in the Nike archives. The craziest stuff ever. A friend of mine has a pair of samples of the original Kanye shoe, and the coloring on the strap, for example, is different from on the Air Yeezy that was released.

It's always a little bittersweet when pairs like that sell because you have something that adds so much to the cache, and then all of a sudden it's gone. And you're like, oh man, now it feels like there's a hole there. The collector inside of us is like, man, I wish we could just display that for the world forever, but—

JED: I think the Undefeated Jordan IV, for me, is one like that. Deep green, orange laces. How much were those? I think they were the most expensive pair we've ever sold.

JOHN: Eighteen grand?

JED: No, twenty-two. And that's not going to come back in for a while. But all good, we sold it, it's fine. It's a business, but, yeah, it hurts sometimes.

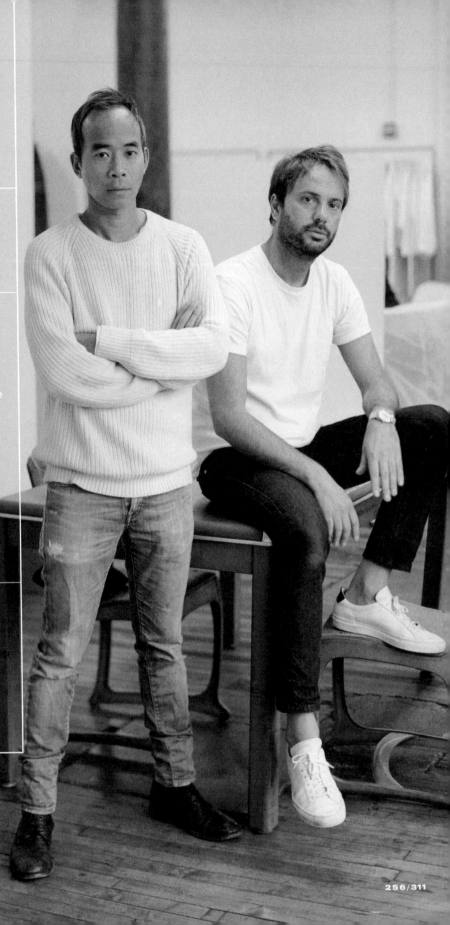

FLAVIO GIROLAMI & PETER POOPAT

BASED IN

NEW YORK,
NEW YORK

VITALS

Jed Stiller isn't the only one to default to Common Projects when he's not in the mood for Air bubbles and UltraBOOST. Girolami and Poopat's elegant, minimalist signature silhouettes show that the most simple sneakers can also be the most timeless.

CHAPTER

43

3701 37 05

COMMON PROJECTS

PETER: We definitely weren't sneakerheads. Maybe we each had one pair of sneakers at the time we started Common Projects. I was an art director at a magazine. Flavio was a brand consultant. I don't even know if you had a pair of sneakers. Did you?

FLAVIO: I did.

FLAVIO: It's the same process of making a dress shoe, but instead of using a leather sole we use a rubber sole. That makes it a sneaker.

PETER: The most pared-down version of the sneaker, the simplest version. There's no technology. It's just rubber and leather—for the most part leather.

FLAVIO: Of course, we were inspired by the classics.

PETER: We were only looking at vintage sneakers that had no technology, like Converse, because maybe we were wearing them.

FLAVIO: And the old-school adidas. Stan Smith before the Stan Smith craze.

PETER: Rod Lavers, Jack Purcell's. Maybe an occasional Van, but—all of those brands and all of those styles had such a particular cult status to them. We wanted something that didn't have that baggage, you know? We did two styles, a low and a mid. Not until way later did we actually make an Achilles high, and before the Achilles high, we did a BBall high and the BBall low. So our idea of a high-top was more like a basketball shoe. The sneaker world is so crazy now. I don't know how anyone can keep up. Back in the day, Converse actually asked us to collaborate, but I don't think they knew that we were also the owners of Common Projects. I think they were trying to get the designers of the Common Projects. But it was a funny moment: For a sneaker company to pair with another sneaker company and do a collaboration.

FLAVIO: The very first sample was done with lamb.

PREVIOUS LEFT:

Peter Poopat and
Flavio Girolami

OPPOSITE PAGE:

Common Projects Achilles
Low

THIS PAGE:

Common Projects Achilles
Leather Low in silver

PETER: And we decided that it was just too soft.

FLAVIO: It looked almost like a slipper or something.

PETER: We were literally at the factory and we were talking about what to do on the outside of the shoe—

FLAVIO: There are factory-standard numbers that they usually do inside. There's the article number, the size, and the color.

PETER: And I think in the heat of the moment, when we saw these golden numbers inside—we said, let's put it here on the outside. And it came out beautifully, so we kept it.

FLAVIO: We just let the shoe talk for itself.

PETER: Yeah, we never want to be that pushy brand that's always in your face, you know? We prefer that someone discovers it. We prefer that someone in Des Moines, Iowa, discovers it and falls in love with it. The more people who discover it on their own, the more they fall in love with it.

FLAVIO: The original sample was white.

PETER: We just called up people we knew and said, oh, we want to show you something. And we showed them, and they all immediately wanted to order. So that was sort of when we realized we had something.

FLAVIO: Actually, the very first order was sold in Japan.

PETER: And from there we kind of had to create the whole thing behind it.

FLAVIO: There are so many things that drive up the price.

PETER: When we first launched eleven years ago, there was nothing else in that price category. And that was a little bit scary, and people—even in our showrooms—were like, how can I make this cheaper? Now shoes are a lot more expensive. They're not necessarily something Flavio and I would go and purchase if we weren't the founders and designers of Common Projects.

PETER: We're wearing white Achilles most of the time.

FLAVIO: I'm just wearing a prototype.

PETER: Luckily Flavio is sample-sized, so he gets to wear those—

FLAVIO: It's, like, a special leather.

PETER: It's a special leather with a pattern. We're really about keeping things as generic as possible in some ways, simple. So the perforated always comes into play; it's something that is sort of standard. We like the idea of standard, and then every once in a while we do what we call a special, you know? And that special is usually in the patterned leather or some sort of embossing—embossing or a special material or a special animal that is not endangered. We've done python.

FLAVIO: And we've done croc too.

PETER: And then they go for a lot of money because we only do four or five of them.

PETER: I don't know that you would find a Common Projects head at Sneaker Con or whatever. It's Sneaker Con, right? I have never been to a Sneaker Con. My son has, but he's not a sneakerhead. It's funny, because I gave him a pair of Common Projects, and he's been wearing them at school. He was rock climbing and there was another kid who got very flustered and said, "What are you doing? You're rock climbing in Common Projects!" And—and he just kind of smiled; he didn't say anything. I sort of taught him not to, but—his friend was kind of like, "Well, maybe because his dad owns Common Projects." It's happened to me too. I've been out kicking the soccer ball around and a dad or something will say, "Dude, what are you doing wearing Common Projects to play soccer?" It's funny. But that's what we designed them to do: to be worn. I love taking pictures of destroyed Common Projects. People send us pictures from time to time of their shoes, like, in India or on a mountain, and that's kind of awesome. They're all muddy. It's amazing to see people actually wear these for those types of things, and see where the shoes have gone.

MARC DOLCE

BASED IN

BROOKLYN, NEW YORK

VITALS

Where Common Projects frames simplicity and consistency as a statement, Dolce, working of out of adidas's new Creator Farm, is looking to test the limits of what sneaker making is. His aspiration? Design that breaks boundaries.

CHAPTER

44

I. City Streets

It was really tough growing up in New York. My mom was a single parent. We lived together in a basement studio apartment in Sunset Park. I started working, delivering food for a local grocery store deli, when I was twelve. Things like brand-name shoes weren't attainable for me. I remember my mom buying me lots of shoes without brands and trying to force me to wear them.

I looked up to the New York sports icons and spent a lot of time sketching the Knicks—Patrick Ewing, John Starks, those were two guys I grew up idolizing. I would always spend a lot more time on their footwear. There was something about the shoes. Whether I could have them or not, there was an emotional connection.

At fourteen and fifteen years old, I was playing sports and got obsessed with wondering about how to make athletes better. And I started to notice more customization. I'm forty-one, so that was a time when people would replace laces with fatter ones and stick the tongues out more. Some people would draw or paint on their shoes. Those were the things people did that made their shoes special. I struggled with customization because I didn't want anything permanent. Part of creation is always thinking about the future and thinking about change. I struggle with tattoos for the same reason. I never got one because I knew I'd want to change whatever I did in the morning by nighttime.

Coming back to Brooklyn is a way of completing a circle. I would really love to create opportunities for my community and focus on the next generation of talent. For me, one of the missions is developing talent. Another is focusing on bigger issues.

I really like where the brand is going through Futurecraft. It's something that means a lot to me. Yesterday, they released a concept at the Biofabricate Conference: using Biosteel, which mimics natural spider silk and is 100 percent biodegradable. It's focused on the world's ecosystem. The Parley shoe is about that idea, too. It's made with recycled ocean plastic.

I also love the idea of co-creation: an ability for consumers to create the products that they wear on their feet. In the future, people may be able to print their own adidas shoes at their house, you know? They may not have to go to a store. They can maybe one day have a digital download of the file—like the way music gets downloaded now—and be able to create that product at home.

II. On the Farm

So what is the Farm doing? The Brooklyn Creator Farm in Greenpoint is a change agent, a think tank, an open source creation center. What that basically means is it's a place for creators to gather, to collaborate, to explore, to play, to sometimes fail, and to create things that we haven't seen before.

THIS PAGE:

adidas Brooklyn Creator Farm

OPPOSITE PAGE:

Marc Dolce

My role is centered around conceptual creative direction, thinking about where the brand is going to be two, three, four years ahead, and start to provide insights and inspiration for the rest of the brand. I'm like a coach-player. I love the idea of a farm being a place where we grow and cultivate ideas and talent. For me, that's a great part of what this is: an opportunity for us to work on people, on product, and also on the process.

We have a small team here. It's about fifteen to twenty people full time, but we also rotate designers in and out and they come in for three months from Portland and Herzo and Japan. We're really trying to instill new processes that allow people to be more collaborative. As a designer, sometimes you work in isolation, but I think the best designers work in collaboration, when you're constantly sharing and exchanging ideas.

Within the Farm, no one has a permanent seating location. So every day you come in and you're either working on a different project or task, or you're working collectively with others. We also have team huddles every morning where we get people together and review the projects that are happening for the day and the week. We give people an opportunity to work cross-functionally. It's amazing to have a footwear designer do apparel and apparel designers do footwear. We provide all of the tools they need by having a maker lab embedded in the Farm.

It's almost like a Disneyland for designers. There are 3-D printers, laser printers, laser etchers, vinyl printers, sewing machines, spray booths, band saws, even knit machines so we can knit our own uppers. Over the last six months, we've been able to make over 200 footwear samples and probably 150 pieces of apparel. And we'll probably be able to make them quicker now that we have lots of these shell patterns.

Designers can take a two-dimensional sketch and make three-dimensional products within the same day. I've been in the industry for twenty years and I've never had the tools that we have here so readily accessible, where designers sometimes don't even sketch and they basically come and start working in the maker lab, and start building and creating products. It's so much nicer to be able to put a shoe on the table versus putting a sketch on the table. I think what

we're really trying to do is give them all of the creativity, all of the freedom and everything that they would need to be the best of themselves.

We use the mantra here "Create without limits; design without limits; dream without limits." There's always a limitation to how far you can push, and here we try to remove that and really allow designers to explore in a conceptual way—to really push themselves. And at the end of the day, it's not about what we can get from them, but what we can give them.

I come in every day amazed by what the team has done the night before. The designers here are incredibly passionate, and they want to work late. And then when you come in and you just see these amazing forms and gestures, they're not products you can ever put on, but they show a design intent. They are made of sound objects and materials that you can't actually put your foot in, but they show a direction, they show a point of view, they show where we would like to go. And to me, those are the ones that are the most inspirational, the products that you can't wear, but that show a design language, a form, a study.

We use a lot of found pieces, from sponges to insulation foam to hoses to anything you can pretty much find in a hardware store. Seeing designers use these tools to make and to create—I hope I can share them with you one day so you can actually see them for yourself. They're really, really, really interesting. One design was made from an air filter, you know? I walked in and it was shaped and showed the gesture of what speed could look like. It looked fast. These are things that can't be drawn. You can only get it by making it, by creating it.

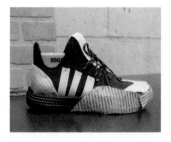

DRAW WHAT YOU BELIEVE IN. AND THEN FIGURE OUT HOW TO MAKE IT.

MARK MINER

BASED IN

BROOKLYN
NEW YORK

VITALS

Dolce's adidas Farm colleague is one of the deepest thinkers in the game, employing memory, philosophy, and identity into his design practice. To him, the shoe is much more than the sum of its parts.

CHAPTER

45

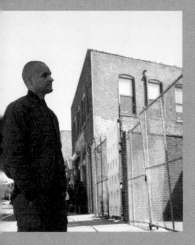

BOTH PAGES:

Mark Miner

FOLLOWING LEFT:

Workspace at adidas Brooklyn
Creator Farm

My journey starts with my mother and my father, and their ancestors—histories made up from many different cultures. From my mother's side it's Irish, French, and Native American. From my father's side it's Venezuelan, Mexican, and Italian. From this I believe comes the idea of imagining what's possible in design.

I was born in Boston, Massachusetts. I'm thirty-three and the oldest of eight children; we lived in many different states. Within those towns and cities, I constantly faced things that were not always the norm. We had a typewriter, not a computer. We didn't have a TV. And through all of this, there's a continuum of adversity—and of the acceptance and joy of the journey: not looking back and questioning why this happened and that happened, but actually embracing it. Design really allows me to channel and provoke these ideas. Coming from different cultures makes me fit into a collective where the things we build can serve not just as products but as vehicles for sharing ideas.

Through all the travels growing up, we had boxes labeled "clothes" and "toys." There wasn't really a box labeled "shoes." My very first pair were bronzed; I think at that time that was what parents would do. They look like little muffins compared to the size thirteens I wear now, but it really shows infatuation with product and that product means something in your life. In this case, in shows journey. It shows growth.

I played basketball a lot as a kid. I'd wear basketball shorts beneath my pants in case people talked shit so we could play right away. My brother and I were lethal in terms of taking people's money. We would play in and around Michigan and travel around the Midwest. Art and design had also been around our household, but I never saw it as a profession. I made some work out of curiosity but didn't want to go to school for design, so I actually hid my work all over the place.

Without me knowing, my mother found it all and submitted it to Parsons. I got accepted, but knew I'd only have enough money for one semester. So, I went about it the same way I grew up: by absorbing, engaging, asking questions. You're not going to sit back and just let it come to you.

So, first semester, I'm staying up all night making paper shoes with hexagonal patterns, thinking about body mechanics and movement. I'm also using a lot of my tuition grant for buying sneakers that I was never able to get growing up. But instead of continuing to spend the money in that way, I started going to Payless and Foot Locker so I could buy things I didn't like for half off so that I could cut them up, redraw, and retape them. I wasn't taking a footwear design class in school that first semester and I didn't know I'd be able to afford a second semester, so I decided to give that class to myself.

I ended up with all these products and ideas around me, and my girlfriend at the time was like, "You have to go meet this guy, Howard Davis." He's Jamaican, has white dreads, cowboy boots. I showed him

"We have yet to find the word beyond 'sneaker' for what these things truly do within our culture."

my prototypes and he was like, "Okay, this is all shit, but I see you have passion." Howard sent me to another guy in Brooklyn for a job interview. I didn't know whether to wear a suit or this big Perry Ellis leather coat with embroidered logos all over it that I was wearing at the time. Howard said, "You should go in with how you feel comfortable and with what best represents you." That was a big lesson.

When I got to the place, they saw my portfolio and thought I wasn't a fit. They were designing construction boots; I was showing them sports designs. But I wanted to get hired, so I asked, "Hey, can you please show me what one of your designers does here? If you show me, I can do this." The guy looks at me like I'm a punk, but for some reason he showed me their work. I looked it over, went home, worked for a week on top of my nineteen school credits, and came back to him with a new portfolio demonstrating I could be a part of it. That's the start of how I ended up in this industry.

And that's the start of this conversation about how design progresses and moves, how it brings people together. How the things that you're creating are actually touching and engaging with different parts of the world. It echoes the diversity of culture I grew up with, the stretching of boundaries, the idea of bronzing those baby shoes. It's about acknowledging lifespan: products marking moments in time.

I feel like the vocabulary sometimes just fall short, you know?

We have yet to find the word beyond "sneaker" for what these things truly do within our culture.

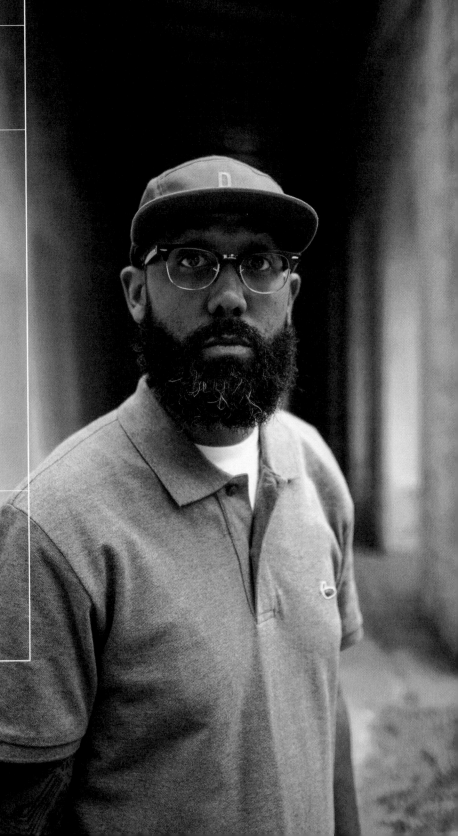

RICK WILLIAMS

CHAPTER

46

I. Sole Records

I started out as an intern at Burn Rubber. My partner, Roland Coit, and I purchased the store from my mentor in 2007. In 2010, we started doing collaborations. Our first collaboration was with New Balance. The silhouette was the MT580, my favorite model, and we decided to use it to tell our own story, the visual story of the brand: the Burn Rubber colors, orange, black, and gray, which we did in an argyle liner. After that, we started using collaborations to tell the story of the city, to tell the story of Detroit.

We did another MT580 collaboration in 2012 and called in the Workforce Pack, inspired by Detroit's blue- and white-collar workers. We wanted to tell a story about the economy and bring to light the hardships people go through, especially in the auto industry. This was our homage to them.

With Reebok, we did a shoe called the Spirit of Detroit, which is a monumental statue here in Hart Plaza, where a bronze Renaissance figure is holding a glowing orb in one hand and a family in the other. The shoes say "Family" and "God," important values around here.

There was the New Balance 574 we did for Miguel Cabrera's triple crown. Oh, the Miggys are crazy. We only had seventy-something pairs of those and those were sold at our story only.

We did a New Balance 572 in green and gold as a tribute to Vernors, which is Detroit's version of ginger ale.

We were one of the first boutiques here that tried to tell stories in this way.

II. The D Goes Digital

One of the most recent projects came out of my growing passion for photography.

I was like, you know what? It would be a dope thing to do a pack of shoes that are inspired by some of my friend's photographs.

So, these are all people that I'm fans of. I met a lot of them on Instagram and they happened to move in this industry as well. I had this hashtag that we used at Distinct Life to identify and find the dope images that we love, #DistinctViews. That's what we called the pack, the Distinct Views Pack.

Putting it together, we collaborated on Reebok's Bolton silhouette and made a four pack. One was with the photographer Bludshot, inspired by a photo he took in Hong Kong. Another was with Ta-Ku, inspired by an image from Tokyo. Another was with Steve Sweatpants. He shot the image in a New York City subway. And one came out of an image I shot here in Detroit, in Brush Park. The image had a lot of gray scale, with a pop of color coming from the trash.

I think we made 1,500 pairs for the pack. We grabbed about 120 for the store.

I don't know if this is the first pack inspired by social media, or by Instagram, but it might be. I love that there's now the ability to see dope work, find the people behind it, and do a project that raises awareness about them.

THIS PAGE:

Downtown Detroit

OPPOSITE PAGE:

Rick Wiliams

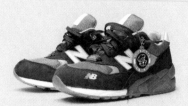

BURN RUBBER X NEW BALANCE MT580
"BLUE COLLAR"

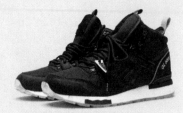

DISTINCT LIFE X REEBOK GL6000 MID
"CAMERA"

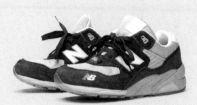

BURN RUBBER X NEW BALANCE MT580
"WHITE COLLAR"

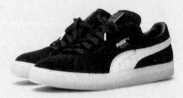

DISTINCT LIFE X PUMA SUEDE

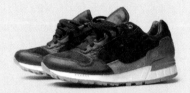

BAU X DISTINCT LIFE X SAUCONY SHADOW
5000 "DISTINCT LIFE"

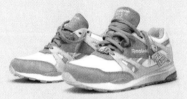

BURN RUBBER X REEBOK VENTILATOR
"BOBLO BOAT"

DISTINCT LIFE X PUMA IGNITE

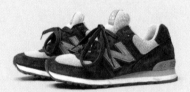

BURN RUBBER X NEW BALANCE 574
"THE MIGGY"

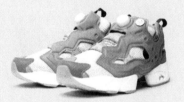

BURN RUBBER X REEBOK INSTA PUMP FURY

DISTINCT LIFE X REEBOK BOLTON
"DISTINCT VIEWS" PT. 4

DISTINCT LIFE X REEBOK GL6000 "NAVY"

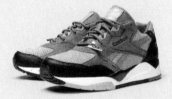

DISTINCT LIFE X REEBOK BOLTON
"DISTINCT VIEWS: DETROIT"

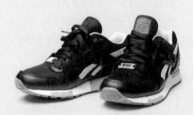

DISTINCT LIFE X REEBOK GL6000 "BLACK"

BURN RUBBER X REEBOK QUESTION
"INQUIRY"

BURN RUBBER X NEW BALANCE 577
"JOE LOUIS"

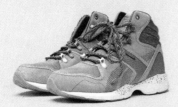

BURN RUBBER X REEBOK NIGHT STORM

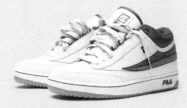

BURN RUBBER X FILA T1-MID "DOUGHBOY"

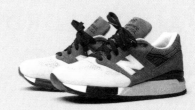

DISTINCT LIFE X NEW BALANCE 998
"DETROITERS"

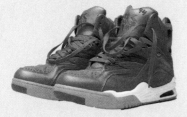

BURN RUBBER X BRITISH KNIGHTS
ENFORCER HI

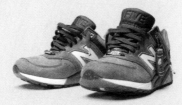

BURN RUBBER X NEW BALANCE 572
"VERNORS"

BURN RUBBER X REEBOK CLASSIC LEATHER
"SPIRIT OF DETROIT"

DISTINCT LIFE X REEBOK BOLTON
"DISTINCT VIEWS" PT. 3

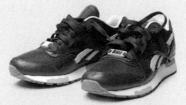

DISTINCT LIFE X REEBOK GL6000
"BURGUNDY"

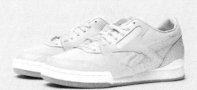

DISTINCT LIFE X REEBOK CLASSICS PHASE 1
"DETROIT PLAYAS"

DISTINCT LIFE X NEW BALANCE 574
FOR MIKE POSNER

DISTINCT LIFE X REEBOK GL6000
"OLIVE GREEN"

DISTINCT LIFE X REEBOK BOLTON
"DISTINCT VIEWS" PT. 2

BURN RUBBER X NEW BALANCE MT580

BURN RUBBER X PUMA STEPPER

JAZERAI ALLEN-LORD A.K.A. JAZZY

BASED IN

EDGEWATER, NEW JERSEY

VITALS

This former Kicks on Fire scribe turned entrepreneur and voice of reason for Instagramming millennials hopes she can teach you to channel your inner Beyoncé.

CHAPTER

47

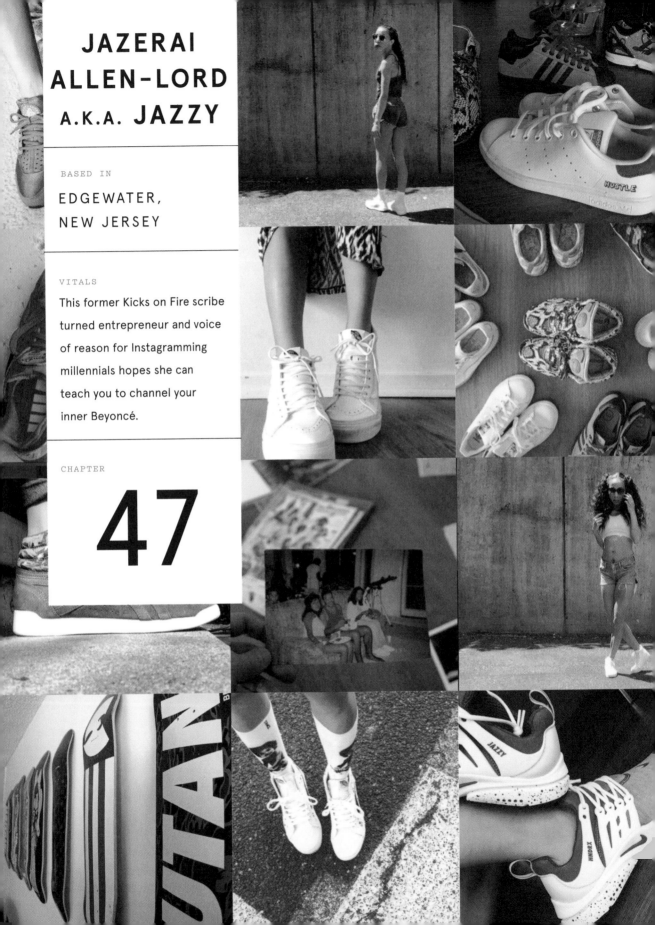

I. Style and Struggle

My mom left my dad when I was two. He had a heroin and cocaine addiction dating back to Vietnam. She told him that he couldn't see me until he got clean, and that wasn't until I was in sixth grade.

Mom worked all day and then went to class until ten o'clock. I was alone a lot, so I really was engrossed in books and magazines. I was reading *Jane* and *Cosmo* at ten. I just really became obsessed with words; words were like my best friends.

My mom was a single mom, and she wasn't getting child support and didn't have $40 even to get me a pair of shoes. And so I would have sneakers from Payless or Walmart. Sitting in PE, looking at my feet and then looking at what everybody else wore . . . I became obsessed with having them. I wanted what I couldn't have. Sneakers became my topic of research.

It moved from poetry and these sad love stories to finding a shoe and where can I get the shoe and what's the next shoe. All of that became my obsession.

When my dad came back into my life, he was really into shoes, and that gave us a way to relate. I really had no idea who he was, but Dad was heavy into '90s flashy fashion. He always wanted to be, like, a cool dad with the cologne and the watch and the whole thing. He was always in Jordans, but he didn't play basketball. And that definitely rubbed off on me. We'd go to Foot Locker, and he would never buy sneakers for me because they were so expensive and he had six other kids. When I was old enough I got a job at the mall. I tried getting work anywhere that had a sneaker department. Neither Foot Locker nor Finish Line would hire me, so I joined on in the old man's department at Sears, selling Dockers.

That job was cool because I got to go into Foot Locker all the time. That's where I spotted the Jordan XI IE lows in cobalt. I was sixteen and didn't have the $75 they cost, so I put them on layaway. I'd go into the store every day just to look at them. It took me two months to pay them down. That was the first important pair of shoes to me. The whole experience behind it is what sneakers is all about. The story, you know? The person behind the design, or the perspective. Most of the time people assume that it's the colorway or the athlete, and it's really not.

What relates people to the shoe is the story that it tells.

II. Sneaker Bride

There's a difference between loving sneakers and being part of a larger community of likeminded weirdos. I found the sneaker community because I was into cars. I used to build Japanese Hondas and race them. Car culture is, like, heavy Japanese, heavy Filipino; and sneaker culture is heavy Japanese, heavy Filipino. So I would see those shoes on people's feet and it was like recognizing a whole community of people who were just like me.

We'd get together, camp together, and have picnics. There would be Saturday meet-ups for sneakerheads—you'd wear a fresh pair and you'd have them all on display. That's how I was introduced to Nike SB and Japanese releases, and brands like ASICS. We put together a Dunk exchange because we had these regional groups of sneakerheads that would get together, and it would create space for you to trade or sell shoes.

I really had an SB obsession because I was a skater. SBs became my first group of shoes that I ever really collected. In 2006, when I got engaged and started planning my wedding, I decided I wanted to be comfortable and be true to who I was. I decided I was going to wear sneakers underneath a $5,000 dress that I had custom-made in Italy. People were really upset about it. There weren't even female sneakerheads at that time; there weren't sneaker blogs, either. It was just a crazy idea that nobody liked, and I did it anyway. I wore the Nike SB De la Soul

highs because De la Soul was, like, my favorite hip-hop group, those shoes were the first shoes I ever camped out for, and they were the first pair of shoes I ever spent a lot of money on.

My wedding photographer took the most epic photos of all time. My dress had all the bustling underneath, so I couldn't even reach my feet. There were a lot of epic photos of my shoes underneath the dress and me trying to tie my shoe in a wedding dress.

Kicks on Fire had just opened that year, and Complex I think wasn't even a site yet, or a fully established network. They didn't have the sneaker side; they only had Complex. And they somehow came across the photos, and Furqan Khan, who owns Kicks on Fire, reached out. We talked a lot about sneakers, and then within fifteen minutes he was like, "Are you a writer?" I was like, "Yeah, I am." And he was like, "I just started this little blog; I'm looking for writers. I can only pay you $5 an article. You can write however many you want, but I would like you to write like five a day if you can. And just talk about the shoes. Just

find shoes on the internet and just talk about them." And I was like, "Oh hell yeah. That's all I do anyway, sit around on the internet and look at shoe stores."

Girls who were starting to pop up in the sneaker community—they were doing topless shoots. Or they were posing in nothing but their

boyfriend's size eleven shoes. So I told Khan, "You can never show my face, and I'll never show my ass. And as long as we can agree upon those things I'll work for you."

I ended up staying there for nine years.

III. Perfect Your Hustle

There are so many cool women doing cool things in sneakers, like designing, opening their own botiques, climbing to upper management at big compaines, starting their own brand. That's why I think being a voice is so important to me

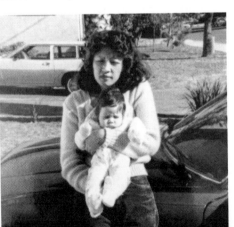

right now. The opportunity is there for so many people to win if they do it correctly. The doors are open for everybody to do anything. If you have the motivation, the talent, the smarts, then the world is at your disposal thanks to the internet and social media. I worked in this business before it was a business, and so that's why I'm so passionate about helping people find the right way to success.

I know that part of the whole marketing of yourself is that people know your face, what you look like, your body, your words—it's the whole package, you know? When you're posting your photos, the sex appeal has to be there occasionally. The goal is to guide people in general, but particularly for young women to guide them to respect and love themselves. If

you're going to show your vagina on the internet, that's cool, but get the check, you know?

Listen, I have no hate at all for women who show their body and use sex as a serious angle for their brand. That's not the issue. The issue is they're not doing it correctly. *Playboy* is never going to cut the check for you if you continue to give it to Instagram for free, you know?

I tell them to tone it down all of the time. They look at it like, only two thousand people are looking at me. Who cares? I tell them, you want to win? You can't say that type of shit, you know? Nobody will ever touch you.

I take my visual presentation very seriously. It's what makes me my money. As soon as ASICS sees something on Instagram that they don't like about my life, it's over; the checks stop coming. My goal is to be the Beyoncé of whatever I'm doing, you know?

I personally don't care how people in general feel about me, but I care about how the people

that cut my checks feel about me. There are no surprise posts because you just never know. I literally went from fifty followers on Instagram to five thousand overnight.

Every caption is intentional; every tweet is intentional. Every photo, every angle. I don't do anything that's not intentional.

I just encourage women to be smart about whatever their hustle is. If being the sneakerhead with the hot body is your thing, then make the biggest check possible being the sneakerhead with the bangin' body. Because now there's a Kia Sportage commercial saying, use this car if you're a sneakerhead because it's perfect for campouts or resellers. And then there's the Honey Nut Cheerios bee dancing in a pair of LeBrons.

That's a real thing.

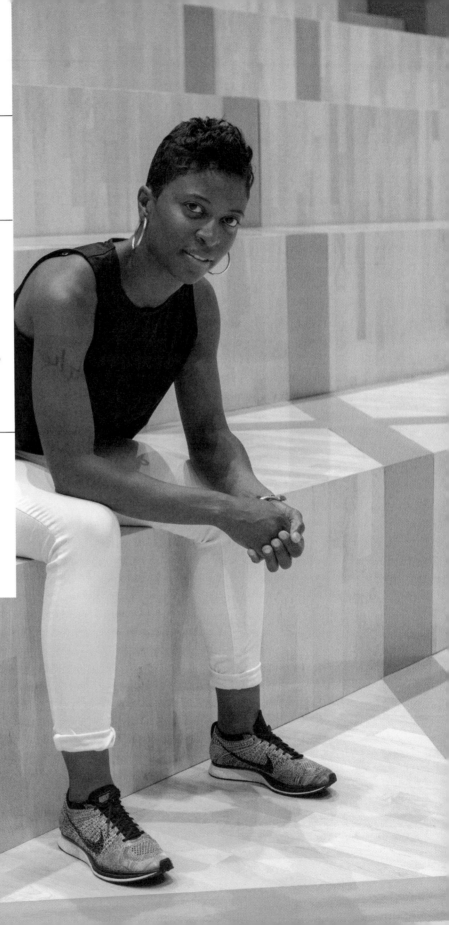

BRANDIS RUSSELL

BASED IN

NEW YORK,
NEW YORK

VITALS

"Shrink it and pink it" used to be the order of the day when it came to women's sneakers. Brandis Russell has spent her career at Nike endeavoring to give women something fresh all their own.

CHAPTER

48

Brandis Awareness

31 inch

5 inch

20 inch

6 inch

3 inch

I started at Nike in apparel in 2004. I was there for two years. A small group of us were hired to get an apparel line off the ground that would hook to Nike's most coveted sneakers: AF1s, Dunks, Blazers, AM 90s. That experience helped me understand the responsibility we have to create a meaningful product. From there, the Jordan team reached out in 2006 and said, "Hey, we just launched a women's apparel line on *Oprah* and we're getting a great response, would you want to come over and work on women's footwear and apparel for Jordan?"

I'm like, "Yes! Jordan wants to do women's? That's awesome!" The Jordan XIIIs were the first sneakers that I actually remembered being really stoked about getting, because I had to pull good grades to get them. They were actually men's shoes, because we hadn't started working on girl's shoes at the time. I dreamed of developing a line of footwear for girls that men would equally covet. Something that would transcend gender and yet represent something special for women who loved to wear sneakers.

What makes a woman's shoe cool? Shape and proportion, for one thing. It was really important to look at the female foot shape. To look at what would be extremely flattering when it was on her foot. Understanding the triggers that she would respond to was something we obsessed over, such as, elongating the look of her leg, creating the illusion of her feet looking a little bit smaller. We really did a lot of science with the support of our development and engineering teams to understand the type of construction necessary to make crush-worthy footwear for the female consumers.

A few widely adopted models our sportswear team developed before I joined the business were the Air Max Thea and the Dunk Sky Hi, both created specifically for her. The Dunk Sky Hi was derived from an iconic sneaker, but relied on feminine nuances, too, like a sleeker toe and stance that would give her a lift. We called this style the gateway to sneaker culture for women.

Finally, showing her how to wear the product was another important component of driving sneaker culture for her. While we were immersed in a culture of sneaker lovers, we realized that many women still didn't feel confident styling sneakers as part of their wardrobe or curating a look with a pair of high tops. That look has become the norm now, but just five years ago the comfort, ease, and prevalence of women in sneakers was not nearly as widespread.

fig 1. Leg

fig 2. Air Dunk Sky Hi

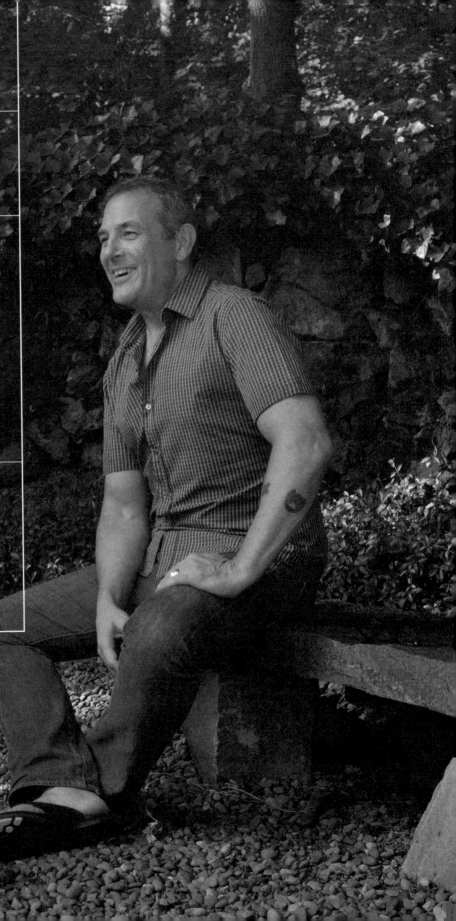

MARK
SMITH

BASED IN

PORTLAND,
OREGON

VITALS,

While Russell shatters style's
glass ceiling, Smith cuts into
Nike sneakers with a laser.
He has turned an industrial
tool into a paintbrush,
making the laser one of the
most dynamic and dramatic
mediums ever.

CHAPTER

49

I. Laser Tags

A long damn time ago, in 2003, one of my colleagues, Jay Meschter, was working on a machine: kind of a flatbed, very detailed. He was doing very technical, material cutting, cutting shoes and shapes—with a laser.

I was fascinated by it. I just thought it was so clean, so precise. I asked him how he was getting those lines in. What was the program? And he just said, "Adobe Illustrator." And I had been an Illustrator guy the whole time, and I just kind of started playing with it. For so long there had just been our standard, old techniques. We hadn't figured out a way to hand-carve artistically. It was exhilarating: here's a new tool!

Instead of cutting all the way through the materials, I investigated using the laser for etching, and that really opened up the door. The proficiency of the tool came very quickly. People started seeing my shoes and asking, "What's that?"

The first one I did was a Cortez. I was doing a filigree-inspired design. I just liked the flowing, tribal aspect. I actually have that exact actual shoe in a little cabinet in my music studio, all beat up. I wore those for about five or six weeks, every day, just to see if they would hold up.

II. Major Laser

Then I made a pair of shoes for MJ as a birthday gift. So, it went from an exploration to a gift, and then, within a year, we released the Laser Pack consisting of a Dunk, an Air Force 1, and a Cortez. Mike Desmond and Chris Lundy did the art on the Dunk. I worked with Maze Georges on the AF1 and with Tom Luedecke on the Cortez.

From there it went to the Air Jordan XX, where I did the graphics on the strap with the laser. There ended up being a hundred on each foot that made reference to MJ stories, stats, and signature moments.

When MJ saw it, he lit up. He said, "No, no, no, don't tell me. I know these mean something." He just started looking at them, and he figured out one, and then he figured out the next one. He was like a kid in a candy store, but it was his candy store, it was his stories, you know? He loves that stuff. He didn't want to be told what they meant; he wanted to figure it out for himself. Competitive, like, you're not going to beat me; I'm going to figure this out.

All of that happened within twelve to sixteen months of the laser. As far as the tool itself, I'm still playing with the machine, with different machines. I have a new one coming in now.

THIS PAGE:

Nike Air Force 1s for President Barack Obama

OPPOSITE PAGE:

Mark Smith

III. Top Secret Sneakers: When POTUS Wore Kicks

I'm basically an artist who found a way to make a living at a company doing industrial design and using industrial tools. I used the laser as an art tool versus as an industrial tool. The machine I generally like to work on now for exploration is 250 watts, and it's got a bed size of twenty-four inches by twenty-four inches, and it's raisable. I can raise or lower it by about ten or twelve inches as I burn.

I'm really excited and proud about the stuff that we've done, which, in large, no one really gets to see, because we're not always doing drops. There are probably a couple hundred projects that we never sold. We've just been doing them as one-off gifts, and for a lot of exploration.

For example, there's the shoes we did for President Obama that nobody ever really saw. That was a hell of a project, a super-fast turnaround. Obama came out to Oregon, I believe in 2015. I heard about it on a Tuesday morning; he was going to be there on a Thursday afternoon. We built a custom pair from the ground up. Laser cuts we'd never done. Words from the Constitution. Stars. Stripes. Gold, red, white, and blue on the Air Force 1. Everybody on the build and assembly team signed the strobel sock. I asked my good freind and frequent creative collaborator Dave Gill to design the B.O. heel graphic lockup.

The pair was called the Eagle and featured laser-cut eagles from many cultures, representing the American melting pot.

IV. Behold, the Primal Burn

The laser is like a digital campfire to me. You can't look away from fire, so you have to look right at it; something in the lizard brain just makes me have to watch. It's basically the power of the sun focused on a pinhead. It's ancient. It's fire, you know? It's just fire.

BOTH PAGES:

Nike Air Force 1s for President
Barack Obama

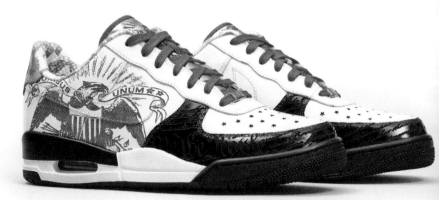

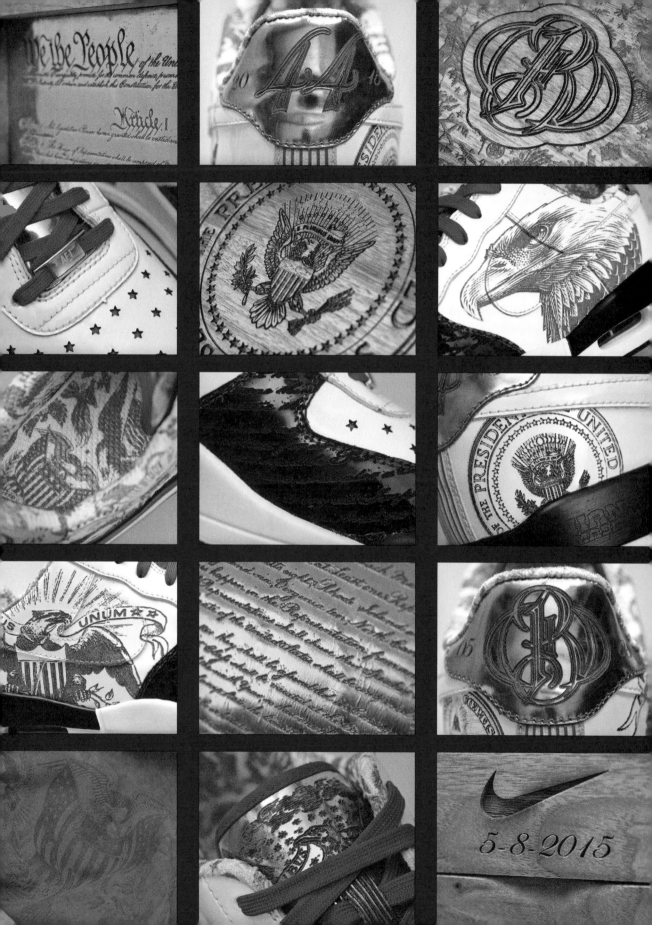

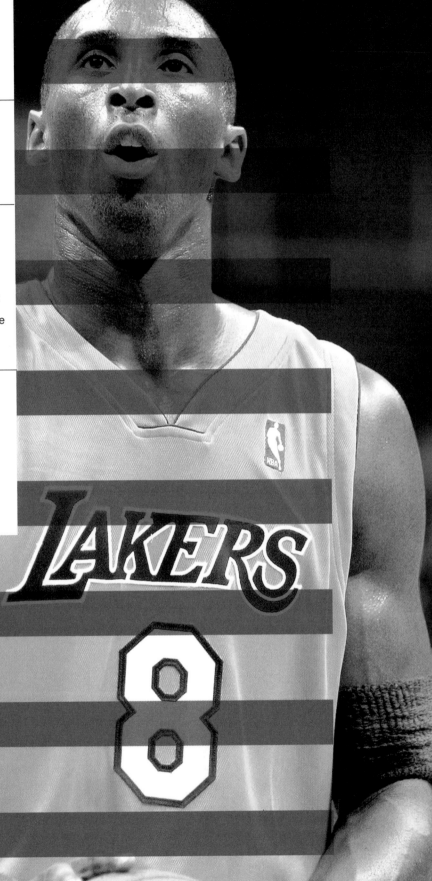

KOBE BRYANT

BASED IN

ORANGE COUNTY, CALIFORNIA

VITALS

Though now retired from the NBA, Bryant's laser-sharp focus on sneaker design hasn't waned. Optimizing performance is a lifelong quest.

CHAPTER

50

I. Soccer and Soul Mates

It came from observing the way soccer players move on the pitch. Soccer players actually put more torque on their ankles than we do as basketball players, and their ankles are more in jeopardy. It got me thinking: maybe a basketball player could play in a low. Then I started really looking at high-tops and saying, okay, well, ankles tend to grow weaker when they're in high-tops because the ankle is not moving in its natural range of motion, and, therefore, it's missing out on opportunities to strengthen itself through natural performance.

That's when I said, "Avar, I think it's time to do a low. It will give us more range of motion, it will actually make our ankles stronger in the long run, and it also gives us the ability to have a much, much, much lighter shoe—and less material."

Avar always sees the big vision like I do, immediately. I mean, I think he thought I was crazy for wanting to take such a risk, but he loves taking risks himself. We're kindred spirits in that regard.

II. A Shoe Is a Machine for Living In

I don't really do too much of the fabrics, or the design of the shoe. I just speak from a story perspective, and of a moment in time in my life and in my career, and the challenges I'm facing internally and externally.

We do a good job of communicating with each other. Because we've been around each other for so long, it's easy to have open discussions about these things. And Avar internalizes them, and then designs something that really mirrors my psychological and emotional state.

For the IV, I was talking about minimalism, efficiency, and being really calculated and methodical about how I approach this game after coming off of a loss against Boston and coming into '09. So how do I simplify things to its purest form? And be extremely efficient? The shoe was designed with that in mind; its lines were very sleek, it was extremely light, and there were no wasted materials, no wasted fabrics, or anything of that nature.

The hero's journey, to me, is an ongoing thing—absolutely. Like I said, we had just come off a really tough loss, so going through those moments of trial—those really dark moments—if you stick to it, it eventually leads to much, much brighter times. I remember having that conversation with Avar—not just on that shoe but many times before and after.

THIS PAGE:

Nike Zoom Kobe IV "61 Points"

OPPOSITE PAGE:

Kobe Bryant

III. Revolution Number 9

The only reason for us to go to high again was to reinvent what a high is; creating a high that behaves like a low. So what do I mean? Well, the elasticity of a high needs to be able to move with the ankle, move with the foot, and not just simply be there as a guardrail or a bumper.

So Avar looked around a little bit, and I talked to Mark [Parker], and he said, "You know, we have this really cool fabric that we're pretty excited about." That's when I was introduced to Flyknit, and I said, "This is exactly what I've been looking for." They said, "The challenge is that it has only performed in one dimension, which is running, and we haven't tested it for basketball." And I said, "Well, that's right up our alley, isn't it?" Because we always liked doing things that people aren't sure whether or not they can do, and we pushed forward, and made it happen.

At the time when I came up with the idea for this shoe, I was thinking about all of the people who inspired me throughout my life, people that I have spoken to directly, or that have inspired me indirectly. I felt like people were wondering, how do I have the mentality of even believing I can come back after this Achilles injury? I said it might be good for them to understand who some of my muses were, and who some of the people I grew up admiring or studying and learning from were. This way they could piece together the process of how I got to this place. And that's where the idea came from: every shoe that was designed was basically based off of one of my muses, from Michael Jackson to Michael Jordan to Beethoven to Picasso.

There's some secret language on the back of the shoe, too. It's for us. We like having fun like that. It's different codes that you've got to kind of piece together. I don't know if anybody has.

The stitching details up the Achilles? It's a constant reminder that there's beauty in scars and that the art you make can make you feel stable.

IV. On the Theory of Integrated Creation, All-Comsuming Curiosity, and Emotional Design

Most of our sessions are centered around questions. Asking questions. Questions, questions, questions, questions. You wind up having an answer, and then that leads to another question. So it's a constant dance. Now, I'm having more time to be around, and read, and get out and travel and things like that, so I'm exposed to many more questions, which leads to getting more answers.

For the A.D. NXT, it's: How do we simplify this for athletes? A process that has been around for many, many years. Since the beginning of time, it feels like. How can we simplify a performance basketball shoe? How can we minimize fabrics? And then how can we create a stronger and a more supportive lockdown system?

We don't create something in a vacuum; we don't create a shoe and say, "Okay, it would be cool if we had a shoe without laces. And then it would be cool to create an even lighter shoe." Ideas must all communicate with each other, right? You can't just have one thing behaving by itself and not communicating with the others, so the fact that there are no laces on the shoe is one thing, but how does that contribute to strengthening the lockdown mechanism of the shoe, and how does that contribute to the shoe being lighter and more stable? Those are all of the problems we tried to solve.

I don't really look at designs and see the object itself. I like seeing the emotion behind it, or the reason behind it: the artist who created the thing. The thing is just a byproduct of something a person was going through, a question that a person had, and believed the best way to answer that question was by designing the product in that manner. I'm spending the same amount of time now on shoes as I ever have. I think about it often. There are always questions. That's never going to change.

ERIC AVAR

BASED IN

PORTLAND, OREGON

VITALS

The decade-long Nike
collaboration between
Bryant and Avar rivals that
of Hatfield and Jordan in its
scope, its intimacy, and
its greatness. And it's not
over yet.

CHAPTER

51

I. Enlight- enment at the Mall

In high school and college, I worked at the Athlete's Foot at the Danbury Fair Mall in Connecticut. I grew up drawing shoes all the time. My mom's an artist: mixed media, watercolor; she was a seamstress, a pattern maker. My dad's a mechanical engineer. So, there was always the premise of: you'll never make a living as an artist, you have to be an engineer.

When I went to the Rochester Institute of Technology in 1986, I had no idea what product design was and so I started studying mechanical engineering.

One day I wandered up to the fourth floor of the design building and walked into a space that was exploding with renderings and drawings. There it was: the synthesis of art science. It was like, "Oh my god, this is what I want to do."

It was a little bit later that it finally occurred to me that I wanted to do it with shoes. After six or seven years of working at the Athlete's Foot, I was selling a pair of Nike Air Stabs that Bruce Kilgore had designed. Inside the box was this brochure with an exploded view and a rendering of the shoe, explaining what it was all about. That was almost senior year. That's when I officially started designing. My professors all thought I was crazy. Footwear? At RIT, everyone was thinking about product design for Kodak and Xerox. But I made my own independent study and had a job with adidas right when I graduated. Six months after that, I came to Nike, where I've been now for twenty-six years. I already had an emotional connection with their shoes. I wore the Waffle Racer for high school track. They made me feel fast.

II. Mamba Time

About ten years ago, I started working with Kobe Bryant. I had already done basketball for ten years with Gary Payton, Charles Barkley, Penny. Quite honestly, I was excited to do something different. I was looking into working on running and training shoes when Mark Parker called Tinker and myself and said, "Hey, we're thinking about signing Kobe Bryant. I would like you guys to be a part of that."

At first I was apprehensive about continuing to work on basketball product but any reservations I had were quickly gone upon meeting with Kobe for the first time. I knew right away we had the opportunity to embark on an amazing journey.

Around the time we were finishing the Kobe III and started talking about the future, that's where he said, "I want to do a low-top." My first question was, "Why?" And he's like, "I don't need all that extra crap around my ankle. I want more range of motion and flexibility and freedom of movement." And I'm like, check.

That's very much my philosophy. We were also working on Nike Free at the same time. So I was working with the Tobie Hatfields of the world

THIS PAGE:

Eric wears Nike Primo Court

Nike Waffle Racer

OPPOSITE PAGE:

Erik Avar

on the Free product. And I'm always a big believer in getting stuff out of the way. So I was like, yes, dude, let's make a low.

But coming back here, to the office, that was a hard sell. They were like, "No, we can't do that, that's too niche." Kobe knew this was going to be an issue and a challenge, but he stuck to it, like, "I want to prove to the world and prove to the kids that you can play basketball at the highest level in a low-top." That athlete voice and confidence gave us the leverage to create the product.

III. High Culture/ Low Culture

The IV, in all honesty, was a low three-quarter. By the V it was a true low-top. Around that time, the new Christian Bale Batman movie had come out. Kobe just loved it. The hero's journey. The Tao: you can't have light without dark. With the ELITE IX, we also came back to a much deeper storytelling perspective. Not pop culture, but more along the lines of Renaissance artists, classical musicians, and I think even philosophers. I was also thinking we'd been working on Flyknit long enough that it was time to do knit basketball shoes. Everyone was like, yeah, you can't do a basketball shoe in knit; we're not there. So of course I just brought some stuff down to Kobe in LA, and he was like, yeah, let's give this a try. At the same time, he was like, "I want to do it in a high-top."

We just spent the past six years doing the whole low-top, right? So, I just kind of laughed. I'm like, "Oh shit, dude, they're going to kill me back there." But he's like, "No, here's the deal. I want a high-top that plays like a low-top." And he was like, "I want it to look like a wrestling boot."

It made total sense.

The nine red marks on the back of the shoe also started on the IX because this was after his Achilles surgery. He had nine staples to sew up the back of his foot. We evolved it to four marks because the doctor

had told him afterward that they'd used four feet of suture cord to stitch him up. It's that classic hero's journey again: rising up from the ashes.

IV. Big in China

I'm wearing the XII now. The NXT. This was Kobe going, "Hey, I want to reinvent laces." So, it's synergistic to a lot of the work with the HyperAdapt. That's one of the beautiful things about design innovation. There's just so many things that influence one another.

Part of the inspiration and storytelling for this shoe is around this notion of the beautiful death: Kobe's NBA career ending and kind of the next chapter of his life. Kobe's unique. He has more ideas a year into his retirement than ever before. We're texting all the time. I probably see him every three months.

So, the NXT, it's very symbolic. It's about his own reinvention and rebirth. The laces cinch down, like with a modified lace lock. The whole thing sucks down on the top of your foot. We made a transparent strobel. It's where the upper is stitched down. Normally, that's all opaque, but we wanted it to be clear so you could see the technology. There's not a ton to the shoe. It's really sophisticated. But it's almost like a Chuck Taylor in its construction.

It's interesting to me that what we do manifests itself into something that is culturally relevant. Like, there was a launch of a Foamposit in China and one of our PLMs there sent me a video of the crowd, and, I mean, it was insane. I can't even imagine that for a product. I never allowed myself to think that way.

Every day I come to work thinking, simply, how do we solve problems? How do we create something that solves the performance problem but is beautiful at the same time? Where do science and art merge? And how do we tell a story? That's really the only way that I look at it.

KOBE III ZOOM
THE HIGH-TOP

KOBE IV ZOOM
THE THREE-QUARTERS

KOBE IX ELITE
THE MASTERPIECE

KOBE V ZOOM
THE LOW-TOP

KOBE VIII
ACHILLES SURGERY

PAUL GAUDIO

BASED IN

PORTLAND, OREGON

VITALS

Gaudio, adidas's Global
Creative Director, has lead
adi's astonishing renaissance.
Now, he explains his vision
for its future.

CHAPTER

52

I. The Reboot

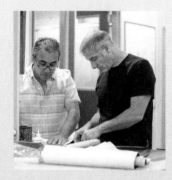

A few years ago we undertook a massive effort, from one end of the organization to the other, to rethink who we are, what we do, and how we do it. We looked at how we were separating ourselves into to two divisions: performance and style. As a company full of creative people who love sport and design we looked in the mirror and said, "These two things aren't separate. They've never been separate. So, why are we separating them?" What we came up with is that we exist to create. We exist to bring sport and creativity together. We decided to put that into the center of the conversation: How do creators think, feel, and act? They create their own path and they don't ask permission.

II. Optimization and Emotion

I was sensitive about my sneakers even as a little kid, you know? I cared. I cared so much about the shape of the toe, the color—really specific things. I remember being a very little kid and pitching a fit about it in the store. This was Pittsburgh in the '70s. Mom was buying me some Buster Browns, like blue canvas with a little rubber toecap. And I remember I put on a pair and I didn't like them. I hated the shape of the toecap, I flipped out. God, I bet I was five or six. They brought out a different pair because there was some variation with quality control, and then I was happy. I got what I wanted. I called those shoes my Tiger Tennies because they had some sort of serration in the front, and I thought that was cool and very aggressive. It made me feel like I could go anywhere and go there fast.

Shortly afterward my father got me these fake adidas shoes. I remember a general sense of dissatisfaction. Because in junior high, sneakers became a big deal for me. We coveted those things, we cherished those things. Every kid in school wore tennis shoes, basketball shoes, not really running shoes so much. Everyone wore three stripe track jackets and we all had adidas T-shirts, and nobody really quite knew what adidas was. It was a big joke that everyone thought adidas stood for, "All Day I Dream About Sex." adidas was like Kleenex almost, like when you're talking about sport shoes you really didn't talk about anything else.

From being a little kid we all experience that emotional feeling when you put a new pair of shoes on: You want to go out and run around. You want to go do something. I first realized the importance of things working well and performing when I got into organized sports. I started playing football and tennis, and footwear was a big part of both. Each one had high performance requirements. That's when you start to notice how important the tools you have to work with are. They're very intimate. These are things you put on your body. They have to move with you, they have to work in harmony with you and your game, and they have to help you feel like you can improve.

I was hardly any kind of elite athlete, but I took it seriously. You don't

ALL DAY I DREAM ABOUT SEX

adidas®

III. All Custom Everything

We couldn't get anything in Pittsburgh. I couldn't even hear the kind of music I wanted to hear on the radio. You had to go discover it, you had to take the bus into town or you had to stick your clock radio out the window to try to pick up college radio stations, and then you could hear music from Europe or LA or New York, or whatever. And fashion was similar. I had to go to the thrift stores and buy vintage stuff, or I had to modify things that my parents would have purchased for me. If you wanted something different or unique back then, and you didn't live in a major

cosmopolitan center, you made stuff.

I would buy blank T-shirts or buy blank canvas shoes, and do whatever I felt I needed to do to make them mine. I made a lot of things. I would spend hours and hours lost in the basement working on projects, building things of my own design. Or customizing things to make them better or more personal. Skateboards, go-karts, tree houses, you name it.

That probably led me to industrial design. I got a very broad education around the design and construction of commercial goods. I didn't work on very many soft goods at first. I was definitely working on more technical things. Consumer electronics, or medical products, or transportation.

I was fascinated with the nuts and bolts of design. How things work, how they go together, how they're made. I never considered

going into footwear or into apparel until a friend of mine presented the idea to me: "Hey, do you want to move to Germany and work for adidas?" And I thought, "Wow, sneakers. Man, I don't know." I was still buying sneakers and into sneakers, but as an athlete. I was doing triathlons and stuff like that, so I had bike shoes and running shoes. That was the time when footwear was just developing into something more than simple foot covering. You know, now there's technology, now there's concepts behind things. So I was interested in it as a consumer, and I thought, what the heck, I'll give it a try.

And I really fell in love. Bringing sports and creativity together to me was the dream. We're talking about athletes, we're talking about biomechanics, we're talking about function, but we're also talking about how things look, and we're talking about style and fashion and emotion and storytelling. So I did that, and then I left adidas for a minute and I got into the motorcycle business because I had been feeling this yearning to return to my sort of nuts and bolts world.

I'm very passionate about motorcycles. And in a weird sort of way motorcycles are similar to sneakers: buying them means making very emotional, aesthetic decisions. There are different types of guys—*I ride a sport bike,* or *I ride in an adventure tour,* or *I'm a Harley guy.* It's a similar kind of passion and emotion and identity kind of connection to. In the end, while there's a million sort of whirling pieces and parts to make

a motorcycle work and feel and behave the way you want it to, the vast majority of people make the purchasing decision based on emotion and identity, and I think footwear is very similar. *How does it look? How does it make me feel? How does it help me express myself or shape my identity?*

IV. Towards the SPEEDFACTORY

You don't set out to make cool stuff. You have to understand why you're here. You've got to have a purpose and a vision. You've got to have a point of view.

Thinking like this has helped us learn that we need to present technology and innovation in a way that's more wearable, human, and crafted as opposed to mechanical, irrational, or high tech. This is where this idea of Futurecraft comes from. We use the latest and greatest processes and technologies, chemistry, and science, but we point them in a direction that is softer and more familiar. It feels like there's still human hands on it. In years past we might have turned all of that innovation into something shiny and hard and slick and polished. We just changed our point of view.

Knit technology has existed forever. We probably worked on it for two years before we brought something to life in footwear because the application of knit for footwear was what was new. In doing that you need to develop materials, you

need to develop the machine technology and capabilities, you need to develop people who know how to design and engineer for knit. You need to learn how to build a shoe with knit. You know, how do you make it last. How do you make sure you can incorporate support and breathability, and the structures, and the flexibility, and all of those things? It takes time. So I would say probably two years as a minimum to get to something like that for us.

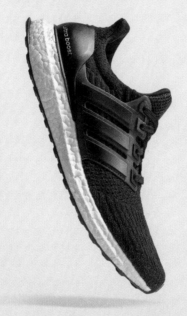

And while BOOST looks familiar, like foam, it's something that came from a completely different place. It came from outside of our industry and we had to completely change the manufacturing process, the material compounds. It was a huge endeavor, and you're not only saying, hey, I'm going to make a shoe with a different material or a different construction, now you also have to change your supply chain, your manufacturing base. You need to

build up the experience, build up the capability in your factories. Because think about it, people are largely stitching synthetics and leathers and textiles together, gluing them to compression molded, EVA midsoles. And now we're talking about knitting structures, knitting materials, knitting reinforcement, all in one, as opposed to layering and laminating.

BOOST came from bicycle helmets. So like Styrofoam. I think it's the same basic idea, right? It's how they make Styrofoam. Thousands of little pellets that we put into a mold and then instead of compression molding, we steam them. It was totally new and different. We had to learn how it can benefit the athlete, literally learn how to make it, learn how to make it to scale. So those are the most exciting, interesting, and rewarding kind of projects we work on.

But what I really love about this is how you bring it to life. 3-D printing is another great example. Really high tech, it's used in all sorts of different industries, but the way we brought it to life to me is what matters. We've been working on this Futurecraft idea for a couple of years now. We've done sort of these little limited releases. The point of doing that Futurecraft is another big shift in kind of who we are as a brand, and how we operate. Meshes and textiles that feel like you want to put them on your feet and walk on them. So it's really translating high tech into craft.

THIS PAGE:

adidas UltraBOOST

Our future will be much more connected to our own supply base, and even potentially internally in our SPEEDFACTORY. Our vision is to ultimately build environmentally sensitive, locally relevant products for people, within those communities, and deliver things in a much shorter timeframe.

The idea of SPEEDFACTORY is local production, one-for-one, made for me. It frees us up from the massive shoe factory model and Asian manufacturing sources. It allows us to read and react, it allows us to be closer to culture and the consumer. It allows us to make those things on-site, anywhere. It can be in Atlanta, it can be in a truck next to the basketball courts.

V. Light and Oxygen in 4-D

Literally, we shoot light and oxygen onto this resin, and wherever you focus the beam, it turns that material into a solid. It turns a liquid into a solid. It's called Digital Light Synthesis. It allows you to do is make a lot of complex structures that you couldn't otherwise make with traditional manufacturing. The process itself look a little bit like magic. You're pulling this really sophisticated structure out of a very shallow bath of fluid. It's hard to believe as it emerges from the bath. At the moment we've just been using smaller units for prototyping, but then of course you can make larger units so that you can reach scale. The small ones are the size of an ATM at the bank.

The design is truly an example of form follows function. What we needed was a latticework, a three dimensional structure that could support a foot and deform and flex as needed. So you start by literally deciding what you want that structure to look like, and you create structure based on data input: say, the nature of the runner's foot or their stride. That then impacts the size, stiffness, or frequency of those lattice structures inside of the sole. It's not something that a designer really sits down and draws in a traditional sense. It's more starting with a structure that you can then populate a volume with and then, using the math, fill the volume with the appropriate structure.

You can't do everything on your own. Something like this, as sophisticated as this is, is clearly beyond our core competence. And so we're looking for people like the ones at Carbon [a Silicon Valley–based tech company]. It's been a really good partnership: they're looking for ways that can provide applications for their technology. One of the reasons why we do things like the Futurecraft is it's a way to broadcast our intentions to the world and let people know where we're headed, and then they can come join us if they think they can help or they want to be a part of that journey. So that's really what happened with the Carbon guys.

The answer for the upper was simple. We've got Primeknit technology, which is a very similar concept, right? Using machines and computers to essentially knit uppers. And within any Primeknit upper are different structures, so there's areas that provide more support, that allow stretch and flexibility, that will allow breathability. So, we can create this really simple, elegant, beautiful upper that has all of the technology built into it. To combine 4-D an d Primeknit was logical. It's a way we can use data, advanced material and process technologies to create something completely new.

Wearing them feels very different. The way I try to explain it is, when you normally wear shoes you have something solid under your foot, you feel a dent under your feet, you feel that sort of density. With the 4-D you feel air under your feet, literally and sort of figuratively. You feel the clearness of air under your feet. But you also have the sensation you're walking on this latticework that is light and airy, that when you step into it at first it's soft and then it gets much stiffer.

From a manufacturing standpoint it really frees us up to do a lot more sophisticated solutions for athletes or specific sports or specific movements without all of the investments and cumbersome process and time that it takes to tool up and make a product.

I think it's too early to say that it's going to become the dominant manufacturing process, but I think it will become a significant manufacturing process over the next few years. The intention is just to keep this as limited excusive content. We are interested in getting it to scale, and again that's why we really needed the partnership with Carbon; it's not just the performance

of their processing in materials, but their ability to go fast and scale.

I think one of the most exciting things is the idea that you can walk into a store and have an assessment—you can learn as an athlete about how you move, how you're shaped, what your performance needs are. I can enter your data in. I can make a shoe for one person or I can make one shoe for many people. It's maybe the most advanced science project we've ever worked on. In an hour or so we could be able to hand you a pair of shoes that are unlike any other.

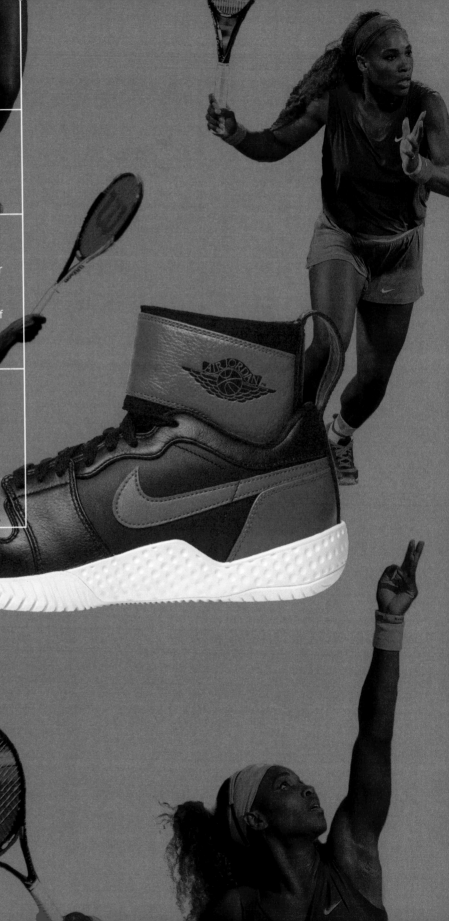

SERENA WILLIAMS

BASED IN

PALM BEACH,
FLORIDA

VITALS

A formidable designer in her
own right, Williams reveals
the Versace collaboration of
her dreams.

CHAPTER

53

Q&A

We know you're deeply involved in the process of designing your own shoes. Do you have a favorite and why?

I think the one I'm currently wearing in matches, because it's the first shoe where I was involved in the creative process from the very beginning. From the first mold to the very end. The shoes are the Nike Air Flare!

Tell us about those custom Jordans you got after, amazingly, winning your twenty-third Grand Slam tournament—what's special, as somebody who cares about sneakers, about having a pair of sneakers like that?

We designed the Jordans together a while back but I think what was special about it was that we decided to release it right after my twenty-third Grand Slam. The timing of it, and the shoe itself, just made the whole thing a really special experience.

In your estimation, what is the coolest pair of sneakers of all time?

Nike Air Force 1 for sure.

What was your first meaningful pair of sneakers?

The LED ones that lit up in the '80s.

If you could collaborate with any other fashion designer on a pair of sneakers, who would you work with and what would you make?

Probably Donatella, and it would be the most fabulous leopard-print tennis shoe!

OPPOSITE PAGE:
Serena Williams

#23 lasered Air Jordan 1 x
Nike Flare "Banned"

AARON COOPER

BASED IN

PORTLAND, OREGON

VITALS

Cooper, the son of a preacher, sees sneaker design as a calling, describing it as an act of empathy. Athletes like Serena Williams would be the first to admit his sensitivity is the key to his craft.

CHAPTER

54

I. Thank You, Sir. Can I Have Another?

Twenty-two years ago, I was the first footwear design intern at Nike. I stumbled into that and never left. It just felt right, it felt like home, you know? I made sure I was first one in, turning on the lights, and the last one out, turning off the lights. Since I was the first intern, they didn't really know what to do with me. When anybody threw me a bone, I made sure I knocked it out of the park.

Back then there was no Illustrator software or any of that, so we were coloring shoes by hand. I would do a line drawing of a model—one of the very first ones was the Air Edge—and I'd print it out a number of times, put all of those on one page, and then just start cranking out colors. I stayed late, drawing a huge stack of colors for them to choose from so when they got in in the morning, it would be as if this little elf dropped a stack of goodness on their desks. In the morning, they'd come into my office and say, "Did you sleep last night?" I'd say, "Yeah, I'm all right. Can I do anything more for you?"

Toward the end of my internship things got crazy good. The company just started growing, and Eric Avar and Wilson Smith just couldn't keep up with all of the design briefs in basketball, so they gave me a brief to design, I started designing it, and before I left my internship, Wilson helped me finish the shoe, the Air Thrill Flight. It was a $75 at retail. Gary Payton ended up wearing it. I still love doing the shoes that cost less. The kids that have only $65 to spend want just as much swagger, science, and art on their feet as the kids with $165.

My father was a preacher, so I think that DNA of helping people is in me. I look at what I'm doing and what I get most passionate about and what I love to do, and when I get most energetic is when I feel like I'm helping somebody, whether it's one person specifically or a whole population.

Sport was a big part of my mom's life. I grew up on Mercer Island in Washington. I was the poorest kid in the richest community. I was the preacher's kid. The kid with the duct tape around my soccer shoes. I played soccer because it was free.

THIS PAGE:

Aaron Cooper holding
NikeCourt Flare "White

II. La Di Da Di, We Like to Scottie

Scottie Pippen was the first athlete I worked with regularly. He had been wearing the big Air shoes, the More Uptempos, and we never heard anything negative from him, so we made a poor assumption that he loved them, and we started designing another full-length vis-air shoe for his signature line.

Nike sent me to go out and meet with him, like, it's going to be great, he loves the Air Max. So I go out there just by myself with somebody from sports marketing, and we start going through my presentation on eleven-by-seventeen printouts on boards. And right on the board he goes, "I don't like that." I'm like, what? He says, "Yeah, I don't want that. I want Zoom." I thought, wait, what? I'm totally new to this. There's no one in the room to help me out, and I have five more boards to get through to get to the shoe that I designed that was basically heading into production. Everybody thought this was going to be an easy sell, which it wasn't.

Now I always tell athletes when I first meet with them, please think out loud, don't hold anything back, positive or negative. You might think it's a crazy idea, a crazy thought that just kind of comes in and out of your head, but the more you can think out loud, the better for me. And it's awesome because I love the surprised look on their face when I come back for that next meeting and say, "Hey, remember when you said this? Well, this is how I interpreted it—it's my job to interpret it—and this is what I'm doing with it." And they're like, "No way, I didn't even think you would have thought about that, or didn't even think like that." I'm very attuned to people's body language, it's what I do for a living, watch people and study them.

Scottie and I were very similar. I think we probably have the same low blood pressure and resting heart rate. We're very mellow. Although, he's very happy and energetic on the outside. I'm a little bit more introverted, more serious to most people.

But with Scottie, I spent the most time with him and was around him so much, and a lot of that was in public and in Chicago—and actually in other cities, too. I noticed he made other people like me feel like they were a part of the Bulls, like they were a part of that same team, and that they were all going after that same goal to win championships. I never asked him, "Hey, did somebody teach you that? Did you learn that in college?" I think it's just who he is as a person. He actually taught me a lot of things I use today, and that's certainly how to treat others and to make them feel like part of the greater good that we're trying to create.

THIS PAGE:

Nike Air Pippen II

III. LeBron-athon in the Time of a Sprint

From athlete's insight to athlete's closet, the production process usually takes about eighteen months or longer. With LeBron James's first shoe, I think the experience was compressed into about three months. And it was high-profile. Articles in the paper, public comments. LeBron was a senior in high school. Everybody was watching him. There was a lot to endure, especially for someone like me who is a very emotional person. To this day, it's probably the most challenging project I've ever done.

When I asked him what the most important aspect of performance was, he said comfort. So that kicked it off. Nobody says "comfort." Comfort had never been anybody's top priority. I looked him dead in the eyes and said, "We will make you the most comfortable basketball shoe you've ever worn."

If you go back and Google "St. Vincent-St. Mary" and "LeBron," you'll see him playing in eight, ten different shoes throughout that season. That was us at Nike basketball sending him shoes so the conversation could happen: "What's the most comfortable shoe you have worn to this point? Why?" And then asking, "Okay, what did you like? What didn't you like about it?"

The first time we revealed to LeBron his shoes in his size—the Zoom Generation—we were in Phil Knight's office, and LeBron jumped straight across the table, put them on, and he was walking around, kind of bouncing around in them, and he stops, and I'm next to him, and he looks at me and goes, "Coop, these are the most comfortable shoes I've ever—" and I see his mom's jaw drop to the floor, basically, and I think it was Gloria who said, "That's exactly what you said you were going to do."

I've been known to cry in public in front of hundreds of people at Nike, and it took everything in me not to cry in front of LeBron. I'll never forget it. I can literally feel those emotions in me right now.

THIS PAGE:

Nike Air Zoom Genation

IV. Mood-Boarding with the G.O.A.T.

Really, it's about relationships. The more you put into them the more you get out of them. It's the same with a marriage, right? Marriages kind of go south when people stop working on them. It's hard, it takes time. The more that you both realize that, and the more effort you put into it, the more that you're going to get out of it. That's also what I try to share with athletes—"Hey, I'm here for you for as long as you want to play at the highest level."

With Serena, we hit it off pretty quickly. I was just talking about this with Tinker, some of the great relationships with athletes. Him and Michael. Eric and Kobe. Teague and Griffey. Me and Serena have a great relationship where I believe we truly create the product together. She and I have built a design board over the years about who she is. It has fashion apparel, home décor, a car. I do mood boards with athletes to try to get to know them better—about what makes them tick, about how they see themselves. Years ago, I said to her, "If you were to ask me to design your engagement ring, this is what it would look like." I can share little sketches with her that I wouldn't even share with a lot of people at Nike because it's such initial thinking. But she knows the design process, being a designer herself, and she really responds to it. It's easy to be vulnerable with her.

Three years ago, I met with Serena, and I said, "I don't think we've seen the best of Serena Williams."

She looks at me like, "Why do you say that?"

I said, "I just think there's something more in you. I think there's something we haven't seen yet. And I'm here to help you find that. I want to do everything I possibly can."

And she goes, "It's so funny, nobody else has said that to me, but that's exactly the way I feel."

The footwear solution was literally 180 degrees different than what she thought it should be. She thought she needed a bigger shoe—more shoe, more stability, higher top, higher silhouette. Beefier materials, all that. But based on what I learned in recent years, I told her the exact opposite: "You need a shoe that actually works with you and basically just kind of gets out of the way and allows your natural ability to shine."

I'm big on millimeters. To me, millimeters matter, and they equate to milliseconds in a sport. Milliseconds make a difference between winning and losing, period, flat out, no question. So talking to Serena about it, it's the milliseconds from her shoe to the ground, the ground back to her shoe, the shoe to her foot, and then all the way up the kinetic chain to hit the ball. I truly believe it can be the difference between her just getting the ball over the net and hitting a game-winner.

THIS PAGE:
NikeCourt Flare

V. What It All Means

Somebody finally asked me years after being here, "Why don't you ever wear the shoes you design?" And I'm like, "Because they're not for me." That goes back to my dad; the message is about caring for humanity. It was never about footwear for me. In fact, I've struggled here at times, because what I'm going after is always bigger. The products I want to be a part of are the ones that are bigger than the shoe, because I want to be a part of something that's bigger than myself. People freak out when they find out I don't have a footwear collection. That's not why I'm here. A shoe by itself doesn't mean jack. It's the stories that matter.

"A SHOE BY ITSELF DOESN'T MEAN JACK. IT'S THE STORIES THAT MATTER."

RODRIGO CORRAL
runs the Rodrigo Corral Art + Design Studio
and is the creative director at Farrar, Straus
and Giroux and New Directions. With a focus
on conceptual art, he designed the *New York
Times* bestselling books *Decoded* by Jay-Z,
Classy by Derek Blasberg, *Influence* by Mary-
Kate and Ashley Olsen, and the book and film
identity for *The Fault in Our Stars* by John
Green. He has also created covers for the
Pulitzer Prize–winning author Junot Díaz,
and bestselling authors Chuck Palahniuk
and Jeff Vandermeer. He has taught at the
School of Visual Arts in New York City and
lectured around the country. Through it all,
Rodrigo remains deeply committed to pushing
the visual possibilities in art, in sports, and
throughout the universe.

ALEX FRENCH
is an *Esquire* contributing editor. His
journalism has appeared in numerous
publications, including *The New York
Times Magazine*, *Wired*, *Grantland*, *Surfer*,
BuzzReads, and *This American Life*. He is the
author of the bestselling Kindle single *The
Killing Season*. He lives on the Jersey Shore
with his beautiful wife and two children.

HOWIE KAHN
is a contributing editor for *WSJ. The Wall
Street Journal Magazine* and a James
Beard Award winner. His journalism has
appeared in *GQ*, *Wired*, *Travel + Leisure*,
and numerous other publications. His
collaborations with Alex French began with
a series of popular oral histories for the
late, great website *Grantland*. Kahn lives in
Brooklyn with his wife and son.

Rodrigo Corral Studio
Art Director/Project Manager:
Anna Kassoway

Designers:
Alex Merto
Anna Kochman
June Park

Photography:
Jason Fulford
Michael Schmelling
Keith Hayes
Zachary Lewis
Anna Kassoway
June Park

Photography Assistant:
Tory Richman

Illustrators:
June Park
Zak Tebbal
Sungpyo Hong
Joel Holland
Na Kim

Design Assistant:
Sasha Veryovka

DEDICATIONS:

To Sloane, Sam, and Tina. To Henry and Casey.
To Anna, Ty, Ace, and Frankie.

SPECIAL THANKS TO:

Tom and Mary French. Dee Dee and Doug Kahn. Abby, Danny, and Zoey Kahn. Toni and Bob Leblang. Heth Waldron-Viville. Ben Schrank. Jim Rutman. David Hiller. Jason Richman. Jason Fulford. Michael Schmelling. Michael Hainey. Jay Fielden. Bobby Baird. Kevin Sintumuang. Jesse Ashlock. Willy Staley. Kristina O'Neill. Chris Knutsen. Lenora Jane Estes. Elisa Lipsky-Karasz. Dan Fierman. Elisabeth Robinson. Charles Finch. Nico Ager. Andrea Oliveri. Alex Bhattacharji. Richard Chang. Nick Hoenemeyer. Shaye Lefkowitz. Michelle Maisto. Luke Zaleski. Alex Sanchez. Corina Lupp. Julie Rosenberg. Lindsay Boggs. Arielle Aslanyan. Anna Kassoway. Anna Kochman. Devin Washburn. June Park. Sungpyo Hong. Alex Merto. Na Kim. Sasha Veryovka. Zak Tebbal. Zach Lewis. Ian Reid (Mr. Ian). Salehe Bembury. Edson Sabajo. Lion Kojo. Yu-Ming Wu. Yu-Ming Wu's dad. Jon Buscemi. Tony Arcabascio. Natasha Yadgar. Sandy Bodecker. Jesse Leyva. Jeff Staple. Sophia Chang. DJ Clark Kent. Matt Halfhill. Kevin Ma. Olivia Ho. Simon Wood. Bruce Kilgore. Bobbito Garcia. Jon Wexler. Tinker Hatfield. Gary Lockwood. Michael Doherty. Isaiah Neumayer-Grubb. Melissa Neumayer. Tom Miller. Missy Miller. Dr. Dana Braner. Tracy Brawley. Lee Banks. Dominic Chambrone. Kyle Riggle. Alexander Wang. Ian Edwards. Nic Galway. Tiffany Beers. Daniel Bailey. Tom Sachs. Trevor Davis. Virgil Abloh. Athiththan Selvendran. Rachel Muscat. John C. Jay. Ronnie Fieg. Austin Scotti. Rachel Zimmerman. Erik Fagerlind. Todd Krinsky. Sara Eckhardt. Daniel Sarro. Frank Rivera. Deon Point. Derek Curry. Justin Snowden. Josh Herr. Peter Moore. Ankur Amin. Bernie Gross. Jim Riswold. Claw Money. Kish Kash. Fraser Cooke. Sam Handy. John McPheters. Jed Stiller. Flavio Girolami. Peter Poopat. Nicole Markowitz. Marc Dolce. Mark Miner. Denis Dekovic. Rick Williams. Jazerai Allen-Lord. Kayce Kirihara. Brandis Russell. Mark Smith. Ryan Unruh. Kobe Bryant. Marly Faherty. Molly Carter. Eric Avar. Paul Gaudio. Serena Williams. Aaron Cooper. Maria Culp. Julia Zellner. Vinti Bhatnagar. Dante Rowley. Erika Schaeffer. Christopher Bevans. Josefine Aberg. Leo Chang. John Geiger. Tyree Dillihay. Rick Shannon. Christine Su. Jeremiah Morse. Matthew Kneller. Tim Yu. Leo Sandino-Taylor. Laura Herbert. Nick Schonberger. Sara Blasing. Haley Bakker. Sophia Hitti. Jenna Golden. Kristi Kieffer. Lennard Stephen. Todd Olbrantz. Tina Warner. Cy Cyr. Keenan Jones. OJ Lima. Jennifer Hutchinson. And Demetria White.

IMAGE CREDITS
AND COPYRIGHT

Thanks to all those credited below for sharing photographs and art and for helping to make this book happen.